AN ACT

OF CONGRESS

AN ACT
OF CONGRESS

The Legislative Process and the Making

of Education Policy

―――――――

EUGENE EIDENBERG
UNIVERSITY OF MINNESOTA

and

ROY D. MOREY
DENISON UNIVERSITY

W · W · Norton & Company · Inc·

NEW YORK

To

Susan AND *Danielle,*
Delores, Diana, AND *Carolyn*

Contents

Preface

On the evening of April 9, 1965, the United States Senate passed the Elementary and Secondary Education Bill by a vote of 73 to 18. For the members of the Eighty-ninth Congress this meant the end of controversy and debate which had started two and a half months before when the House Education and Labor Committee started hearings on the bill. For the proponents of federal aid to education it was their most significant victory in a struggle which spanned more than a century.

Two days later President Lyndon B. Johnson stood outside a former one-room schoolhouse in Stonewall, Texas, where he had first attended classes, and signed into law the Elementary and Secondary Education Act of 1965, officially bringing into being Public Law 89-10 (the tenth Act of the Eighty-ninth Congress). On this occasion the President said that no measure he had "signed or will ever sign means more to the future of America." In one sense this was a personal victory for Johnson. This bill was the most cherished item in his 1965 domestic program. In a larger sense it was a victory for all those who had waged the long battle for federal aid.

The scope of this book covers the relevant major events preceding the passage of the Elementary and Secondary Education Act of 1965, the passage of that act and its subsequent modifications in 1966 and 1967. It is the direct product of an opportunity afforded us by the Congressional Fellowship Program of the American Political Science Association. For nearly a year we viewed the first session of the Eighty-ninth Congress from the vantage point of participant-observers. It was our good fortune to be in Washington in 1965 to witness the passage of the Elementary and Secondary Education Act. As we watched the passage of this bill from different

perspectives (Eidenberg in the office of Majority Whip Hale Boggs and Morey in the office of Robert P. Griffin—then second ranking Republican on the House Education and Labor Committee), the notion occurred to us to combine our experiences and observations.

Our original intent was to prepare a case study of the 1965 act. But the scope of the project was gradually broadened to include an analysis of the federal aid to education controversy prior to 1965, plus a coverage of subsequent events. This study is designed to be neither an assessment of the merits of federal aid to education nor a substantive review of specific school aid proposals. Our major purpose is to offer a working description of the American policy process by focusing on the issue of federal aid to education.

This book is divided into three major sections. Part I (Chapters 1, 2 and 3) presents a brief description of our view of how public policy is made in the American political system, and a history of the school aid issue prior to 1965. It also treats the major changes in national politics during the thirteen-month period following the assassination of President John F. Kennedy and the opening of the Eighty-ninth Congress. Part II (Chapters 4, 5, and 6) presents a case study of the 1965 Elementary and Secondary Education Act. This includes coverage of executive activities in late 1964 through the passage of the supplemental appropriation bill designed to implement the act. Part III (Chapters 7 and 8) analyzes the reassessment and modification in school aid policies in 1966 and 1967. It also includes a broad view of the policy process.

In addition to the Congressional Fellowship Program experience, the research for this study was made possible by support (for Eidenberg) from the Graduate School of the University of Minnesota and (for Morey) from the Denison University Research Foundation. Funds from these sources were used primarily to finance several trips to Washington by both authors to conduct a series of forty interviews with members of Congress, executive departments, and the White House staff, and with interest group representatives.

Both of us owe an imposing debt of gratitude to Theodore J. Lowi of the University of Chicago, who provided invaluable assistance throughout the preparation of this study. In addition we would like to thank Charles O. Jones of the University of Arizona, James A. Robinson of Ohio State University and John M. Gaus for reading all or parts of the manuscript and for providing helpful suggestions and comments.

A special note of appreciation is extended to all those associated with the Congressional Fellowship Program for making the experience such a positive and productive one. The offices of former Representative (now Senator) Robert P. Griffin (R. Mich.), Senator Norris Cotton (R. N.H.), the House Majority Whip Hale Boggs (D. La.), and the Vice President of the United States Hubert H. Humphrey were congenial and productive locations from which to watch and contribute to the legislative process.

Appreciation is expressed to the late President A. Blair Knapp, Dean Parker E. Lichtenstein, Professors Louis F. Brakeman and W. Neil Prentice, Sharon Kiley, Sue Douthit, and Richard Collister, all of Denison University, and to John D. Rome of the University of Minnesota. In addition we wish to thank Mr. D. B. Hardeman. To the Bruce Ladds we express our appreciation for their warm hospitality. To Delores Morey, Diane Pioske, and Patricia Hayman-Chaffey go our deep thanks for their services in typing the manuscript.

Of course it is understood that much of whatever value this book has is directly derived from the efforts of the people mentioned above and many others who gave so generously of their time in interviews and memoranda, but who must necessarily remain anonymous. Any failures of omission and commission, however, remain the responsibility of the authors.

EUGENE EIDENBERG
Minneapolis, Minnesota

ROY D. MOREY
Granville, Ohio

The law is only a memorandum. We are superstitious, and esteem the statute somewhat: so much life as it has in the character of living men is its force. The statute stands there to say, Yesterday we agreed so and so, but how feel ye this article today? Our statute is a currency which we stamp with our own portrait: it soon becomes unrecognizable, and in process of time will return to the mint.

—Ralph Waldo Emerson, *Essay on Politics*

PART I

History
and Change

I

THE EDUCATION POLICY SYSTEM

Introduction

A specific policy such as the 1965 Elementary and Secondary Education Act can be enacted only at that point in time when public support (especially as expressed by the major groups) coincides with a sufficient level of support within the political system. This coincidence of support, however, is not necessarily inevitable. If the school bill had failed in 1965, chances are it would not have been enacted subsequently, at least in the same form.

The question is how does one determine public support of a proposed policy and how is this support transferred to the decision makers within the political system? In measuring the level of public acceptance the political decision makers rarely take their cues from mass opinion polls! The opinion polls may be helpful in delineating the outer limits of acceptability, but they are of little assistance in guiding decisions on specific and complex policies. The "public" is not a monolithic mass which articulates its wishes with a single voice. In the eyes of the congressmen and other political decision makers the "public" is a bewildering col-

lection of groups and associations only some of which are attuned to the policy contemplated by the system. Hence, for the policy maker, "public" acceptance is voiced by the leaders of a relatively small collection of attentive groups.

The leaders of these attentive groups join with decision makers strategically placed within the political system to form a small group we shall describe as the *policy system.* Of course those who make up the policy system will vary over time and from issue to issue.

The Education Policy System

The national political system is a myriad of decision points, and for this reason it provides a multiplicity of access points where various groups and individuals can influence decisions. The essence of the public policy process, as we see it, is alternate conflict and cooperation over matters that make a difference to the individuals and groups involved. In short, the policy process is neither random nor accidental in its major components. Those who play important roles in policy making have access because they have the skills, expertise, and/or power to participate. Their resources and therefore their access is accepted by others involved.

Such is the case in the education field. The policy system that contributes to the making of education policy is primarily an elite of individuals and groups who have a right to participate in the decisions affecting public education, based upon recognition of their particular interests in the issue. The extent and depth of that interest obviously varies from group to group and from time to time. We are not dealing with a static system of established participants and rules. The conditions of the broader political environment will alter the distribution of resources necessary for meaningful participation.

In specific terms, there is a policy system for education whose principal representatives constitute the elite that

contribute significantly to education policy. The education policy system is comprised of the major education interest groups (e.g., the National Education Association, the United States Catholic Conference,[1] and the American Federation of Teachers); the state commissioners of education; the Office of Education and some elements of the Department of Health, Education, and Welfare; the influential members of the education committees in Congress; several major religious groups (National Council of Churches, Baptist organizations, etc.); and the White House.

The recognition of legitimate interest is not a recognition of either mutual interest or of equal rights. Policy systems may also be viewed as complex sets of strategies which may or may not result in a resolution of conflict. Furthermore, the skills and techniques that lead to effectiveness in the world of the policy maker are neither equally known nor equitably shared. In an important sense the political skills of the participants are their varying capacities to exploit whatever resources happen to be available at the time.

It should be understood that the elite corps of participants who make up the policy system do not make final decisions on behalf of the political system itself. The policy system does, however, establish the boundaries within which binding choices will be made. It makes a necessary contribution to the decision, but final decisions are shared with numerous other participants within the political system.

The passage of HR 2362 (the education bill) in 1965 was not a product of one event, decision, or cause. Rather, it was enacted because the policy environment that affects education supported the decision to pass federal aid legislation.

The leadership of Lyndon Johnson and the Democratic majority of the Eighty-ninth Congress, plus a minimal level of agreement by the National Education Association and the United States Catholic Conference, were necessary to

[1] Formerly the National Catholic Welfare Conference.

get favorable legislative action by Congress. These two groups eventually accepted a program they had not drafted. The multiplicity of forces at work on any issue as complex as education demands that the policy makers be prepared to redefine situations as time brings new developments to the fore. Shifts and realignments take time since the response is rarely to one dramatic event but is more typically the result of a series of less dramatic incremental changes.

The formal institutions of government are the arenas of official and authoritative decisions of the policy system. The content and style of bargains and other interactions that take place within the policy system help form the choices that are made within the executive, legislative, and judicial institutions of government. Not only do the events in particular policy systems affect the formal decisions, but there is an equally significant relationship between the conditions internal to the formal arenas of decision and the climate of activity in the policy systems. For example, the individuals and groups participating in a policy system will tailor their appeals and demands to meet the institutional setting within which the formal choices are made.

Education policy has been a legislative issue in the sense that the executive branch has indicated its willingness (and on occasion its eagerness) to champion the cause of federal aid to education. The courts have taken a mixed view on the question of public support for private education but have left the policy planners in the education arena room to maneuver and innovate.

Congress (particularly the House of Representatives) historically has been the stumbling block. Congress, therefore, was the principal target of those in the education policy system who sought some form of policy action. The climate surrounding the policy elites on education was drastically altered by the dramatic 1964 elections. The new range of expectations about congressional action triggered the necessary cooperation among the participants.

Much of the fascination surrounding the education bill

election of liberal democratic congress

in the Eighty-ninth Congress (1965–66) centered on the question of whether the legislation would flounder on unresolved conflicts among several elite groups both inside and outside Congress. The techniques employed to bring divided groups together into a coalition make up much of the invisible but vital substance of why HR 2362 was enacted in 1965.

The new party ratios in Congress provided the precondition and stimulus to the policy system to begin earnestly seeking a settlement. Congress does not easily resolve issues which raise basic ideological concerns. The church-state dogma that divided the education policy system is not typical grist for the congressional mills, where power, influence, and authority are so effectively decentralized. Such an institution is much more sympathetic to the negotiated and bargained settlement among interests willing to recognize the need for compromise. But until the individual participants in the policy system saw some reason to expect a loss in congressional action, there was no overwhelming reason for serious negotiating to begin—thus the impact of the 1964 elections.

Similarly, the political skills that are necessary for success in a collegial decision-making body like Congress are those which persuade individuals and groups to define issues in a way that makes solutions palatable, where under other conditions they are simply unacceptable. Success in 1965 depended on providing the coalition of congressional federal aid supporters with a formula that resolved the church-state dispute and a rationale for accepting that formula. The administration and the education policy community recognized that Congress, built on patterns of experience and tradition with highly distinctive modes of operation, had to be presented with a *fait accompli*. Even with the 1965 party ratios, Congress could not have arrived at a settlement to the education issue isolated from agreement in the policy system.

The pattern of legislative, executive, and interest group

elites reaching prior agreements on acceptable policy out-
comes is probably atypical in the sense that most policy
elites rarely reach similar levels of accord. In fact, removed
from the special circumstances of 1964–65 it is highly prob-
lematical whether the education policy elites would have
been able to arrive at a working agreement.

However, what is typical is the existence of stable rela-
tionships among a series of groups and personalities with
deep interest in an issue, who establish the "permissible"
limits of decision for the official decision makers in gov-
ernment. That is, the policy systems become points of
reference for the legislators and administrators who make
the authoritative decisions and of which they are also a part.
The consensus or lack of consensus within the policy systems
informs the legislator and executive of the intensity, direc-
tion, and permanence of agreement or disagreement. The
American political system moves slowly and deliberately, in
part because the elites associated with particular issues are
not typically united. The forming of coalitions and combina-
tions of shared interest among these elites constitutes an
important aspect of the pregovernmental phase of the policy
process.

This policy system view of the political process shifts the
focus of attention away from the formal arenas of govern-
ment to a world where the relevant persons from both pri-
vate and public sectors meet to work out agreements or learn
better the nature of their disagreements. The history of the
education issue clearly reflects this quality. Congress had
been unable to act until the policy elites had reached a level
of understanding among themselves on the issues that di-
vided them. That level of understanding was a long time
developing.

We are not arguing, however, that policy action in every
issue area is stalemated until similar levels of agreement
are reached. The degree of agreement necessary for policy
action will depend upon the history of the working rela-
tionships of the groups and individuals involved, expecta-

tions concerning power and influence, and the nature of the issue itself. But in all cases the locus of bargaining, negotiation, and persuasion flows freely back and forth between private and public sectors. Only after information has been exchanged and accommodations sometimes achieved will the executive and legislative phases of the policy process act out their official roles.

The history of what Congress does with an issue is an important precedent for what Congress is likely to do with the same issue in the future. The overlapping, continuous sequence of decisions, conflicts, and agreements over the three years we have watched Congress deal with education policy is dramatic testimony to the validity of this view.

In studying the education issue there are many important questions that our study does not answer. Our conception of policy elites operating in a network of relationships that affect how and what Congress does has not allowed us to say with precision what kinds of resources, strategies, and tactics allow different elites to gain access to Congress. The story of education policy making is suggestive of the way the process works, but it does not provide a definitive case.

What follows is a description of the American policy process as it applied to one issue over several years. We begin with a brief history of the issue and a discussion of the significant conflicts that have surrounded it.

2

A LEGACY
OF CONFLICT

The Issue

Education of the nation's youth has been one of the most venerable values in America. Historically there has been consensus on education as a goal, however, there has been strong disagreement on the means of its realization. During most of the nineteenth century conflict centered on the question of private versus public education. In 1800 the few schools in existence were private and usually operated by a religious sect. For the next hundred years the number of private sectarian schools continued to grow, but there was an even larger increase in the number of public schools. By 1900 over 90 per cent of the nation's elementary and secondary schools were in public systems. Typically these public schools were financed by local districts and governed by locally elected boards.

During the twentieth century the focus of debate shifted from private versus public schools to questions involving the financing of local schools. In the past sixty years there has been a trend toward consolidating schools into larger districts and increasing the amount of aid contributed by state government. As class enrollments increased and the

burden of state and local taxes became more severe, the
cause of federal aid became more popular. In recent years
public school enrollments have soared from 23.3 million
in 1945 to 51.4 million in 1963 and are expected to exceeed
62 million by 1973. State and local expenditures for edu-
cation increased from less than $2 billion in 1935 to almost
$22.5 billion in 1964. Some have pointed to these statistics
with alarm and have argued that this "education explosion"
requires greater participation by the federal government.
Others maintain that state and local governments have done
a remarkable job of meeting increased educational needs
without the interference and control of the federal govern-
ment.

The opponents of federal aid have viewed the issue as a
matter of basic political philosophy. They argue that assist-
ance to local schools inevitably will lead to national control.
They feel that the federal grant is merely a "foot in the
door" which will end in national control of administrative
decisions, teacher certification, and curriculum. The more
adamant spokesmen for this view describe federal aid as
a sinister plot hatched in the half-baked minds of the power
hungry Washington bureaucrats to "bribe" local officials into
transferring their authority to the national Office of Edu-
cation. This view was expressed several years ago by Senator
Barry Goldwater in a debate with Interior Secretary (then
Congressman) Stewart Udall when he said that in the
struggle to control our educational system, "I fear Wash-
ington as much as Moscow."

The foes of federal aid maintain that state and local gov-
ernment could do an even better job of caring for educa-
tion if they were given a greater share of the total national
revenue. This would preserve local autonomy and boost effi-
ciency. Revenue could be collected and spent at the local
level thus avoiding the waste and red tape of the national
bureaucracy. A taxpayer, the saying goes, "sends a dollar
to Washington and receives fifty cents in return." Further-
more federal aid is a palliative which creates a false reliance
on Washington. People tend to ignore existing inequities in

state and local government as they turn to Washington for assistance. This works as a deterrent to strengthening government at the local level.

Finally the opposition argues that the so-called "education explosion" does not automatically necessitate more federal programs. In fact local schools have done an amazing job of adjusting to the crisis created by the World War II "baby boom." Elementary and secondary school enrollments have increased by 44 per cent since 1954, but expenditures have risen by 77 per cent. Between 1954 and 1965 nearly 700,000 classrooms were built and teachers' salaries rose by 43 per cent. Not only did total expenditures increase during this period to almost $24 billion annually but more was spent per student. Per pupil expenditures rose from $296 in 1954 to $444 in 1964—a gain of approximately 50 per cent.

The advocates of federal aid are willing to commend state and local government for their increased role in financing education, but they argue that it is still not enough. In many areas of the country classrooms are overcrowded, facilities are inadequate, and equipment is obsolete. Thousands of students are forced on double sessions. In many areas of the country (especially in the South) teachers are still underpaid and are being driven into higher paying jobs in private industry. Aggregate figures, it is asserted, show an overall gain for education, but they do not disclose the hard-core pockets of distress.

It is further argued that one should not assume that only local communities have a direct interest in the quality of the schools. With the increased involvement of the United States in the world community the federal government's stake in education has increased. The federal government is primarily responsible for the nation's defense and, increasingly, education is the key to maintaining this responsibility. The large number of draftees annually rejected by Selective Service for illiteracy indicates that even the most rudimentary standards have not been met. Even in recent years the rate of illiteracy rejection for ten states has ranged between 25 and 48 per cent.

Though state and local government has made an effort to meet rising education needs, some areas of the country simply do not have the available resources to do the job. Mississippi, for example, expends a larger percentage of per capita income on education than most states in the union, yet it has one of the highest records of Selective Service illiteracy rejections.

Finally the proponents of federal aid feel that every child in America should have an equal opportunity for education. Ultimately only the federal government can assure this equality on a national basis. During the Senate debate on federal aid in 1946 this position was stated by the late Senator Robert A. Taft (R. Ohio) when he said:

> Education is primarily a state function—but in the field of education, as in the fields of health, relief, and medical care, the federal government has a secondary obligation to see that there is a basic floor under those essential services for all adults and children in the United States.

ORGANIZED PRESSURE

One of the best organized and most vocal opponents of federal aid legislation has been the United States Chamber of Commerce. The Chamber is well financed, broadly based, and adept at exercising its constitutional right of petition. Its techniques of congressional influence range from direct lobbying and presenting testimony before congressional committees to organizing letter writing campaigns. Another major group which has joined the Chamber in numerous federal aid fights is the National Association of Manufacturers. Other opposition groups include the Southern States Industrial Council, the National Economic Council, the American Farm Bureau Federation, the National Conference of State Taxpayers Association, and the Daughters of the American Revolution.

There are several groups which have favored certain forms

of federal aid but vigorously oppose any type of assistance
to private and parochial schools. Included in this category
are Protestants and Other Americans United for Separation
of Church and State, the Council of the Churches of Christ,
the Baptist Joint Committee on Public Affairs, the Ameri-
can Jewish Congress, the National Association of Evangeli-
cals, and the American Civil Liberties Union.

Leading the fight for federal aid has been the National
Education Association. This group represents classroom
teachers and school administrators. It is the largest educa-
tion organization in the country, with a membership in ex-
cess of 900,000 in over 8,000 local affiliates in all fifty states.
On most matters the NEA has worked closely with the
Office of Education and operates out of a modern, well-
equipped office building located a few blocks from the De-
partment of Health, Education, and Welfare. Though the
NEA has been a tireless advocate of federal aid, it actively
opposed (until 1965) public assistance to parochial schools.

Other major groups favoring federal aid include the AFL-
CIO and its constituent American Federation of Teachers,
the National Congress of Parents and Teachers, the National
Farmers' Union, the American Association of University
Professors, the American Association of University Women,
the International Brotherhood of Teamsters, Americans for
Democratic Action, and the American Library Association.

There are several groups which favor federal aid provided
it includes aid to private and parochial schools. Groups in
this category of qualified support include the United States
Catholic Conference, the Council of Catholic Men, and
Citizens for Educational Freedom.

A Federal Aid Tradition

Like all institutions Congress spends much of its time liv-
ing in the past. Rather than anticipating the future, Con-
gress is preoccupied with the task of offering temporary so-

lutions to existing needs. Its most trusted tool in performing this function is past experience. House Speaker John McCormack described the legislative process accurately by saying, "the business of Congress today was conceived yesterday and will be amended tomorrow." A specific act such as the Elementary and Secondary Education Act of 1965 is the offspring of an historic struggle.

The practice of national assistance to local schools is older than the American Republic itself. Even before the adoption of the Constitution in 1789, the national Congress, operating under the Articles of Confederation, established a national role in education. Under the Survey Ordinance of 1785 (outlining the disposal of land in the Western Territory), one section of land in every township was set aside for the endowment of education. Two years later the Northwest Ordinance was adopted requiring land to be reserved for local schools.

The most significant nineteenth-century development in federal assistance to education came in 1862 when Congress passed the Morrill Act, which provided land grants to states and territories for the establishment of colleges specializing in agriculture and mechanical arts. This act led to the establishment of "land grant" colleges in every state in the Union. Federal aid was extended to other levels of education in 1917 when Congress passed the Smith-Hughes Act establishing a grant-in-aid program to assist states in developing vocational education below the college level. This program has been extended and modified several times since.

SPECIFIC AID FOR HIGHER EDUCATION (1944-1965)

Many assume that during the two decades following World War II federal aid to education proposals produced political controversy and congressional deadlock. This was certainly the case with general assistance to elementary and secondary schools but it was not true of aid to higher education.

One form of assistance to college students came in 1944 with the passage of the Servicemen's Readjustment Act—better known as the GI Bill of Rights. Under the GI Bill almost eight million veterans received aid for living expenses, books, and tuition at a cost of $14.5 billion. Similar but more limited programs were established for Korean War veterans in 1952 and for "Cold War" veterans in 1966.

Higher education received a form of indirect assistance with the establishment of the National Science Foundation in 1950. The NSF was founded to promote research and education in the sciences. Between 1952 and 1964 NSF spent over a half billion dollars on research fellowships, teacher training institutes, and related activities.

The 1950 Housing Act authorized low interest loans for the construction of college dormitories. An initial borrowing fund of $300 million was provided. This program has been continued and expanded.

In October 1957 the Soviet Union announced to the world that it had launched the first successful earth satellite (Sputnik). This event was cause for intense soul searching within American education and provided a major stimulus for congressional passage of the National Defense Education Act in 1958. The act provided an original authorization of approximately $1 billion for basic science, mathematics, and foreign language programs in the form of student loans, equipment acquisition, and teacher training institutes. Congress has continued and expanded this program.

In response to the college classroom shortage, Congress passed a bill in 1963 authorizing over $1 billion in grants for classroom construction in public and private colleges.

Congress expanded its college assistance programs with the 1965 Higher Education Act. This authorized a three-year, $2.5 billion program which included funds for undergraduates and graduate student scholarships, libraries and library training, faculty and student exchange programs with "developing colleges," community development projects, and construction grants.

SPECIFIC AID FOR ELEMENTARY AND
SECONDARY EDUCATION (1940–1965)

Between 1940 and 1965 there were several programs enacted by Congress which provided limited and specific aid to elementary and secondary education. The first of these was the Lanham Act of 1940. This was an emergency measure providing school aid for selected communities affected by the relocation of military personnel and defense workers which accompanied an overall defense build-up. This program, which was an early form of "impacted areas" legislation, was later extended for the duration of World War II. It was continued on a yearly basis between 1946 and 1950.

This plan was placed on a more permanent basis in 1950 with the passage of two major "impacted area" acts. The first authorized payments to local schools whose tax base was affected by major government contracts and installations, Indian reservations, and substantial federal land holdings. The second act authorized aid for teacher salaries and building maintenance. Since 1950 the growth in popularity of this program has paralleled the growth in size and numbers of federal installations. Even the most implacable foes of federal aid share this enthusiasm—Senator Barry Goldwater, for example, whose state of Arizona received more than $84 million in impacted aid funds between 1951 and 1965. During this same period the federal government spent over $3.5 billion on this program and has obligated almost $3 billion for future use.

The National Defense Education Act of 1958 should be mentioned once again, this time as a program of assistance to elementary and secondary education. Title III of the act provides matching grants to states for purchasing equipment and remodeling classrooms used in teaching science, mathematics, and foreign languages. Under Title V funds are authorized to develop testing, guidance, and counseling programs. Title VI provides aid for establishing advanced for-

eign language institutes designed to train public school teachers.

Other miscellaneous programs of specific aid still in existence include the National School Lunch Act of 1946 and the Agricultural (school milk) Act of 1954.

General Aid for Elementary and Secondary Education (1943–1965)

Since at least 1836 Congress has periodically debated general school aid bills. But the most significant period of sustained congressional consideration was the twenty-two-year period preceding 1965. For the opponents of federal aid this period was an era of success in forestalling the extension of general aid. For the proponents of federal aid it was a time of frustration and bitter disappointment. And for combatants on both sides of the issue it was a quarter-century of legislative intrigue and intense conflict.

The entrance of the United States into World War II caused an obvious strain on the nation's education system. Thousands of teachers entered the armed forces or left their profession to take higher paying jobs in defense plants. School ills were reflected in the high number of illiteracy rejections by the Selective Service System. These problems prompted the introduction of a general aid bill in 1943 jointly sponsored by Senators Lister Hill (D. Ala.) and Elbert Thomas (D. Utah). This bill was designed primarily to boost teachers' salaries for the duration of World War II. It provided $200 million a year to be apportioned among the states on the basis of school age population. The bill cleared committee and was sent to the floor of the Senate where it encountered a snag which was destined to plague general aid bills for the next twenty-two years—the racial issue. Southern support for the bill evaporated when the Senate adopted an amendment requiring an equitable distribution of funds for racially segregated schools. Before a

final vote was taken a motion was accepted to recommit the bill to committee, where it remained for the rest of the session.

Between 1943 and 1948 a general school aid bill was not passed by either house, but there were numerous bills introduced and considered by the committees. In 1946 the cause of federal aid won an important Republican ally when Senator Robert Taft of Ohio switched his position from opposition to support. With Taft's assistance a general aid bill was approved by committee but the session ended without any floor action.

In 1948 the Senate approved a $300 million general aid bill by a vote of 58 to 22. This marked the first time in more than half a century that a general aid bill cleared either house of Congress. But the session ended with the school bill locked in the House committee.

When the Eighty-first Congress convened in January 1949, federal aid proponents had reason to be optimistic. The Taft bill had received easy Senate passage the year before. President Truman, in his State of the Union message, pledged his active support. And federal aid to education was endorsed by both major parties in the campaign platforms of 1948. The Senate easily passed a bill by a vote of 58 to 15, but in the process the explosive question of race was raised once again. Senator Henry Cabot Lodge (R. Mass.) offered an amendment designed to deny funds to segregated schools. Federal aid supporters, fearing that the amendment would kill the chances of the bill, teamed with the Southerners to crush the amendment by a vote of 16 to 65.

Meanwhile in the House, John Lesinski (D. Mich.), chairman of the Education and Labor Committee, appointed Graham Barden (D. N.C.) to head a school aid subcommittee. After conducting a series of hearings the subcommittee reported the so-called Barden bill which differed from the Senate bill by specifically prohibiting any form of assistance to private and parochial schools. Chair-

man Lesinski, a Roman Catholic, vowed that this "anti-Catholic" bill would never clear the full committee and promptly introduced a bill of his own. The Lesinski bill was more expensive and allowed funds for auxiliary services to public and private schools. The colloquy between Lesinski and Barden ignited a religious controversy which had been smoldering for years and which was quickly snatched up by the mass media.[1]

The fires of religious controversy continued to rage during the second session of the Eighty-first Congress in 1950. Heat was especially intense within the House Committee on Education and Labor which was considering the Senate bill of the previous session. Finally the committee leaders on both sides of the private aid controversy recognized the irreconcilable nature of the conflict and joined with eleven other committee members (including Representatives Richard Nixon of California and John Kennedy of Massachusetts) to kill the bill by a vote of 13 to 12.

In 1954 the United States Supreme Court added a new dimension to the segregated school issue by declaring, in the case of *Brown v. Board of Education of Topeka*, that segregated schools specifically violate the "equal protection" clause of the fourteenth amendment of the Constitution. School aid legislation did not reach the floor of either house in 1954, however Congress did satisfy a request of President Eisenhower's by authorizing the establishment of a White House Conference on Education.

In 1955 President Eisenhower proposed a $1.1 billion

[1] Mr. Barden incurred the wrath of Francis Cardinal Spellman of New York who described the Barden bill as "a craven crusade of religious prejudice against Catholic children" and labeled the North Carolina Democrat and his backers as "new apostles of bigotry." Mrs. Eleanor Roosevelt entered the fray by defending the private nonassistance features of the Barden bill in her nationally syndicated column. This prompted Cardinal Spellman to send Mrs. Roosevelt a much publicized letter in which he asked: "Why do you repeatedly plead causes that are anti-Catholic?"

school construction program with over 80 per cent of the funds to be in the form of loans. This request disappointed some of the more vocal Republican federal aid supporters and drew hostile fire from the Democrats. The House Education and Labor Committee rejected the Eisenhower proposal and reported a much stronger school aid bill. But this measure encountered a new snag in the school aid struggle—the House Rules Committee. The session ended without floor action.

During the next session (1956) the Kelly bill (Edna Kelly, D. N.Y.), which was a compromise between the Eisenhower bill and several NEA sponsored proposals, was cleared for floor action. Once on the floor the bill was given the kiss of death when the House accepted an amendment offered by Adam Clayton Powell (D. N.Y.) prohibiting aid to segregated schools. The Powell amendment coupled with a Republican attempt to substitute the bill for the original Eisenhower proposal resulted in defeat for the Kelly bill by a thirty-vote margin.

In 1957 a school aid bill once again reached the floor. And once again it was killed. In this episode the causes of death were similar to the year before—Republican opposition and segregation—but the technique employed was different. The House adopted an antisegregation amendment, and there was dissension between Republicans and Democrats over the form and substance of the bill. Finally in a last-ditch effort to placate the Republicans, the Democratic leadership agreed to accept the Eisenhower bill in toto. But before this agreement could be consummated, the wily chairman of the Rules Committee, Howard Smith (D. Va.), moved to strike the enacting clause—which is tantamount to killing the bill. This motion was adopted by a margin of three votes.

A new level of frustration among school aid advocates was reached in 1960. For the first time in the history of general assistance legislation a measure passed both houses of Congress in the same session. But ultimately it was killed

in the House Rules Committee. Two of the familiar ingredients for defeat—segregation and Republican opposition—were present once again. Early in the session the Senate passed a school bill and in May a measure was approved by the Rules Committee by a vote of 7 to 5. Once on the floor it was modified to include the Powell antisegregation amendment and was finally passed. But the bill passed the two chambers in different forms and this necessitated the creation of a conference committee to iron out the differences. In the House the bill was returned to the Rules Committee before going to conference. With the inclusion of the Powell amendment, the bill lost two of its earlier Southern supporters on the Rules Committee (B. Carroll Reece—R. Tenn. and James Trimble—D. Ark.), and on the second round the vote switched from 7 to 5 to 5 to 7, thus killing the bill.

In 1961 the federal aid cause gained an enthusiastic supporter in the White House (John Kennedy), and the members of Congress prepared for battle once again. But the historic stumbling blocks of race, religion, and Republican opposition were still present. In mid-session the Senate passed a $2.5 billion school aid bill, and one week later a similar measure was reported by the House Education and Labor Committee. Earlier in the session the Democratic leadership (with the help of the President) waged a successful fight to enlarge the Rules Committee from twelve to fifteen members. Two of the new additions (Carl Elliott—D. Ala. and B. F. Sisk—D. Calif.) were known federal aid supporters, and it was anticipated that this would tip the scales by one vote. But this proved to be a false hope. Even though Representative Powell had agreed to withhold his antisegregation amendment, Southern members of the committee feared it would be offered by someone else. Catholic members of the committee were reluctant to allow the bill on the floor unless it was jointly considered with the NDEA extension bill which contained loans for private schools. Ultimately both bills were killed in Rules when James Delaney, a Catholic Democrat from New York, joined an

opposition coalition which included Chairman Smith, William Colmer (D. Miss.), and all five Republicans. Later in the session Representative Powell attempted to bring the bill directly to the floor under a special parliamentary procedure, but his efforts were in vain.

During the 1962 session the Senate took no action on school assistance, and the House Rules Committee repeated its performance of previous years by squelching the aid bill. In 1963 and 1964 Congress enacted a number of measures which gave specific assistance to various levels of education, but no general aid bill was forthcoming.

An Autopsy of School Aid Bills

The legislative process is deliberately designed to block as well as to pass legislation. It is not a network of clear channels which binds the two houses of Congress and facilitates the flow and speed of legislation. It more closely resembles a maze which is separately constructed in each house and is filled with pitfalls and blind alleys. The difficulty of working within such a system is illustrated by the previous brief review of federal aid to education legislation.

In searching for school aid stumbling blocks, one is quickly led to the House of Representatives. Starting in 1948 the Senate passed each bill that reached the floor—1948, 1949, 1960, and 1961. On the other hand, in the House three bills were killed on the floor (1956, 1957, and 1961) and another (1960) was passed but subsequently held in the Rules Committee on the way to conference.

From 1943 to 1955 the prime obstacle in the House was the Education and Labor Committee. During this period hearings were held on seven bills, but not one was reported. In 1955 the opposition bloc finally crumbled when fifteen non-Southern Democrats aligned with seven Republicans to approve a bill for the first time in recent history. By 1959 federal aid supporters had a solid majority on the committee.

The position of this bloc was improved in 1961 when Adam Clayton Powell replaced Graham Barden as committee chairman.

As the complexion of the Education and Labor Committee changed in the mid-1950's, the anti-federal aid bloc in the Rules Committee was solidified. This committee was the principal obstacle to school aid bills in 1955, 1959, 1960, and 1961 through 1964. Chairman Howard Smith and ranking Democrat William Colmer coalesced with committee Republicans (with the exception of Reece in 1960) to halt school bills. Even after the committee was enlarged to fifteen members in 1961, the religious issue kept this bipartisan coalition alive.

A Change in the Weather

The storm clouds of race and religion hovered over the federal aid fight throughout the post-war period. By 1965 one of these issues had been extricated from congressional debate and the other ceased to be a dilemma and became a resolvable problem.

Under Title VI of the Civil Rights Act of 1964 the Commissioner of Education was authorized to discontinue federal aid to segregated schools. With the issuance of the 1954 Supreme Court decision of *Brown v. Board of Education of Topeka*, most Southern congressmen realized that someday federal assistance to segregated schools would be discontinued. But because of personal conviction and constituent pressure they chose to prolong the inevitable. For similar reasons it was difficult for civil rights advocates to refrain from promoting their cause by amending federal aid bills. After 1964 this became a moot question.

It is ironic that John F. Kennedy's election to the White House in 1960 was both a help and a hindrance in the struggle for federal aid to education. Being a Roman Catholic, Kennedy was forced by his critics to assume a hard-line

position on the issue of public aid to private schools. This stand was enunciated in his celebrated speech before the Greater Houston Ministerial Association when he stated, "I believe in an America where the separation of church and state is absolute . . . where no church or church school is granted any public funds or political preference."

After taking office, public pressure precluded the President from softening his position even though he fully realized that lack of Catholic support would defeat his federal aid proposals, which was the key to his domestic legislative program. In a series of lectures at Columbia University, top assistant Theodore Sorensen described the dilemma of his boss by saying, "While it should not be impossible to find an equitable constitutional formula to settle the church-school aid problem, it is difficult for that formula to be suggested by the nation's first Catholic President."[2] In 1965 it was possible for a non-Catholic President to search for that "equitable constitutional formula" and thereby to convert Catholic opposition to support.

There were numerous other changes, both inside and outside Congress which paved the way for the passage of the 1965 act. They will be treated as they occur in the following chapters.

[2] Subsequently published as *Decision-Making in the White House*, Columbia University Press, 1963.

A NOTE ON SOURCES

Most students of Congress would be lost without the Congressional Quarterly Service. The authors of this study are no exception. Background information on legislative occurrences relating to the federal-aid fight is found in the annual volumes of the *Congressional Quarterly Almanac*. A more concise compendium of this material is included in *Congress and the Nation*, a mammoth volume published by Congressional Quarterly in 1965. The most useful source specifically devoted to federal aid is *Federal Role in Education* also published by Congressional Quarterly in 1965.

A wealth of statistics relating to the federal role in education is found in *The Federal Government and Education*, House Document No. 159 (88th Congress, 1st Session, 1963). Of course the best chronicle of floor debate is the *Congressional Record*, which is indexed in the permanent volumes. Extensive hearings on federal aid were held by the House and Senate committees, and this material is also available. A useful explanation of the Elementary and Secondary Education Act of 1965 is contained in the House Education and Labor Committee's *Report*, No. 143 (89th Congress, 1st session, 1965). The "Minority Views" contained in this report include statistics on the increased financial role of state and local government in education.

There are several excellent sources which cover in detail

the chronology of the federal aid struggle. These include: Frank J. Munger and Richard F. Fenno, Jr. *National Politics and Federal Aid to Education* (Syracuse: Syracuse University Press, 1962); H. Douglas Price, "Race, Religion, and the Rules Committee," in Allen F. Westin, ed., *The Uses of Power* (New York: Harcourt, Brace, 1962); Robert Bendiner, *Obstacle Course on Capitol Hill* (New York: McGraw-Hill, 1964); Philip Meranto, *The Politics of Federal Aid to Education in 1965* (Syracuse: University of Syracuse Press, 1967); and Stephen K. Bailey and Edith K. Mosher, *ESEA: the Office of Education Administers a Law* (Syracuse: University of Syracuse Press, 1968).

Coverage of the Cardinal Spellman-Mrs. Roosevelt dispute is found in the July 4 and August 1, 1949, issues of *Newsweek*. An account of Senator Taft's views on education is in *The New York Times*, April 2, 1948. For a compilation of President Kennedy's ideas on education see William T. O'Hara, ed., *John F. Kennedy on Education* (New York: Teachers College Press of Columbia University, 1966).

3

EDUCATION AND THE CLIMATE OF POLITICS: 1965

Once again education became an issue on the national agenda in 1965 because of a combination of events and forces that were set in motion by the continuous changes in both the external and internal environments of Congress. Some of these changes included the Presidential election of 1964, accompanied by sweeping electoral gains for liberal Democrats in Congress; the changes inside Congress that the election precipitated; and the culmination of a series of shifts among the professional groups and associations. These factors contributed to a climate that for the first time promised a positive congressional response on the thorny education issue.

The question that Congress faced in 1965 was whether federal aid was to be extended in a major way to the elementary and secondary levels with or without aid to private and parochial schools. As a result the groups that were still arguing against federal aid in principle simply were not given the same kind of access to the points of decision as those groups who were contributing to the dialogue over what kind of aid would be best.

JFK to LBJ: Prelude to 1965

Presidential politics of 1960 led John Kennedy to select Lyndon Johnson as his running mate. The details of that choice are still the private knowledge of a very few men, but none could have known the profound effect that choice was to have for the Kennedy legislative program three short years later. Congress had worked long and hard in examining the Kennedy program, which included medicare, federal aid to education, area redevelopment, Appalachian programs, and a host of other sweeping social programs, and had in one way or another defeated or emasculated much of that program.

Few observers of Congress were surprised by the pace of events during the Kennedy years. The election of John Kennedy to the Presidency did not, after all, remake the map of American politics. Congress is a representative institution, and the returns of the Presidential election in 1960 did not reflect an overwhelming desire by most Americans to embrace the Kennedy legislative program.

The mid-term elections of 1962 provided some tentative endorsement of the Kennedy Administration, with the Democrats retaining their strength in the House and increasing their majority by four in the Senate. With another Presidential election coming in 1964 congressional Democrats were probably more amenable to following the leadership of the Administration in the Eighty-eighth Congress than they had been during the Eighty-seventh Congress. In addition, the Kennedy team had learned a great deal about the techniques of lobbying on Capitol Hill. Lawrence O'Brien (special assistant responsible for coordinating the Administration's lobbying effort) had become one of the most skilled and respected members of the Administration in the eyes of the Congress.

The shock of President Kennedy's assassination on Novem-

ber 22, 1963, had the potential of pulling the nation apart with the strains of disbelief and recrimination. The political tensions that were sweeping the nation in the months prior to the murder were deep and fundamental. When the assassination occurred, however, Lyndon Johnson's instincts led him to pull the nation together. He was conditioned by long personal experience to move in the direction of consensus, not division. His behavior in the weeks immediately after the assassination, as premeditated as they may have been, were also the instinctive moves of a man who had reached success through the tangles of one-party Texas politics. A man schooled and successful in that arena has learned well the lesson of submerging division and debate in the interest of apparent harmony. Votes are won by working together for the agreed-upon nominee. Whatever differences men have over who that nominee should be are worked out quietly behind closed doors. When the choice has been made, the electorate is presented with a harmonious and united party.[1]

It was Lyndon Johnson's good fortune to have accumulated prestige on Capitol Hill and a leadership style that was uniquely appropriate to the needs of the American people and Congress in the year following Dallas. The Vice President on November 22, 1963, was a man with the instincts to unite and to find the common level of agreement among even the most resolutely divergent groups.

The people who were there during the second half of the Eighty-eighth Congress recall with anguish the atmosphere that pervaded official Washington. "Depressing," "without purpose," "the fun had gone," "tiring," were some of the words used to describe it. Under these circumstances Lyndon Johnson brought just the right set of attitudes and instincts to cajole and lead Congress into action.

The assassination had a profound impact on congressional politics. It abruptly changed the atmosphere on Capitol

[1] See David Broder, "Consensus Politics: End of an Experiment," *The Atlantic* (October 1966), 60–65, for an excellent development of this theme.

Hill during the latter stages of the Eighty-eighth Congress from one of intransigence and obstruction to a collective attitude of guilt, fatigue, and reluctant cooperation with the White House.

There are two theories about what happened in Congress during the month of December 1963 and throughout 1964.

At the moment of the assassination the Kennedy legislative program, including the controversial tax cut and the public accommodations civil rights legislation, was tied up in committee, generally receiving the treatment a Democratic President's liberal program is likely to receive from a Congress controlled by a coalition of conservative Republicans and Southern Democrats. When 1964 came to a close, much of that program had been enacted into law.

Some close observers of the legislative scene say that the heart of the Kennedy program was on the verge of being passed and that, even if Kennedy had lived, much of the legislative program enacted in 1964 under Lyndon Johnson's stewardship would have passed anyway. The premise of this theory is that the three years of the New Frontier were, from the legislative standpoint, spent in preparing the way for what was a wide-ranging legislative package. The adherents to this theory argue that Congress rarely responds with great favor to new and sweeping legislative requests from an activist President without at first going through a time-consuming critical examination of each program. Lobbyists supporting the program in and out of government need time to generate public support and to translate it into votes in Congress. The lesson of the three years of the Kennedy Administration is not one of frustration and defeat on Capitol Hill, although there was much of that, but rather the story of three years of hard preparation, of sowing the seeds which were about to bear fruit when the assassination occurred.

Lyndon Johnson, then, inherited a ready-made situation to exploit, and he merely kept the legislative ball rolling. In 1964 the tax cut became law, the first major civil rights legis-

lation since reconstruction was enacted, and the war on poverty was launched. Each of these programs was conceived in the New Frontier but did not reach legislative maturity until after the assassination.

The other theory is that Lyndon Johnson's fabled legislative skills took an obstructionist Congress and made it work his will where Kennedy had failed. The Johnson mystique on Capitol Hill is a combination of truths, half-truths, and a never-ending series of apocryphal stories. But in the end it is the story of a master tactician who never let an issue reach the arena of public debate and decision until "all his ducks were in a row." This meant long hours of negotiation and bargaining with his associates when he was Majority Leader in the Senate. He had to know what each man needed when he needed it and when his needs could be translated into a vote. It is said that when Lyndon Johnson was Majority Leader he never let a week pass without having at least one conversation with every Democratic Senator. Each conversation involved the famous Johnson treatment from which he learned of recent developments in the Senator's home state and office situation which might be exploited later when a vote was needed. The process of keeping informed of every detail of senatorial life was one of the keystones to the Johnson system. He rarely, if ever, acted without sufficient information.

When Lyndon Johnson became President, he assumed the one office that has more leverage with the Congress than the Majority Leadership. He was quick to recognize the potential of his situation, and he lost no time in involving the leadership of the Congress in making the transition from one administration to another. In short, the new president both exploited the legislative advantages of his position and worked exhausting hours keeping himself informed.

When the summer of 1964 was drawing to a close, and with it the Eighty-eighth Congress, America and Congress had responded to Lyndon Johnson's leadership. There were approximately fifty major pieces of legislation in committee or other stages of the legislative process when he took office.

When the Eighty-eighth Congress finally did adjourn in the fall, Congress had passed the tax cut, civil rights, mass transit, poverty, and foreign aid bills.

The campaign for the Presidency had been under way for months. It was clear that President Johnson would seek election to continue and expand the directions he had set during 1964. But the Republican picture was uncertain. In San Francisco it became clear that the supporters of Senator Barry Goldwater had taken advantage of the time preceding the convention to secure delegate support. While the anti-Goldwater wing of the party floundered over who their candidate should be, the conservatives already had the nomination locked up.

The nomination of avowed conservative Barry Goldwater at the Republican convention was the final tactical decision which set the stage for the fundamental choice the electorate was to make in November. There was interest and even some drama in the President's selection of Hubert Humphrey as his running mate. There was significance and even humor to Goldwater's choice of a nondescript New York Congressman, William Miller, as his running mate. But all of these choices and the conventions themselves were secondary in importance to the central fact that a consensus Democratic President, enjoying the fruits of success with Congress and the sympathy of a grateful nation uninvolved in a major foreign crisis, was to face a conservative Republican candidate who had achieved his nomination over the prostrate body of a divided party.

While the education matter was hardly a central issue to the campaign in 1964, many of the Democrats who were elected to Congress in the Johnson landslide counted themselves as supporters of the federal aid concept.

Eighty-ninth Congress: The Liberal Majority

The statistics of the Johnson-Goldwater election as reflected in the makeup of the House in the Eighty-ninth Congress

are overwhelming: 295 Democrats were elected to the House
as against only 140 Republicans; of the Democrats there
were 69 freshmen in the House when it convened on Janu-
ary 3, 1965, and of those, 38 had defeated incumbent Repub-
licans.

Collectively, the profile of the Democratic freshman
class's electoral victory in 1964 shows the depth of the
Republican defeat. Fully 45 per cent of the freshman Demo-
crats who replaced Republicans won with margins of more
than 10,000 votes, while 33 per cent won with less than
5,000 votes. Approximately 62 per cent of the freshman
class who replaced Republicans had what are considered
marginal victories of better than 51 per cent of the vote
but less than 55 per cent of the vote. The surge of strength
that the Democrats showed at the congressional level
reached an extreme with one candidate who won in a dis-
trict which in 1962 had given the Democratic candidate less
than 35 per cent of the vote.

The coattail affect of the President's margin of victory
was evident in nearly every congressional district. Only nine
of the sixty-nine freshmen Democrats in the House won
with margins larger than the President's.

The complex environment which surrounds Congress was
radically altered by the violent change of Administrations
in late 1963. That event itself had a profound impact on
the important internal environment of Congress. The
chances for passage of an education bill were improved
measurably by the change in the makeup of Congress itself.
The result of the 1964 election was not only an increase
in the majority of Democrats, but an increase in that major-
ity at the expense of especially those Republicans who had
records of opposition to education legislation. The Repub-
licans lost a total of more than four hundred years of cumu-
lative seniority in the election. The forty-six Republicans
who were defeated by Democrats had an average length of
service in the House of nearly ten years. This was a major
blow for the Republican Party to sustain in a body that
places so much importance on seniority.

Stephen K. Bailey, in a book written between the 1964 and 1966 elections, suggests that an evolutionary process was at work in 1964 which inevitably was to present the nation with a Congress more or less like the Eighty-ninth Congress. The growing urbanism and civil rights concerns of the nation have radically changed the nature of congressional constituencies to be more like the single national constituency which elects Presidents. As this trend moves forward, Bailey argues, we will get more and more Congresses responding positively to White House leadership, since they will both be products of the same voting patterns. In Bailey's own words, "A new electorate is creating a new Congress."[2]

Whether Bailey is accurate in the long run makes for interesting debate, but there is little doubt that the Eighty-ninth Congress was to be dominated by Northern urban-oriented Democrats like no other before it. The impact of this new Congress on the internal and external environments affecting education policy was immediate and profound.

Internally, the relationship between the parties was suddenly reshaped. Since 1890 Presidents had controlled an average nominal party majority of approximately 54 per cent in the House of Representatives. In 1965 the Democrats gave President Johnson a 68 per cent nominal majority in the House.

Whereas in the Eighty-eighth Congress the coalition of Southern Democrats and conservative Republicans held a working majority in the House, the Eighty-ninth Congress was held tightly by the Northern liberal Democrats. They were able to pass nearly every major Administration program without help from liberal Republicans. This meant that the Democratic leadership could make all strategic and tactical decisions without consulting the Republicans. Republican support for the Democratic majorities was welcome but unnecessary.

[2] Stephen K. Bailey, *The New Congress* (New York: St. Martin's, 1966), p. 16.

Institutionally, the new majority that the liberal Democrats held in the Eighty-ninth Congress was reflected in the new vigor of the Democratic Study Group (DSG).[3] The liberal Democrats, long frustrated over their inability to translate the national Democratic platform into legislative action, moved in 1959 to create an organization in the House designed to promote the national platform's legislative goals. In establishing the DSG, the liberals were sensitive that their movement would be interpreted as an effort to subvert the established House party leadership. To counter this image, emphasis was placed on supporting the party position, and the title of Study Group was taken to avoid the implication of a break with the party leadership. Official blessing from the regular Democratic leadership was neither sought nor received. In fact, the DSG was organized to give some organizational drive to the liberals' dream of enacting legislation under conditions where they lacked a working majority. They hoped to develop enough organizational strength to force the leadership to negotiate with them on the same terms as the leadership had negotiated with the conservative coalition of Southern Democrats and Republicans.

The institutionalization of an ideological bloc such as the DSG is a rare event in the American congressional party which is dominated by fragmented regional and philosophical allegiances. The DSG's success can be attributed to its members' attention to organizational detail and to its judicious use of its resources both in and out of Congress.

The organization's membership is a closely guarded secret to protect those members who would suffer in their district if their association with a liberal organization were known.

[3] The Democratic Study Group, which was formed in 1959, is a self-conscious move on the part of a number of liberal Democrats from northern and western states to "form a spearhead for liberal legislation." See Clem Miller, *Member of the House* (New York: Scribner's, 1962), for a discussion of the DSG's origins.

Because membership can be secret, a growing number of Southern Democrats, especially from the new urban South, belong. The total membership figure is necessarily an approximation, but when the Eighty-ninth Congress convened, the DSG claimed a membership of more than 180 Democrats.

In its genesis the study group held regular and frequent caucuses. Now, because of size and the difficulty of getting all its members to a meeting, fewer caucuses are held and authoritative policy positions can be taken by a thirteen-member executive committee.[4] However, not all the nominal members of the DSG consider the executive committe's recommendations binding.

The DSG has worked hard since its founding to make acceptable and legitimate its ideological posture and at the same time avoid alienating the complex congressional power structure based on elected party leaders and committee chairmen. Generally, if the President's program squares with the national party platform the DSG will support him. When the DSG opposes the President it rarely fights him publicly. Indeed, the DSG is convinced it has been accepted as a legitimate subgroup within the House, in part because it has not been too ideological and because it has been willing to play the game according to the established rules.

The DSG's leadership has consciously tried to avoid having the organization take stands on too many matters. On the theory that effectiveness is diffused when one is recorded firmly in one corner or another on every issue, the DSG takes stands only on what the executive committee

[4] The Executive Committee for the Eighty-ninth Congress was made up of Congressmen Hollified of Calif., Blatnik of Minn. (both former chairmen of the DSG); six regional leaders: Gilbert of N.Y., Burton of Calif., Reuss of Wis., Edmundson of Okla., Moorhead of Penn., and Ashley of Ohio; and the present slate of officers: Thompson of N.J., Chrm.; O'Hara of Mich., Chrm. at large; Udall of Ariz., Secretary; Brademas of Ind., Program Chrm.; and Yates of Ill., Research Chrm. Also see Kenneth Kofmehl, "The Institutionalization of a Voting Bloc," *Western Political Quarterly*, XVII (1964), 256–272.

feels are the most important matters of the day. The DSG is a mature political force in the congressional environment, and its style of bargaining is not unlike the other power blocs in Congress. The difference is that the DSG has gone further than most other blocs to formalize its structure.

In 1965 the DSG claimed the allegiance of most freshman Democrats. The DSG "participated" in 105 congressional campaigns in 1964 with a combination of funds, literature, and other research material. Of the sixty-nine freshman Democrats, fully two-thirds had some form of contribution made to their successful campaigns by the DSG. It is not surprising that most of the freshman Democrats joined the study group.

According to the DSG's statistics, during the first session of the Eighty-ninth Congress the DSG membership supported the President's Great Society legislative program (as measured on eighteen key roll-call votes) at a 96 per cent level. This compares with a support score of 75 per cent for all Democrats, 48 per cent for all non-DSG Democrats, and 85 per cent opposition score for the House Republicans. This record of near unanimous and consistent support for the Administration's major legislative programs is important to the DSG's bargaining power on those few issues when it has reservations about White House legislative policy. In 1960, well before the DSG scored its largest successes, there were already indications it was being taken seriously. "On legislation such as the Area Redevelopment Bill, the School Aid Bill, and the Forand Bill, the chairman of the DSG is now among those to whom the leadership looks in the constant negotiation for position and fulfillment."[5]

Perhaps the character of the Eighty-ninth Congress, and therefore the explanation for the ultimate and inevitable passage of federal aid legislation in 1965, is most simply manifested by the dominance the DSG had in Democratic counsels after the election of 1964—for the DSG for the

[5] Clem Miller, *op. cit.*, p. 131.

first time constituted a majority of the majority Democratic party in the House. With its new-found strength the DSG actively and positively sought to change the environment inside Congress in such a way as to make certain that its new-found voting strength could be used to pass President Johnson's program.

The Rules Changes: House Liberals
Consolidate Their Power

The response from the regular Democratic leadership to the "liberal" dominance in the new Congress was almost instantaneous. Speaker John McCormack was watching the returns in Boston and quickly realized that the Democratic caucus in the coming Congress was to be numerically controlled by the Northern and Western Democrats of the DSG and that the old dominance of Southern committee chairmen would be reduced. He knew that the DSG finally would be able to change the rules of the House to remove some of the traditional weapons employed so successfully over the years by the conservative coalition to stop liberal legislation like federal aid to education. This meant diluting the power of the Rules Committee and its venerable chairman, Judge Howard Smith of Virginia. Speaker McCormack moved quickly to insure his leadership by seeking the necessary changes that would make the House more responsive to the new working majority. He called several leaders of the DSG and told them that he wanted to know as soon as possible the rules changes the DSG wanted and that he, as Speaker, would work with them to effect the changes.

The DSG did not waste time taking advantage of the Speaker's receptiveness to their requests. At a meeting called on December 2, less than a month after the election, the DSG officially recommended a list of seven proposals they would offer to the Democratic caucus. Two of the seven suggested steps were aimed directly at reducing the role of

the Rules Committee to that of a traffic cop, guiding but no longer regulating the flow of legislation to the floor of the House. The DSG also advocated a revision of the party ratios on committees so that all would reflect the nearly 7 to 3 majority of Democrats in the House at large. By informal agreement the ratio of majority to minority on the Appropriations Committee had not changed since the Eighty-first Congress, 1949, when it was set at 3 to 2. Similarly the Ways and Means ratio of 3 to 2 had been unchanged since the Eighty-sixth Congress in 1959.

However, of the seven changes that the DSG was advocating, it was clear that the most significant would be the changes designed to reduce the influence of the Rules Committee, which, under Judge Smith's chairmanship and with a conservative majority, had become the bastion for opposition to liberal legislative programs in the House. The procedural power over the flow of legislation to the floor that the House rules gave the committee was easily used for the ideological purposes of the chairman and the committee's majority. Except under extraordinary circumstances every piece of major legislation that the House considers is first given a rule. Without the rule the bill does not get on one of the regular calendars of the House under which the House considers its business. This strategic procedural power has been effectively used to obstruct, delay, and sometimes prevent legislation which the Rules Committee has found objectionable from ever reaching the floor. Indeed much of the history of federal aid legislation in the House is made up of such legislation being bottled up in the Rules Committee.[6]

There were several devices that the DSG could have offered as means of divesting the Rules Committee of its

[6] See H. Douglas Price, "Schools, Scholarships, and Congressmen: The Kennedy Aid to Education Program," in *The Centers of Power*, ed. Alan F. Westin (New York: Harcourt, Brace, & World, 1964), pp. 53–105.

life-and-death control over legislation. During the Eighty-
seventh Congress Speaker Rayburn and President Kennedy
moved to expand the committee and through the power of
committee assignment change the ratio of conservatives to
liberals.

The DSG asked for the reinstatement of the so-called
twenty-one-day rule which would give the Speaker the power
to bring a piece of legislation to the floor after twenty-one
calendar days passed from the date a standing committee
had requested a rule from the Rules Committee. The impor-
tance and implications of this change were clear.[7] If the
House Education and Labor Committee reported a school
bill and requested a rule for the consideration of such a bill,
there was potential for completely bypassing the Rules Com-
mittee after the twenty-one days had passed. The Speaker,
as one legislative arm of the President when both White
House and Congress are under the control of the same party,
would be able to get a legislative decision from the House
on the President's major legislative requests.

The Eighty-first Congress had adopted a modified version
of the twenty-one-day rule which gave the committee chair-
men the power to bypass the Rules Committee after the
time had elapsed. However, this was an unacceptable altern-
ative to the DSG in 1964 because they were loathe to trans-
fer power from one committee to another. What they
wanted was the potential for national party control of the
Congress, and this could be achieved only through a rule
which institutionalized the informal relationship that had
grown since the New Deal between the Speaker of the
House and the President. The second device the DSG
sought to have adopted was a so-called seven-day rule which
also was aimed at diluting the influence of the Rules Com-
mittee. When the House and Senate have passed differing

[7] It should be noted that the twenty-one-day rule was sub-
sequently abandoned after the Eighty-ninth Congress.

versions of the same legislation, the bill must go to a con-
ference committee where the differences are reconciled.
Under rules prior to 1965, unless unanimous consent could
be obtained, a two-thirds vote was required to bypass the
Rules Committee and send a bill directly to conference. If
this could not be obtained, the bill was sent to the Rules
Committee and was then sent to conference by majority
vote provided the committee was willing to give it a rule.
The new rule gave the Speaker the authority to recognize
a member who could offer a motion to send a bill to con-
ference by a simple majority vote. The two-pronged attack
against the power of the Rules Committee contained in the
twenty-one-day conference committee rules increased the sig-
nificance of the Democratic caucus scheduled for January 2.

The party caucuses are typically routine affairs which
nominate a candidate for Speaker and fill other party leader-
ship posts. Since all the incumbent leaders for the Demo-
crats were returning to the Eighty-ninth Congress and since
there was no overwhelming opposition to their reelections,
the rules changes were the only controversial issues before
the caucus.

The results of the caucus demonstrated the new-found
power of the liberal plurality within the Democratic major-
ity. The twenty-one-day rule and conference committee rule
were adopted and taken to the House for approval. In adopt-
ing these rules the Democratic caucus promised to alter
considerably the internal environment within which the
Johnson Administration's program would be considered. A
final change in Rules was brought to the caucus by Speaker
McCormack himself. The change denied a member the
right to request an engrossed copy of the bill before final
passage. An engrossed copy is the final text of legislation
as amended by floor action and certified by the clerk of the
House. To demand an engrossed copy of a bill usually
delays the final vote by twenty-four hours while it is being
certified and printed. This change, which was approved,

removed one more procedural delay to the consideration of legislation and was warmly supported by the DSG.

By the time Congress convened, the regular party leadership knew in detail what the DSG was going to propose and in fact had contributed to the building of the DSG package of proposals. Apparently the DSG was persuaded to reduce the number of its recommendations and to focus its energies on getting the most significant proposals (the twenty-one- and seven-day rules) adopted. The twenty-one-day rule was eventually adopted by the House, but victory was short-lived because this rule was subsequently repealed by the Ninetieth Congress in 1967. The DSG helped enlist the Speaker's support for the rule by giving his office the power to call the legislation to the floor. As one member of the Study Group related, "Precedent, which is pretty strong around here, was all on the side of giving the power to the chairman of the committee which had written the legislation. But we figured we'd get along a lot better with the Speaker if we could show we were interested in helping him."[8]

The successes the liberals had in the opening weeks of the Eighty-ninth Congress were due in part to employing the techniques that the conservative coalition and regular party leaders had used for so long. The technique of limiting their goals, plus enlisting the support of established leaders, combined with a new alertness in the DSG camp to give them the necessary coalition to win. One member of the DSG put the first point this way, "The first rule was to keep our objectives flexible enough to bring new people in on their terms rather than demand allegiance to any credo of our own."[9]

In addition, the liberals made sure that their goals were not outside the mandate they felt was given the Democratic

[8] Joseph W. Sullivan, "The House Liberals," *The Wall Street Journal*, February 16, 1965.
[9] *Ibid.*

Administration in the election. "We're not for pushing things way over to the left, only for making sure the national consensus in support of certain programs is fulfilled," was the way one member of the DSG put it.[10]

Having demonstrated their skills at strategy and tactics, the DSG and the liberal forces in the House went into the legislating phase of the Eighty-ninth Congress with a new sense of strength and vigor. The changes that they had been influential in bringing to the internal structure of the House were to be instrumental in passing the education bill. Judge Smith said, just prior to the changes in the House rules which emasculated his power, that he could see that "the legislative skids were greased" and there was little point in his trying to stop the vote other than to protest what was about to happen.

The Judge's observation accurately characterizes the dilemma and frustration facing the Southern Democrats and Republicans for much of the first session of the Eighty-ninth Congress. The liberals had the votes and used them to "grease the legislative skids" in 1965. However, before the Eighty-ninth Congress could begin to write the substantive record of that remarkable session, the internal environment was to undergo another of the tremors that periodically rock Congress and materially affect the climate of activity within the legislature.

The GOP Leadership Change

The Republicans dumped Charles Halleck of Indiana as Minority Leader in the House and replaced him with Gerald Ford of Michigan.[11] This fight was a premeditated attempt

[10] *Ibid.*

[11] For a complete account of the events surrounding the Republican revolt against Halleck, see Robert Peabody, "The Ford-Halleck Minority Leadership Contest, 1965," *Eagleton Institute Cases in Practical Politics,* 40 (New York: McGraw-Hill, 1966).

by younger House Republicans to reshape their image to conform to the views that seemed to be dominating American politics at the time and a spasm response to a devastating defeat at the polls which cost House Republicans so many of their brethren.

What we have already described taking place within the Democratic party was also about to happen to the Republicans. The party in Congress is a convenient labeling and identification device, and its importance should not be minimized. Indeed, the party becomes an important dimension within the Congress for organizing and dividing the Congress as it does its substantive work. However, the factions and blocs that develop within and across parties also explain much about Congress.

In Congress the Republicans had long lived—in image and in fact—as a party that maintained its effectiveness in a minority position because its leadership was willing to act as a broker between the conservative Southern Democrats and those Republicans ideologically in tune with the conservative position. The leadership of Charles Halleck had not been ineffective. Indeed, in one sense his downfall was a product of his effectiveness as broker in forming a working majority within the House that could no longer be formed after January 1965. Halleck, like the Southern Democrats, was not to be in fashion during the Eighty-ninth Congress.

Just as the 1964 election had reshaped the Democratic majority in the House, it also changed the complexion of the Republican minority. Many of the defeated conservative Republicans probably would have supported Halleck in 1965. In short, the 1964 election encouraged a Republican leadership fight.

While no individual Republican blamed Halleck for the Republican's devasting defeat in 1964, the change of Republican membership and Halleck's ties with the old guard in the party provided the younger members with an excuse to tie Halleck to the events of the preceding November.

As one Ford supporter commented, "Halleck seemed to have no awareness of the shape that we were in. His attitude was one of extreme indifference. He said that, back in 1936, when he had been the only Indiana member returned, there were only eighty-eight Republicans in the House. Well, some of us were not here in 'thirty-six. We were interested in 1964 and what could be done about it."[12]

The Democrats opened the Eighty-ninth Congress with a shift of power from the conservative Southern committee chairmen to the liberal Northern DSG. The Republicans started 1965 by rejecting the leadership that had been in power during the years of cooperation between House Republicans and Southern Democrats. When the purges were over, a new generation had taken control in both parties.

The rarity of the events and the radical changes they brought made the opening of the Eighty-ninth Congress the most dramatic and portentous since the House revolted against the dictatorial powers of Speaker Joe Cannon in 1910. It is a difficult thing to assess the meaning of such basic changes in the internal environment of Congress. The patterns of behavior that have been built over nearly two hundred years in the House have a strong element of deference for the *status quo*. This is particularly so with respect to the internal organization of the power structure.

House Committee Changes

The internal environment of congressional decision is most profoundly affected by changes in the committees of Congress. The changes of federal aid to education were considerably enhanced by the changes affecting the Rules Com-

[12] Robert L. Peabody, "House Republican Leadership: Change and Consolidation in a Minority Party," paper delivered to the American Political Science Association Convention in New York, September 1965, p. 3.

mittee. Similarly the party changes in the House were to have a less dramatic but nevertheless important impact on the House Education and Labor Committee. For example, less than twenty-four hours after Gerald Ford of Michigan became the Minority Leader in the House he entered into negotiations with Speaker McCormack over the party ratios that ought to be reflected in the committee memberships.[13]

Under the agreement the Democrats picked up and the Republicans lost from one to four seats on each of the nineteen committees affected. This agreement left the Democrats with the opportunity of filling thirty-seven vacancies on committees (made up of new seats primarily), and the Republicans with filling seventy-seven (made up of vacancies occasioned by the defeat of so many members). Ford secured one concession from the Speaker which insured that no Republican would be dropped from a committee on which he had served during the Eighty-eighth Congress.

The Education and Labor Committee which had a ratio of 19 to 12 during the Eighty-eighth Congress was now expanded in favor of the Democrats, 21 to 10. The Democratic members of the Ways and Means Committee who appoint Democrats to committees had three replacements to fill and two additional seats to fill stemming from the agreement to increase the Democrats' proportion of seats. The Republican Committee on Committees had but two vacancies to fill on the Education Committee. Of the twelve Republican members of the committee during the Eighty-eighth Congress four were missing from the roster during the Eighty-ninth. Three—Bruce of Indiana, Snyder of Kentucky, and Taft of Ohio—were defeated for reelection during the Democratic sweep in November. The fourth, Peter Frelinghuysen of New Jersey, left the Education Committee to devote more attention to the matters facing the Foreign Affairs Committee on which he became the fourth

[13] On a secret vote Ford defeated Halleck 73 to 67 on January 4th in the Republican caucus.

ranking minority member. In leaving the Education Committee Frelinghuysen gave up his ranking minority status on the committee.[14] His departure moved William Ayres of Ohio into the ranking minority position on the Education Committee.

But, as is often the case with education legislation, the lines of battle that are drawn on controversial issues rarely are resolved solely along party lines. The divisions within the party ranks on the committee are as significant as the numerical divisions that separate the two party blocs.

The changes within the Education Committee from the Eighty-eighth Congress to the Eighty-ninth gave the Democrats overwhelming control with members firmly committed to the principle of federal aid to education. The last major House vote on a federal aid issue before 1965 had come on August 30, 1961, when the House voted down a motion to consider the Kennedy Emergency Aid Program. Of the thirteen Democrats who had served on the committee during the Eighty-seventh Congress when that vote occurred, all but one (Scott of North Carolina) had supported the motion to take up the bill, which can be construed as a vote for federal aid. Of the eight Republicans on the committee who were recorded on the 1961 vote, there was unanimous opposition to considering the legislation. At the time, the Republicans were protesting "the whole manner in which this thing [the aid issue] has been handled," so it is not necessarily the case that all nay votes were in opposition to federal aid in principle. Nevertheless, on the record votes the split on the Education Committee before new members were added for the Eighty-ninth was 12 to 9 in favor of federal aid—a scant three-vote margin.

On the Democratic side of the committee there were three replacements and two new additions. Congressman Landrum of Georgia relinquished his third-ranking majority

[14] Frank J. Munger and Richard F. Fenno, Jr., *National Politics and Federal Aid to Education* (Syracuse: Syracuse University Press, 1962), p. 148.

spot on the committee to take a long-desired seat on the Ways and Means Committee. Congressman George Brown of California, the lowest ranking Democrat on the committee during the Eighty-eighth Congress, moved over to the Science and Astronautics Committee for the Eighty-ninth, giving up his seat on the Education Committee. Thomas Gill of Hawaii was replaced in Congress by another Democrat from Hawaii, Patsy T. Mink.

The five new Democratic faces on the committee were all freshmen who had campaigned in part on the need for federal aid to elementary and secondary education. They were William Ford from Michigan, William Hathaway of Maine, Patsy Mink from Hawaii, James Scheuer from the Bronx, New York, and Lloyd Meeds from Washington. All five ardently supported the Administration education program during the Eighty-ninth Congress, and one, William Ford, played an important role as a member of the education subcommittee.

The two new Republican members of the committee were sophomore Congressman Ogden Reid from New York and freshman Glenn Andrews from Alabama. Coming from a liberal old-line Republican clan in New York, Reid was a supporter of federal aid to education. He was an ambassador to Israel during the Eisenhower administration and is from the same Reid family that at one time owned the prestigious but now defunct New York *Herald Tribune*. Andrews was one of the group of seven new Republicans in the House who came from traditionally conservative Southern Democratic districts. This group hardly qualified as liberal supporters of the programs their Democratic predecessors opposed. While the Democrats were adding five strong new votes for federal aid to the committee, the Republicans added only Andrews who could be counted in opposition. When all the shuffling around was completed, the ratio of pro-education votes to negative votes on the committee for the Eighty-ninth Congress was better than 2 to 1 (21 to 10).

As the Eighty-ninth Congress began its work, the bloc structure within the Education and Labor Committee reflected the urban orientation that the Congress itself was going to have during 1965–66. The Demoratic majority on the committee was dominated by Northern urban-oriented members. Twelve of the twenty-one Democrats came from cities with populations of more than 500,000. The cities of Detroit, Chicago, Los Angeles, and New York were all represented on the committee. Furthermore, the remainder of the committee Democrats were, with few exceptions, receptive to the various programs that the federal government had been developing to meet the needs of the nation's urban centers. Principally this meant the 1964 establishment of the Economic Opportunity Program, known in the Great Society as the "war on poverty."

This urban orientation was to be important to the elementary and secondary education bill since the Administration's eventual solution to the education stalemate revolved in large part around the previous congressional commitment to the poverty program. As the bill was finally introduced and enacted, the legislation distributed funds according to the number of children from families defined as impoverished in the affected school district. The heavy urban character of the majority members on the committee certainly mitigated possible obstacles at the committee stage since the legislation consciously appealed to their constituency's needs, and the poverty dimension of the bill helped encourage members to perceive the education proposal as an extension of the previously enacted "war on poverty."

By tying the one legislative program to the principles of the other, the architects of the education program in 1965 were acknowledging a known principle of congressional politics, namely that the intensity and depth of opposition in Congress to various proposals is directly proportional to the "newness" of the program. The corollary of this proposition is that potential opposition can be neutralized and reduced by making the proposed legislation appear to be less inno-

vative and precedent setting than perhaps it is in fact. One of the intriguing dimensions to the education story in 1965 is just how this bill was made to appear as different things to different people. Each of the various groups and interests that were actively engaged in the debate over this bill was able to see in it what it wanted to see.

The existence of certain blocs within the House and its Education and Labor Committee enabled the framers of the legislation to exploit the importance of precedent in legislative policy making to improve the chances of the 1965 bill. Whether or not the proposition about the importance of precedent to congressional decision making is valid for all issues and at all times, it is interesting to note that the people most intimately involved in getting the bill passed acted as though *this* were an important factor in getting the legislation enacted.

For example, one Presidential assistant summarized his impressions of the legislative phase of the education issue in 1965 by saying:

> Even with all conditions being favorable and the omens saying the right things, the fight to get Congress to make a new departure is a difficult one. Legislative departures are much more difficult than expanding programs that have already met their initial legislative test successfully.

The Chairman and The Committee

The structure of the Education and Labor Committee in the House is, as we have shown, an important part of the internal environment of Congress that was to affect the decisions Congress would make in 1965 on the education issue. A factor of considerable importance to the structure of the committee was the chairmanship of Adam Clayton Powell of New York. In 1965 Powell was starting his fifth

year as chairman, having succeeded Graham Barden of North Carolina in 1961.

Among other things, the Education and Labor Committee has had jurisdiction over many of the volatile domestic issues around which most of the political campaigns have been waged in this country during the past thirty years. It is the Education and Labor Committee that considered Taft-Hartley and the remaining issue over the proposed repeal of Section 14b of that act. The same committee authorized the poverty program, the National Defense Education Act, the higher education program, and finally dealt with the delicate question of federal aid to elementary and secondary schools. While the list is not exhaustive it can be said that there are relatively few domestic issues that attract the same intense levels of debate and attention as those that fall to the Education and Labor Committee's jurisdiction.

The man who sits as chairman of this committee is, therefore, at a particularly sensitive spot in the legislative process in particular, and in the broader policy process in general. Furthermore, many of the programs that Powell's committee considered between 1961 and 1966 had as either their primary or ancillary goals the easing of various discriminatory pressures on the Negro population. Until Powell lost his chairmanship in January of 1967, he was generally acknowledged to be the most influential Negro politician in America and one of the Congress's most warmly disliked members.

Chairman Powell went to great lengths to generate an air of sweet reasonableness and fair-mindedness, but there was paradox and irony in the comments that were made about his chairmanship. The view from the Democratic side of the committee conveys a complex picture. One influential Democrat on the committee described Powell as an "effective chairman because he never got in the way." The same member suggested that Powell pre-empted possible challenges to his flamboyant style of leadership by "letting the committee have its head," and thereby not exercising

the kind of control that would have been challenged. The interesting distinction was drawn between being an effective chairman and an "outstanding legislative leader." Powell got universally high marks on the former, and consistently low marks on the latter. The difference apparently refers, on the one hand, to the permissive administrative style he brought to the committee and, on the other, to his publicly flamboyant, devil-may-care attitude, which reduced his effectiveness when dealing with his colleagues. The high level of personal antagonism that Powell was always able to provoke is evidenced by the comment heard several times: "Powell loses twenty votes every time he stands up on one side or another on an issue." Some estimated the loss of votes to be as high as forty!

Generally speaking, Powell's position on the Education and Labor Committee is not typical of the posture of most chairmen in the House. Normally the committee chairman is not only the man who has the most years of consecutive service on the majority party, but is also looked upon as a specialist with substantial expertise regarding the matters that face the committee. While this latter state of affairs may not always obtain, there is a definite presumption on congressional committees that the chairman's views are to be respected as much for his expert knowledge as for the power and influence he wields as chairman.

On the education issue in 1965, Powell's behavior ran both good and bad from the perspective of his Democratic colleagues on the committee. The same member who called Powell an effective chairman also claimed that Powell had "no role whatsoever on the education bill," and his implication was that this was all to the good for the sake of the bill. The point is that there were limits to the administrative permissiveness that the committee majority would tolerate as compensation for behavior they felt inimical to the best interests of the committee's legislation. Permissiveness of "giving the committee its head" was acceptable while the bill was in the education subcommittee, chaired by Carl

Perkins of Kentucky, but once the full committee got juris-
diction there were serious criticisms of Powell's behavior.

At a critical juncture in the bill's course through Congress
Powell was in the Caribbean on vacation.[15] His absence, and
apparent refusal to return, delayed the legislation a full three
weeks. An outspoken member of the majority on the com-
mittee relieved his rage over the delay with these words:

> Why the son-of-a-bitch! The committee had nothing
> else on its schedule, the coalition was just barely stick-
> ing together . . . in danger of becoming unglued . . .
> we were all ready to go and he's down in Bimini. If
> he doesn't make a contribution he shouldn't be chair-
> man. There is no divine right of committee chairmen.[16]

The apparent ambivalence on the Democratic side of the
committee to Powell's chairmanship is a product of many
things. But in the final analysis the liberal Democrats on
the committee knew that Powell would support the "right"
position, and that he could be counted on not to cramp the
style of the subcommittees. This distaste for the tedious
aspect of shepherding the education bill through the intrica-
cies of the House was repeated in other areas but ironically
worked in Powell's favor. He was content to let the sub-

[15] Full committee mark-up is the point at which the full
committee goes into executive (secret) session to amend and
consider what the final committee bill will contain.

[16] Interestingly enough, this member distinguished between
the causes of Powell's ultimate demise as chairman and the
refusal by the House to let Powell take his seat in January of
1967. The threshold of permissiveness was crossed "once too
many times" when Powell held up the committee's proceed-
ings with his absence. This kind of behavior cost Powell the
chairmanship, when the Democratic caucus voted at the start
of the Ninetieth Congress to take it from him. Powell's flam-
boyance and extravagances caused the wrath of the House to be
brought down on his neck. Powell had committed the penul-
timate sin in his colleagues' eyes: he caused the House to be
held up to public ridicule in the nation. This caused the House
to deny him his seat.

committees do their work with latitude and freedom. The smaller work groups handled much of the detail and tedium of guiding legislation through to the floor. Powell was satisfied to act as chairman and to receive the perquisites of office (symbolic and material), and generally let others run the legislative show.

There were some matters that caught and occupied Powell's attention, however, and when he turned his considerable political talents to a subject it was rarely without effect. Perhaps the best known example of Powell at work on legislation was the recurrent antidiscrimination amendment which bore his name. The Powell amendment was a predictable addition to much of the welfare, grant-in-aid legislation that the Congress considered during the eighteen years Powell served. The amendment was simple enough. It prevented the use of federal monies for programs being administered on a discriminatory basis. The Powell amendment was an inevitable issue attached to every school aid proposal from 1955 on.

The Brown decision in 1954 gave Powell's amendment obvious relevance and impetus. Often opponents to the federal aid principal would join with the bill's supporters to pass the Powell amendment and thereby deny education legislation the necessary support of the Southern Democrats on final passage. This is what occurred in 1956 with the ill-fated Kelly bill.[17]

The cumulative, overlapping impact of decisions in the policy process is nicely illustrated by the Powell amendment. With the passage of the 1964 Civil Rights Act, which prohibited the use of federal funds for segregated facilities in Title VI, Powell's fight came successfully to a close. For the very next year after the 1964 civil rights bill became

[17] Munger and Fenno, *op. cit.*, p. 14. In 1962 President John F. Kennedy in a TV interview commented that with respect to education legislation the church-state question was important but that also, "the integration question is another matter which comes into it."

law, the education bill reached the floor of the House without it first being necessary to fight the civil rights issue directly. The elementary and secondary bill had enough obstacles in its path to fully occupy all its adherents. It is no small accomplishment that they no longer had to fight the civil rights issue before getting to the federal aid to education question itself.

Aside from his regular leadership on the one amendment and the periodic bills that would attract his attention, Powell was viewed with dismay and concern by most of his Democratic colleagues on the committee. Powell never really labored at keeping the majority on the committee working together as an integrated whole, and as a result committee legislation (particularly in the education field) lacked the advantage of a united and concerted majority working for its adoption.

While the committee Democrats have been liberals, by and large, elected with the support of organized labor and the Democratic Study Group, they hardly can be characterized as a homogeneous unit. Munger and Fenno were told by a Republican on the committee that the Democratic condition on the committee was ". . . like the old situation where they hate the heretic more than the infidel."[18]

Edith Green's (D. Ore.) resistance to the Administration's education bill in 1965 is a good case in point, the details of which we will treat in the next chapter. Suffice it to say that while Powell's style of leadership held certain benefits for the majority members, one of the significant costs was that it reinforced the contentiousness and partisanship that existed within and between both parties on the

[18] See Munger and Fenno's description of the Education and Labor Committee in *National Politics of Education;* Fenno's "The House Appropriation's Committee as a Political System: The Problem of Integration," *American Political Science Review* (June 1962), for a contrasting House Committee; and Fenno's *The Power Of The Purse: Appropriations Politics in Congress* (Boston: Little, Brown, 1966).

committee. Most of the committee's proceedings were affected by this situation, and the education issue was no exception.

The minority's view of Powell and the committee's style of operation was as complex and contradictory as that offered by the Democrats. Perhaps the most interesting difference between the two is that, while the Democrats saw Powell as administratively permissive, the Republicans on the committee were impressed by the "tight ship" Powell ran. One Republican member recalling the mark-up session of the full committee said:

> As usual he [Powell] was the epitome of judiciousness and reasonableness. He always wants to give the air that he is a calm, fair-minded, and reasonable chairman. This isn't to say that he would not try to cut off debate or abuse anyone. The facts of the matter were that it was obvious he had the votes and therefore he could afford to present any image he wanted to.

The difference in party perception on the Education and Labor Committee was not confined to opinions about Powell. There was a similar difference in the members' attitudes about Carl Perkins, the chairman of the general education subcommittee. Generally the Democrats on the subcommittee saw Perkins as a kindly enough man with limited legislative and intellectual resources. The Republicans, interestingly enough, saw Perkins as a very shrewd leader who ran the subcommittee with a firm hand. Republican Member Charles Goodell of New York complained, for example, that Perkins loaded the subcommittee hearings in favor of the bill's proponents. He argued that Perkins deliberately left only a very few hours for the minority's witnesses to get a hearing. This, Goodell suggested, was a part of the overall Administration plan which Perkins was executing without a flaw in order to speed the bill through Congress with a minimum of debate.

The minority's feeling that they were dealing with an

unshakeable monolith (especially during the first session of
the Eighty-ninth Congress) apparently contributed to Peter
Frelinghuysen's (R. N.J.) decision to give up his ranking
minority spot on the committee when the Eighty-ninth
Congress convened. A colleague of Frelinghuyson's on the
committee reported that he had been frustrated in dealing
with Powell, and made special reference to his experience
the year before with the poverty program. Of course, while
there were other considerations that must have motivated
Frelinghuyson to give up the most senior position he could
have achieved on the Education and Labor Committee,
there is reason to believe that under any circumstances he
viewed work on that committee as a thankless task.[19]

Again like the Democrats, the Republicans on the com-
mittee were very sensitive to the politically explosive nature
of the issues they had to deal with on Education and Labor,
and as a consequence the Republican ranks were as badly
split as the Democrats' over the 1965 bill.

Both Alphonzo Bell (R. Calif.) and Ogden Reid (R.
N.Y.) made it plain early in the proceedings that they
were sympathetic to the Administration bill, and both even-
tually voted for it. The difference between the two parties
was that Edith Green's defection from the majority coali-
tion, as an avowed supporter of the federal aid principle, was
potentially more damaging to the legislation and the Demo-

[19] Frelinghuyson was also on the Foreign Affairs Committee
in the House. He perhaps felt pressure from his Republican
colleagues who looked askance at one man occupying two such
important spots. Indeed, while the Republican leadership fight
was in progress in January of 1965, Congressman Albert Quie
(R. Minn.) chaired a Committee on Internal Organization
which investigated the value of eliminating the possibility of
two committee posts for a member who was ranking on one.
Though this Republican committee modified its final position,
this may have affected Frelinghuysen's decision. Finally, of
course, Frelinghuysen himself indicated a preference for the is-
sues the Foreign Affairs Committee handled over the jurisdic-
tion of the Education and Labor Committee.

cratic cause than Bell and Reid's defection would have been to the Republican camp.

To the Democratic leadership, concerned over the staying power of a delicate coalition of aid supporters, the defection of one classed as a supporter was viewed as no trivial event. People from the Office of Education, actively engaged in the congressional liaison phase of the bill's development, worked long hours with Bell and Reid to maintain their support as counterweight to the Green defection. Most serious of all from the Democratic view was that Edith Green's objections to the legislation were precisely those that the Republican leadership was making. This made for a convenient coalition of sympathies if not of votes between Mrs. Green and committee Republicans. Both the Republicans and Mrs. Green disclaimed any working relationship, while the Democrats charged with getting the legislation passed were sure they saw an active alliance at work. The extent and effect of Mrs. Green's opposition to the bill will be of more specific concern in the next chapter.

The Private Groups Respond

Congress reflects changes in its external environment in a number of ways. We have already examined several of the most dramatic and immediate links, in 1965, between the internal organization of the House of Representatives and its Education and Labor Committee with the broader political environment of 1964.

As Congress passed through its organizational phase early in 1965 and began the tasks of examining the substance of legislation, basic realignments in the positions of the major education pressure groups were under way. The National Education Association, the National Council of Churches, the United States Catholic Conference, and the American Federation of Labor-Councils of Industrial Organization (AFL-CIO) had all been involved in the debate over fed-

eral aid to education for virtually as long as the question had been a modern policy issue.

The actions Congress would be likely to take in this area were closely tied to what these groups would accept or reject in any proposed bill. The relationship between the private groups and the Congress (particularly through the Education Committees in both houses) is simply another important example of the linkages between the external and internal environments in which congressional decisions are made.

Furthermore, relations between the major private groups were not conducive to compromise until the shape of the total policy environment was clear in 1964. In short, the shaping process takes time and requires strong forces. Just why that is so and how it can work becomes clear with the evolution of the positions of the education groups in 1964–65.

By mid-afternoon on January 28, 1965, the House general education subcommittee, chaired by Carl Perkins of Kentucky, had received public acknowledgment that both the NEA and the USCC had accepted the essentials of HR 2362. This was the first time in history that these two groups were on the same side of an elementary and secondary aid bill fight.

To the outsider it appears as though the external environment changed in direct response to the changes in the internal environment. In fact, the private groups that had represented the varieties of opinion on federal aid legislation began their realignment a full year before the Eighty-ninth Congress convened. There is no doubt that the liberal Democratic gains in the 1964 election were significant in reinforcing the shifts that were well underway prior to the election, but the significant development is that the major private groups had started to reassess their positions of public record before the internal changes in Congress had occurred.

It is fair to say that there were and are three distinct

positions on the question of federal aid in the United States. The rationale and motives for any one group's position will vary for a number of reasons, but it is not a distortion to say that there is one body of opinion in favor of federal aid as long as no assistance is provided to private and/or parochial schools. Another posture supports federal aid only under conditions where aid is granted to the private and parochial sector, and yet a third body of opinion holds that there ought not to be any federal aid to education under any circumstances. The latter view is usually a product of an overriding fear of federal standards and perceived threats of central control of American education from the Office of Education.

Such groups as the Chamber of Commerce and the Daughters of the American Revolution have traditionally held this last view, but it should be said that their role and effectiveness within the education community and the Education and Labor Committee were negligible by the time the 1965 debate began. For the simple fact is that Congress had long since affirmatively answered the question of whether there ought to be a role for the federal government in American education. The Morrill Land Grant College Act of 1862, the National Defense Education Act of 1958 and subsequent extensions, the Area Vocational Education Act of 1963, the Higher Education Facilities Act, the Library Construction and Services Act, the Mental Health and Retardation Act, and others had long since involved the federal government in American education with expenditures of billions of dollars annually.

For this reason, and because there were other powerful interests aligned with the other categories of opinion we have identified, there were in fact a limited number of formal groups that carried significant weight in the process of getting HR 2362 adopted. Among the groups that stood for aid only to public schools, the National Education Association and the National Council of Churches stand out. There were other well-known organizations in this category,

such as the American Association of University Women, the American Jewish Committee, the American Civil Liberties Union, and the less well known but very influential Council of Chief State School Officers. But the NEA and the NCC, representing respectively the largest professional teacher's association and the dominant religious attitudes in the country, surely wielded infinitely more political muscle than any other pro-public school aid interests.

The NEA is a federal organization of state associations. Their public position over the years has been one of strict support for a general aid bill; one which would support teacher's salaries, would use state departments of education to administer the programs, and would provide no funds for private or parochial schools.

In support of the association's position, the NEA has been one of the twenty-five largest spenders among the lobbyists registered with Congress. In 1964 it ranked as the seventeenth largest spender, ahead of such well known lobbying groups as the American Medical Association.[20]

The NEA has nine professional staff members responsible for federal relations. A legislative commission reports to the representative assembly of the association and between conventions is responsible to the executive committee of the association. Its mandate is to develop and pursue a legislative program consistent with the NEA platform most recently adopted by a convention. It has eleven members, each of whom is appointed to a four-year term by the executive committee. The commission was established in 1920 "to represent the teaching profession before Congress," and that still is its primary reason for being.

Even with staff, many members, and prestige the NEA came dangerously close in the mid-1960's to losing its access and hence its effectiveness with the Office of Education. The association's firm ("rigid" was an adjective used by

[20] "Legislators and the Lobbyists: Congress Under Pressure," *Congressional Quarterly Publication* (Washington, D.C., 1965), p. 40.

people in the Office of Education) stand in opposition to aid to parochial schools was leading some people in the Office of Education to see the NEA as an obstacle to compromise on the delicate church-state question. Fear over possible exclusion from the policy making process helped persuade the NEA to go along in 1965 with an aid formula that would see some funds channeled into the hands of private and parochial schools. In 1965, to be on the side of a minority when education legislation got passed would have left the NEA without influence during the critical period after passage when the administrative regulations were being drawn up. The testimony before the House and Senate was replete with questions about how a particular title and section would be implemented. If for no other reason, the NEA could not afford to be with the losers the year federal aid finally got enacted. Since the NEA's principal reason for being was the passage of federal aid to education legislation, the rival teacher organizations' (the AFL-CIO-affiliated American Federation of Teachers) charges that the NEA had not been successful up to 1965 touched a sensitive chord.

The combination of chance and design that characterizes important policy developments is illustrated again in the relationships between the NEA and the AFT. The older, more conventional NEA was being threatened by the more militant AFT which was and is willing to use the traditional devices of organized labor in its efforts to represent the teachers of America as their agent in collective bargaining. With the AFT reflecting more permissive attitudes toward aid to private and parochial schools, the NEA had to get on the bandwagon or be accused of being unrealistic and obstructionist.

The combination of the probability of legislation passing Congress, the AFT threat, and the growing opinion of the Office of Education about the NEA's resistance to compromise surely was enough to swing the association over to the side of the Administration bill.

A representative of the NEA's federal relations staff told one of the authors that it was simply a logical case of "the NEA not wanting to risk being out in the cold when the hard decisions were made later on." This same respondent said that the NEA "recognized that if it took a rigid position on the church-state issue as an organization it would have been hamstrung politically."

The effect of all this was to give the Administration the important early support of an influential group. It was on December 16, 1964, that the NEA let it be known that they would accept the principle of aid to students of nonpublic schools. The announcement signalled an important and basic shift in policy on the part of the NEA. Furthermore, the NEA's willingness to go along had important effects on the attitudes of other groups. It was perfectly clear that a radical change in the political climate in favor of federal aid had occurred when the NEA shifted its stand. As one Presidential assistant put it: "The overwhelming victory of the President and party in 1964 had the effect of forcing the pressure groups to come to terms with each other." The NEA was the first group to make a public move toward accommodation.

The National Council of Churches, as a federation of thirty-one Protestant churches in the United States, could justly lay claim to representing a cross section of dominant religious beliefs in America.[21] The NCC had, over the years, opposed any federal support for non-public elementary and secondary schools. This placed the NCC in favor of the 1961 Kennedy bill. When Arthur Flemming, former Secretary of HEW during the Eisenhower Administration and first Vice President of the National Council of Churches, appeared before the Perkins subcommittee in the House to testify on the 1965 bill, it was not at all clear what the council's position would be. Further, the policy board of

[21] The thirty-one communions of the NCC accounted for more than 40,000,000 constituents.

the council had not yet considered HR 2362 when Flemming appeared (the bill was made public only ten days before the hearings began), but he referred in his testimony to the board's 1961 support for federal welfare programs for children regardless of "the school they may be attending, provided such services are identifiable by recipients as public services, and the expenditures are administered by public authorities responsible to the American electorate." Flemming made explicit the council's willingness to find a solution to the church-state dilemma when he told the subcommittee that the Board ". . . in confronting the church and state issue [has] drawn a line between assistance to students in private schools and assistance to private schools."[22]

In the absence of having considered the proposed legislation and the formula it included for solving the church-state issue, Flemming had to be circumspect in giving the council's support to the Administration's bill. Nevertheless, having indicated the council's desire to find such a solution, and having indicated what the council's conditions for aid to children of nonpublic schools would be, he concluded his opening statement with a vigorous defense of the principal of accommodation and compromise on the church-state issue:

> The church and state issue . . . has been one of the principal roadblocks standing in the way of constructive federal legislation in the areas of elementary and secondary education. It has likewise been a divisive factor in the life of our nation.
>
> I hope that all concerned, both inside and outside of Congress, will analyze HR 2362 with the end in view of doing everything possible to make it an instrument of reconciliation. I believe that it can be. I believe that

[22] "Hearings Before the General Subcommittee on Education of the Committee on Education and Labor, House of Representatives," Eighty-ninth Congress, First Session, on HR 2361 and 2362, p. 737.

President Johnson and his associates should be commended for providing us with this opportunity of approaching an old unsolved problem with a new spirit.

The National Council of Churches is prepared to do anything it can to make HR 2362 such an instrument of reconciliation. The time for action in the area of federal financial assistance to elementary and secondary education is long overdue.[23]

Thus did the NCC join the NEA in moving off dead center on the most controversial aspect of the proposed legislation. The important point in this regard is not whether the NEA or the NCC "changed" their positions. The important element in their reactions to HR 2362 is their apparent willingness to accept the thrust of the legislation as not being inconsistent with their prior stances. A representative of the NEA put it rather simply: "While the NEA was not 100 per cent in favor of the bill, as it was introduced, we had decided that we could live with it. It was minimally acceptable."

The process by which these two influential groups came to their positions on HR 2362 was neither accidental nor unrelated to the accommodations made by the principal interest group representing the hierarchy of the Catholic Church in the United States, the United States Catholic Conference. Since the post-World War II period, the USCC had taken a position of opposition to any school-aid bill "that excluded the Catholic schools from its benefits." While any school aid legislation that would have provided funds to nonpublic schools would have spread the federal largesse beyond just Catholic institutions, Catholic education—as the largest nonpublic secondary and elementary educational operation in the nation—spoke with the single most important voice of nonpublic education in the land.

On Capitol Hill, Catholic education interests were protected by people such as Hugh Carey (D. N.Y.), who sat

[23] *Ibid.*, p. 739.

on the Education and Labor Committee, and Speaker John McCormack from Boston, Massachusetts. The national Catholic constituency that Carey and McCormack and others represented was not small. By 1965 more than five-and-a-half million American children attended Catholic schools compared with two-and-a-half million in 1950. Twenty to 26 per cent of the school population in nine Northern states is enrolled in Catholic schools, and in New Orleans fully one-third of all school children are in parochial schools.[24]

The so-called Catholic position is not universally held by all Catholics. Congressman Andrew Jacobs (D. Ind.) has taken the position that ". . . as Catholics, we do not have the right to a separate publicly supported school system nor does any other group of people have such a right."[25] Cardinal Richard Cushing, Archbishop of Boston, represents the view that the Catholic school ought to avoid the risk of federal control by simply not accepting any governmental assistance of any kind. Indeed, this view was the dominant Catholic position before the end of World War II, when the church hierarchy took a new stance in favor of equal treatment for nonpublic education in any federal assistance program.

Though there are exceptions, the USCC can be said to represent the official Catholic position on questions of federal aid to education. At least the people in the Office of Education felt confident that they were dealing with the representatives of the church hierarchy when they met with the legislative representatives from the USCC. Frank Hurley and William Consodine were in frequent contact with Education Commissioner Francis Keppel and with Douglass Cater, the President's special assistant who represented the White House's interest in the development of the bill.

[24] "Federal Role in Education," *Congressional Quarterly Publication* (Washington, D.C., 1965), pp. 60–61.
[25] *Congressional Record*, Eighty-first Congress, First Session, 1949, p. 4606, quoted in Munger and Fenno, *op. cit.*

The late Msgr. Frederick G. Hochwalt was the director of the USCC's Department of Education and appeared before the Perkins' subcommittee on the afternoon of January 28, 1965.[26] In his comments to the committee, Msgr. Hochwalt gave a carefully controlled endorsement to HR 2362, although the legislation was not perfectly satisfactory from his standpoint. One of the USCC's principal spokesmen told the authors that "while the USCC was not perfectly satisfied with the bill, we expressed no objections to it."

The primary problem with the bill from the Catholic standpoint was that all funds were to be administered by a public agency, and there was no guarantee that Catholic education would receive equal funding under the legislation. The dilemma Catholic educators found themselves in was that the long-run implications of the bill were not clear. One could not predict, for example, whether the bill really constituted a victory for the USCC's twenty-year battle to get public support for the parochial school, whether it was a fraudulent package offering token support to Catholic education that would wither under the control of public school boards, or, finally, whether the bill was just a compromise.

With this uncertainty, the USCC's position finally was that they ". . . could withhold objections to the bill." When John Brademas (D. Ind.) asked Msgr. Hochwalt if the USCC endorsed the legislation, Hochwalt's response was instructive of the kinds of reservations that Catholics had about the bill: "It is a strong word [endorse], but it comes close to it. We look with favor upon those kinds of provisions and hope they can be worked out successfully. To say we endorse the whole thing line by line is a little too

[26] Also appearing with Msgr. Hochwalt, who passed away shortly after the bill was passed, were two other representatives of Catholic education: Msgr. William McManus of the Chicago Catholic school system, and Msgr. John McDowell, Superintendent of the Catholic schools of Pittsburgh.

broad for us." Brademas' reply was meant to be funny and
was indicative of the delicate lines that were being redrawn
vis-à-vis the Catholic's posture toward federal aid. He said,
"Monsignor you should be a candidate for public office,
I think that sounds encouraging enough to me."[27]

Summary

So it was that the threads of the external and internal
environments of Congress were woven together to create a
series of conditions that seemed to make the passage of an
aid program in 1965 inevitable. There should be no mis-
understanding that we are suggesting that chance alone set
in motion a series of irresistible forces which culminated in
the bill's passage. On the contrary, as is usually the case
with matters of public policy, the creation of conditions
necessary for the enactment of such legislation was a prod-
uct of a great deal of planning and hard work as well as
of good fortune.

President Johnson's accession to the Presidency was a
matter of chance. But his style of leadership and his strong
desire for a compromise settlement to the church-state stale-
mate preconditioned every other participant's perceptions
and actions. The NEA had long taken the public position
of no grants to private and parochial schools. The United
States Catholic Conference had long been on the public
record as not accepting less than parity of treatment between
the public and private school systems. Obviously both
groups were going to have to give some, or one was going
to have to be run over roughshod. Lyndon Johnson's poli-
tical style simply would never have permitted him to trample
one of these two positions, although it is not insignificant

[27] "Hearings Before the General Subcommittee on Education
of the Committee on Education and Labor, House of Repre-
sentatives," Eighty-ninth Congress, First Session, on H. R. 2361
and 2362, p. 835.

that both sides thought that, had he wanted to, the President had the votes in Congress to do just that.

In many ways the education bill was the archetypical Great Society legislative program. The pressures for consensus were great. The President wanted to overcome divisiveness, not create it. And even with the new Democratic majorities, the White House and the Office of Education were never secure in the feeling that they were going to pass the elementary and secondary program until it in fact was through the legislative maze. The internal changes in Congress just were not very impressive to a group of people who had grown battle fatigued and accustomed to defeat on federal aid legislation. The Administration team approached the legislative problem here as though they were facing the Eighty-seventh or Eighty-eighth Congress.

The story of how the education formula of 1965 was created and how the Administration and its allies nursed the conditions necessary for passage are the subjects of the following chapters. Success in policy making is the skill of exploiting opportunities for movement when they occur. We leave this chapter having outlined the opportunities that were available to the supporters of aid legislation shortly after Congress convened in January of 1965. We turn now to a consideration of how those opportunities were taken and used to enact the bill into law.

PART II

1965:
A Case Study

Chronology of the 1965 Elementary and Secondary Education Act

Dec. 16	NEA announcement on support for private school aid
Jan. 12	President's education message sent to Congress
Jan. 12	Msgr. Frederick G. Hochwalt of the United States Catholic Conference applauds the President's education message
Jan. 12	Introduction of HR 2362 by Representative Perkins and S 370 by Senator Morse
Jan. 22	House General Subcommittee on Education hearings begin
Jan. 26	Senate Education Subcommittee hearings begin
Feb. 5	HR 2362 reported by House Subcommittee
Feb. 25	House Full Committee mark-up session begins
Mar. 2	HR 2362 clears House committee
Mar. 8	Congressmen Ayres, Goodell, and Curtis announce the Republican education alternative
Mar. 16	House Rules Committee hearings begin
Mar. 22	House Rules Committee clears HR 2362 for floor action
Mar. 24	Debate on House floor begins
Mar. 26	HR 2362 passes House
Mar. 29	HR 2362 received by Senate and referred to Committee
Mar. 30	Senate Subcommittee starts executive session on HR 2362

(Continued on p. 74)

Apr. 1 Senate Subcommittee approves HR 2362
Apr. 6 HR 2362 reported by full Senate Committee
Apr. 7 Debate on Senate floor begins
Apr. 9 Senate passes HR 2362
Apr. 11 Elementary and Secondary Education Act signed
 into law by the President

4

THE EXECUTIVE

INITIATES

Woodrow Wilson once said that legislation "is an aggregate, not a simple production. It is impossible to tell how many persons, opinions, and influences have entered into its composition."[1] This was clearly the case with the 1965 education bill. It is impossible to know with certainty who was responsible for each idea in the bill, but certain patterns of the policy process that have been asserting themselves for several decades were reflected in the development of the 1965 legislation.

We are used to viewing Congress responding to the initiatives of the executive branch. Typically, most major legislation comes to Capitol Hill in the form of a Presidential message or request which is introduced as legislation by a member who belongs to the party of the President. Most often this is one who serves as chairman or ranking minority member of the committee with the appropriate jurisdiction. What is not so clear or visible from these familiar institutional patterns is the growth of a series of stable working

[1] Wilson, *Congressional Government* (Houghton-Mifflin, 1925).

relationships that connect the people and groups in and out of government who share an interest in a particular policy area. These policy networks focus their early concerns at the White House level since some of the first important decisions are made there—whether to request legislative action by Congress, for example.

Normally the bargaining, persuading, and negotiating that characterize the relations of these policy groups is like the rest of the process: open-ended and repetitive. The establishment of conditions favorable to adoption of a major policy departure is a time-consuming and unending process. Having once passed legislation there is still the battle of reauthorizing the program next year and the year after; also, there remains the yearly battle of having the programs adequately funded. We need to look closely at how the education policy community negotiated a settlement of the key issues in the 1965 bill.

The first point that should be made about these negotiations is that the Democratic membership of the education committee in the House (where the key battle was to be fought) by and large took the position that they would be able to support any legislation that carried the endorsement of the Administration and the principal interest groups. In effect this left the salient private groups and the Administration to their own devices to work out the essentials of the legislation. The Congress (or, more precisely, the House Democrats on the Education and Labor Committee) would have veto power over the proposal when it was finally received on Capitol Hill.

It may be somewhat overstating the case, but an official in the Office of Education described the legislative phase of the education bill by saying, ". . . there was extraordinarily little congressional consideration given the legislation." In fact, the Perkins subcommittee in the House did add some significant amendments to the Administration bill that was sent up, yet it should be noted that one of the Administration's key spokesmen on educational matters

saw the history of HR 2362 as essentially noncongressional in character. It is clear that the important agreements that were necessary before the House would give favorable consideration to a federal elementary and secondary aid bill were made outside Congress and, furthermore, with the explicit authorization of committee Democrats.

The explanation for this peculiar "surrender" of congressional autonomy over a vital phase in the decision making on the education bill is deceptively simple. The Congress, and particularly the members of the committee who had experienced education fights before, feared they would have to resolve the church-state issue on Capitol Hill. The political consequences of taking sides on "the religious issue" was the greatest concern of most members. One Democratic member of the committee put it this way: "We were all sensitive to the start of another holy war. Politically, not many of us can afford a religious war—at least those of us from two-religion districts."

In effect, the Democrats on the committee wanted and expected the Administration to work out the necessary agreements (whatever they might be) so that the principal factions were satisfied. Their failure on so many prior occasions to find agreement predisposed the leading congressional figures to leave these delicate negotiations in the hands of the Administration. Then the committee and the House would act to ratify those agreements. Indeed, talking to members of the Administration and the leading figures on the House committee, there was unanimous agreement that the reason the bill was given relatively little attention in Congress was that the leadership operated under the assumption that the more time the bill was given the greater the chances of igniting the "holy war."

The President's role, ironically, was like that of Congress. After the election he went to the Commissioner of Education, Francis Keppel, and asked for an education bill that would avoid a church-state fight. He was willing to leave the legislative details to his staff (Cater and Lawrence

O'Brien) and to Keppel in the Office of Education. Thus, the legislative phase of the 1965 education bill had its origins not on Capitol Hill but inside the White House during the Presidential campaign of 1964.

In 1964 Douglass Cater, former editor of the *Reporter* magazine, had joined President Johnson's staff as a special assistant. His duties were, like other Presidential assistants, undefined and wide-ranging. During the months leading up to the campaign in the fall of 1964, Cater assumed the responsibility for policy matters relating to education. By the time of the 1964 election everyone in the White House looked to Cater for staff leadership on this issue. As a result Cater reviewed the report of a task force on education that the President had appointed earlier in the year. Its report was submitted to the White House in mid-November, shortly after the election. Hence, by the time the task force report was received, the White House was thinking about education as a legislative issue, rather than as a campaign issue.

The task force had been chaired by John Gardner, then president of the Carnegie Foundation, who was later to become Secretary of Health, Education, and Welfare from 1965 to 1968. Gardner and the task force approached their problem as experts trying to solve an educational problem, not as tacticians trying to meet a complex political problem. One high-level official in the Department of Health, Education, and Welfare who had seen the report described it as a "politically sterile and naive report." The Gardner task force couched the proposals in educational terms, only being peripherally concerned with the political accommodations necessary to gain passage. But the Administration's priorities were exactly reversed. It apparently contained little mention of a solution to the question of federal aid to private and parochial schools, but rather devoted itself primarily to the technical question of how federal aid should be structured.

Cater and Francis Keppel, who sat on the task force, had

the responsibility of keeping the task force sensitive to the issue of political viability, and the task force report did contain a recommendation that profoundly shaped the act itself. The report developed the notion of tying education legislation to the existing poverty program—or, to put it another way, of basing the formula for distributing federal funds on the number of children from impoverished families in each independent school district. Eventually this became the basis for the child-benefit approach of allocating aid, which became the hallmark of the legislation. The debate in Congress and the Administration's major lobbying efforts were directed at protecting the allocation formula and the child-benefit approach.

The issue was narrowly drawn in part because of the makeup of the new Congress. For the congressional Democrats it was a matter of constructing a proposal that would unite the various factions warring over aid to private and parochial schools in and out of Congress. The answer was to be found in the formula and the child-benefit theory which side-stepped the church-state issue by providing the funds not to institutions but to children of nonpublic schools.

Douglass Cater assessed the key tactical problem facing the Administration this way:

The problem we faced was not one of having to mold public opinion. Public opinion had geen generally in favor of such a bill for at least several years. The problem continually facing the bill was the opposition of the two major interest groups: the National Education Association and the National Catholic Welfare Conference [now the United States Catholic Conference]. The overwhelming victory of the President and the [Democratic] party in 1964 had the effect, beyond expanding Democratic majorities in the Congress, of forcing the pressure groups to come to terms with each other. Both had to know that a bill was going to be

passed; and as a consequence, the legislative goal for
both groups was to maximize their gains in the bill
while minimizing the gains of the other side . . . with
the major difference that now they both accepted the
fact that the other side had to be given something.

The "new" ideas from the Gardner task force enabled
the groups to review their positions with fresh standards.
Neither group had to face the prospect of losing on a bill
identical to the one they may have opposed last time. The
new formula gave them the opportunity to save face while
at the same time bending a little from prior positions.

In addition to the "poverty base" for the formula, the
task force also suggested the concept of supplementary edu-
cational centers which was eventually contained in Title III
of the bill. But if the reports of those who have read the
report are accurate, the report did not directly address itself
to the political solution of the church-state issue.[2]

The substantive suggestions of the task force, however,
did meet tactical legislative needs arising from the church-
state issue. It was not unimportant to the Administration
that the political solutions to the church-state stalemate had
support in a blue ribbon task force headed by the president
of the prestigious Carnegie Foundation. However, the heart
of the process that produced the elementary and secondary
legislative formula was not to be found in the Gardner
task force but rather in a series of meetings and informal
negotiations involving the principal groups and forces that
had contended over federal aid in the past. The United
States Catholic Conference was represented by Mr. Frank
Hurley and Mr. William Consodine. Mr. John Lumley and
Mr. Robert E. McKay were the principal contacts for the
National Education Association. Lumley was director of
the NEA's legislative commission. Mr. Robert Wyatt of the
Indiana Education Association participated in several meet-

[2] The report itself has not been made public as of this writ-
ing, spring 1967.

ings in late 1964 which were important as precedents and standards for the ones that followed. The National Council of Churches, while not as regular a participant in the meetings as the other groups, was represented by Dean Kelley at several critical sessions. The Democratic majority in Congress also had its spokesmen in these discussions, especially at the early stages. They were Carl Perkins, the chairman of the general education subcommittee of the House Education and Labor Committee; John Brademas of Indiana, a highly respected member of the education subcommittee who was a former educator before being elected to Congress; and Hugh Carey of Brooklyn, New York—also a member of the education subcommittee and a man whose reputation in Congress had been largely built on the force of his articulate representation of the cause of private and parochial education interests. This meant that Carey represented the Catholic hierarchy's position on Federal aid to education. The perfect index of official Catholic attitudes toward an education bill inevitably would be Carey's public statements.

In many ways the one man who was able to bridge the gaps that separated the various factions on this issue was Francis Keppel, the Commissioner of Education. The Keppel role dates back to the Kennedy Presidency when Keppel was appointed to his post. According to several persons close to Keppel during his tenure in the Office of Education, his assignment from Kennedy was to prevent the National Education Association-United States Catholic Conference battle over elementary and secondary aid from affecting the course of the Administration's Higher Education Bill. The contacts that Keppel established with the education community on the Higher Education Bill in the early 1960's proved invaluable in 1964 and 1965 when the Johnson elementary program was being constructed.

The pattern of relationships, expectations, and confidence that are critical to a group of highly skilled professionals working closely on hotly contested issues was created and nurtured through the Kennedy program's experience in Con-

gress. While the USCC was not happy about the 1961 Kennedy program, Keppel came out of the legislative battle unscathed. A prominent spokesman for the USCC described Keppel's success as owing to his not ". . . being an adherent to any of the historical stereotypes nor a prisoner of any of the conventional faiths of the professional teacher associations." Similarly a representative of the NEA was highly complimentary to Keppel and his skill at "leading the factions to agreement" in 1965.

When the Johnson Administration began to take hold of the education issue in 1964, Keppel was experienced in his job and had successfully created the network of relationships within the professional education groups and church organizations that could be used to find a solution to a problem that seemed all but insoluble. The Keppel contacts provided the start of a series of important conversations that began as discussions but grew over a period of several years to become negotiations.

These meetings were so important to the final evolution of the Elementary and Secondary Education Act that it is worth quoting extensively from a memorandum describing the negotiations sent by an observer to one of the authors.

Major aspects of the Elementary and Secondary Education Act had to do with such fundamental public policy considerations as the nature of federal-state relations, the shockingly inadequate program for the poor, the ancient problem of formulae distribution of money to the states based on need, and the role of research and development.

In one way or another most of these issues were touched on in the rather general conversation that took place at the meetings. . . . In the modern language of program budgeting, one might say that the meetings consisted of delicate, diplomatic soundings on "trade-offs" involving the factors mentioned above, and

were not by any means strictly limited to the church-state issue.

My memory is not entirely clear on how the meetings were initiated, but I seem to recall that key factors were:

1. The desire . . . of the NEA, to work out a solution to the political question of passing an elementary and secondary bill. Wyatt was not rigid in his views on church-state relations, and was a skilled maneuverer in legislative circles in his own state.

2. Congressman John Brademas took a broad view of national needs and felt that the raising of educational quality was a top priority and could only be done by working out new ways of influencing public education. The aspects of the Bill that involved research and development and demonstration, using private as well as public groups as resources, received his vigorous support.

3. . . . the nation needed to pass a bill to do something about the really serious situation in cities and the poor rural areas . . . even at the risk of creating a new relationship between public and private schools. As a matter of social policy, it seemed . . . that we were faced not just with inadequate education in the public schools for poor children, but also in the private—and particularly in the Catholic parochial—schools. . . . one has to worry about *all* pupils, and the recent reports on the quality of Catholic education were not particularly encouraging. Specifically, it seemed . . . it was in the public interest to devise programs that would encourage the "rubbing of shoulders" between Catholic students and students of other religious backgrounds.

The idea of such dinner meetings of an informal character arose initially at the suggestion of Mr. Brad-

emas, who, as an Indiana Congressman interested in education, had been long acquainted with Mr. Wyatt who, for many years, was the executive director of the Indiana State Teachers Association. Mr. Brademas, a Protestant, represented the district in which the University of Notre Dame is located and was acquainted with spokesmen for the USCC.

. The details of the legislation as introduced by the administration were never discussed in an organized fashion at these meetings. It was rather a matter of sensing moods, of feeling out how far the several groups would be willing to go. A central question, to put it bluntly, was whether the Catholic group could afford to come out in public opposition to an administration bill proposing an educational program for the children of the poor. The NEA, at the same time, would be in a difficult position to come out in opposition to a program that focused on poor children and that put the responsibility for the management of money in the hands of public bodies.

The reason that the meetings went off as well as they did was because there was a genuine desire on everyone's part to solve the educational problem of the children. . . . Without this, nothing could have happened. Also important was the willingness to explore possibilities of Mr. Wyatt and Msgr. Hurley. I do not mean that either were soft minded: but rather, that they did not automatically freeze at a new suggestion.

. . . no "agreements" were reached. The administration put together a bill, and, while the several groups mentioned had a pretty good idea of what was in it, they did not have really detailed information.

In a nice way, the administration in effect said, "Do you dare oppose this one?" In fact, the parties did not, and actually they gave generally favorable testimony when asked their views by the committees of Congress.

It seems to me fair to say that these meetings were influential in that there was an unspoken agreement on the part of the participants to support what they could support and to be either quiet or only gently critical of the parts that did not fit their official prior positions. . . . all of the participants kept their "word," even though unspoken, in magnificent fashion. William Carr of the NEA, who was not present at the meetings, did so even though he must have had very grave doubts and even though it risked his position within his organization. When the bill finally came to the political infighting, [there was] the delightful sight of the NEA and the USCC representatives on the Hill combining their efforts on the recalcitrants.

An informal series of such conversations with people representing all sides of the issue helped the Office of Education define the nature of the limits within which the Administration would have to work. It was critically important for Keppel to get a working idea of how far each group would be willing to go to find a compromise on the church-state matter.

Peculiarly enough the NEA and the USCC operated from very different perspectives and perceptions. They trusted Keppel to get a working idea of how far each group would to discover the permissible limits of an Administration bill. But according to several of the participants in these discussions it all seemed an exercise in futility or unreality until the 1964 elections. As soon as the returns were in, all the contacts and the exploratory discussions took on radically new meaning. For the first time both groups recognized the possibility of legislation being passed that would simply ignore their policy preferences.

The USCC was particularly afraid of the overwhelmingly urban Democratic House of Representatives which could, if it wanted, pass a bill identical to the Kennedy pro-

gram. The changes in the rules and the new party ratios left the Catholics no procedural foothold from which to stop a bill that ignored their needs and interests. One can appreciate that, after the election, the pressures on the USCC to cooperate and compromise were irresistible. When it was made clear through Keppel and others that the Administration was soliciting the desires and opinions of the USCC, they were quick to recognize the opportunity to get at least part of the proverbial policy loaf.

The NEA on the other hand had supported the Kennedy aid program all the way to its defeat in the Rules Committee. The NEA's influence in the Office of Education was waning, and they were afraid of losing access to the administrative machinery on education matters if they persisted in opposing any aid for the private educational sector. The results of the election had the effect of moving the NEA to a more flexible stance on the private aid question. That is, the NEA was willing to cooperate with a program that provided funds in some way to the private educational sector before the Eighty-ninth Congress ever convened. On December 16 the NEA made known its willingness to support a bill that did provide funds for students of nonpublic schools.

The election, therefore, changed the political conditions under which education policy would be made in 1965. It changed this environment sufficiently to move the two principal groups to positions of tolerance and flexibility on a legislative program which they both would have opposed under different conditions.

The Administration did not suddenly become authoritarian and dictorial after the returns were in. Contact with the major education interest groups continued throughout 1964, and conscious efforts were made to solicit their attitudes and judgments. No doubt the conditions of these negotiations took on new meaning after the elections, but the negotiations themselves were continuations of some-

thing that had been started much earlier. The good faith and credit that had been built up through the earlier contacts were important after the election for maintaining the spirit of cooperation and accommodation. The judicious and measured efforts to find working levels of agreement on difficult questions continued to characterize the approach that Keppel and Wilbur Cohen, then Assistant Secretary of HEW for Legislation, used with the private groups.

Without exception the participants in these negotiations credit Keppel's work with producing a series of "understandings" that developed into the basis for the church-state settlement; namely, that the aid money would go not to private and parochial *schools* but to the *children* of non-public schools based on a formula that reflected the number of children in a school district that came from families with incomes of less than $2,000 per year. Further, the formula would take into account how much money the state was providing for elementary and secondary education on a per capita basis at the time the formula was being applied.[3] In part, the theory was to reward those states already spending considerable portions of their resources on education as a means of stimulating the others to do likewise.

Keppel's acknowledged success as broker in these negotiations stems in part from what one participant called his "skills at deference." This same participant went on to say:

> He never made anyone feel he was shooting for the honor of authoring the first general aid bill. This was a magnificently orchestrated effort of many people of goodwill. The process was one of extended conferences aimed at achieving a legislative vehicle to which we could withhold objection. Furthermore, without request

[3] The formula in the bill provided for the federal government to pay a maximum of 50 per cent of the average per pupil expenditure in the state multiplied by the number of children in the district from low income families.

there was a high degree of self-restraint of every involved group plus very accurate assessments of each group by the other groups. The course of events resulted in a product with no prior commitments, and that is all.

By the time the bill was introduced all the formerly used pressure tactics were unnecessary. Our group gives credit for the bill from its origins to passage to absolutely nobody but the Administration and particularly Mr. Keppel.

One of the tools that Keppel used to great advantage during the course of the negotiations was his immediate access to the White House. He frequently called Douglass Cater and used his office for crucial meetings with one of the groups when he felt that the physical location in the White House would have a salutary effect on the people with whom he was meeting. The not too subtle moral was not lost on the participants; Francis Keppel was not a politically ineffectual commissioner, and he was handling the show for the President.

Wilber Cohen (who was appointed HEW Secretary in 1968) let Keppel take most of the initiative in the development of the bill. They kept each other informed of what each as doing, but it was essentially Keppel's affair until the bill reached Capitol Hill.

Through this period of meetings and negotiations the White House maintained its one concern: assurance that the bill finally introduced would not start the religious conflicts on the Hill. By the end of January 1965, Cater could report to the President that the basic conceptions of the bill had been agreed to by the major factions involved. No one, including Cater and Keppel, ever saw a draft bill throughout these meetings. In part this was a deliberate tactic not to have anything in writing that could cause misinterpretation and objection, or to give any of the participants any reason to feel that prior decisions had been reached before the consultation process had taken place; and

in part because the counsel's office in the Office of Education had not yet written the legislation.

The bill was actually drafted by Chester Relyea of the General Counsel's Office in the Department of Health, Education, and Welfare. Samuel Halperin, who was Acting Deputy Commissioner of Education in 1965, played an important role in the drafting of the bill as well—although Halperin's role became more visible after the bill reached the House on January 12.

On January 12, 1965, President Johnson set his long-awaited education message to Congress; and simultaneously Congressman Carl Perkins and Senator Wayne Morse introduced identical bills in the House and Senate respectively. The formal legislative process started to work on "a bill to strengthen and improve educational quality and educational opportunities in the Nation's elementary and secondary schools."

While the thorny church-state problem had been resolved in the Keppel negotiations with the private groups, it would be misleading to suggest that the bill faced no obstacles on its road through the House and Senate. Most of the attention has been focused on the church-state controversy, and with good reason; but once that issue had been settled outside Congress, the financing formula, poverty level questions, and matters of application all came to the fore. In many ways they were problems as difficult and as fraught with disaster for the bill as the more frequently discussed church-state issue.[4] It was at this stage that the categorical aids approach was open to attack. Title I of the proposed legisla-

[4] For an excellent account of the church-state resolution in the 1965 bill see Dean M. Kelley and George R. La Noue, "The Church-State Settlement in the Federal Aid to Education Act," *Religion and the Public Order, 1965*, An Annual Review of the Institute of Church and State of Villanova University, School of Law (Chicago: University of Chicago Press, 1966). Also see Staff Memorandum prepared in conjunction with the Office of Education explaining the development of the formula in HR 2362, pp. 1228–1232, Subcommittee Hearings.

tion disbursed funds to children in certain categories (in fact the 1965 bill's Title I is an amendment to the Federal Impacted Areas Bill of 1950—Public Law 874 of the Eighty first Congress).[5] The low-income family child-aid was of course the key to the 1965 approach.

The Administration people most involved with the 1965 school aid bill credit Senator Wayne Morse and Senate Labor Subcommittee staff director Charles Lee with tying the 1965 bill to the poverty approach. They also credit this uniting of approaches with maintaining the political viability of the 1965 bill during its most trying moments on the Hill.

It is important to point out that while the poverty level approach enhanced the chances of passage for the 1965 bill, Morse and Lee had been advocating some form of poverty-child categorical aid since 1954.[6] The fact is that the categorical approach was appropriate to the political issues involved in general aid to education. It was at the level of the impoverished child that the most convincing case could be made for federal aid. For example, the President stressed this facet of the nation's educational needs in his message to Congress when he said, "Poverty has many roots, but the taproot is ignorance."

The point is that the bill that eventually passed in 1965 as the first general federal aid bill in the nation's history was in reality a categorical aids bill, albeit with extremely broad categories. A Democratic member of the House committee put it this way:

> The bill itself was really categorical aids with categories broad enough to resemble general aid. We made the categories so broad that the aid splattered over the

[5] This impacted area approach simply provided federal funds to alleviate the pressure on local school systems associated with large federal installations in various communities.

[6] On p. 344 of the 1966 Senate hearings (Part I) on elementary and secondary education legislation, Secretary of Health, Education, and Welfare John Gardner publically credited Senator Wayne Morse with devising the formula used in Title I of the 1965 Act.

face of the entire school system and could be called general aid in principle while politically remaining categorical aids.

In the end it does not matter much whether the 1965 bill is called categorical or general in any technical sense. What is important and interesting from our standpoint is that the participants in the federal aid fight in 1965 all acted as though and spoke as if the issue to be decided was whether the federal government would enter the field of general aid to education. Further, there was implicit in the attitude of the two sides the feeling that the outcome of the battle in 1965 would permanently settle the question.

The Republicans attacked the bill, in part, because they felt the Democrats were making claims for the bill that were not justified. Some Democrats on the committee were not happy with the way the bill was handled in Congress either. The dilemma for the Democrats who counted themselves as aid supporters was contained in the choice between supporting that which was being called a general aid bill, or resisting sections of the legislation they felt were technically inadequate, with the risk that major changes in the legislation would shake the uneasy coalition of supporters that had so painfully been put together via the Keppel negotiations.

This dilemma is dramatically illustrated in the case of a liberal Democrat on the committee from a district that does not benefit in any major way from the formula. This member comes from what he calls a "suburban, bedroom district with few families under the poverty line established in the bill. On the other hand the families in my district are paying a heavy price to maintain decent school facilities through the property tax, and the tax base just can't absorb very much more. Families continue to move to the suburbs, and they need help with school construction and improvement grants."

In pursuing what he obviously felt were his constituent's best interests, this member challenged the Administration on what he felt was the major inadequacy in the legislation:

that it did not make any distinction between a district with poor children in it and a poor or marginal district. This member's resistance caused considerable agitation in the White House, where the attitude had quickly developed that all good Democrats ought to swallow their technical objections to the bill in support of the federal aid principle. Indeed, so many particularistic objections were coming from members whom the Administration was counting on that Douglass Cater persuaded the President to address himself to the problem at a meeting in the White House on March 1, 1965 with representatives of the NEA. The President told the gathering in the East Room that, "the education bill we picked out can be improved." His theme was that the Eighty-ninth Congress had to make a commitment to the principle of federal aid and then later the act could be perfected. He used the analogy of the 1965 bill being like the model-T Ford which had been improved over the years.

The degree of pressure being generated by those opposed to the formula for some kind of change is forcefully clear in Chairman Perkins' response to Congressman James O'Hara's testimony that his district would suffer under the formula. Perkins' extraordinary reply was: "Let me state immediately after we dispose of this bill, I have been instructed to open up some hearings; and I intend to go into all of these problems and see if we cannot come up with some good answers."[7] Understand that this promise came before HR 2362 was even reported from the subcommittee.

In essence the Administration approach was, "look, we saved you from having to square off on the religious question; we have a bill that has the support of the major interest groups; all you have to do now is give us the one vote that gets the program off the ground. We will worry about altering the program at some future date."

With few exceptions this argument overcame all objections. As the member referred to above told us:

[7] "Hearings," op. cit., p. 953.

The President's remarks get to the heart of the issue that had been bothering a lot of people who counted themselves as supporters of the federal aid principle. As a consequence we just had to make the hard choice and face the reality that in 1965 the issue was not good education policy versus bad. The question Congress had to settle in 1965 was whether there was ever to be federal aid to the elementary and secondary schools of this nation.

He went on to say:

> The 1965 bill, in all candor, does not make much sense educationally; but it makes a hell of a lot of sense legally, politically, and constitutionally. This was a battle of principle, not substance, and that is the main reason I voted for it. If I could have written a bill that would have included provisions to meet the national interest in the education field it would not have been 89–10 [HR 2362 became Public Law 89–10 when it was enacted].

There was, in addition, considerable sentiment among committee Democrats to accept any formula that had been put together with the support of the interest groups. Since the committee members had accepted and even actively sought the Administration's aid in securing a church-state settlement before the bill came to Congress, there was considerable reluctance to do anything that would either upset that delicate balance or start a chain reaction of amendments (on the Hill) that would have the same effect.

The most important role the full Education and Labor Committee played in the education battle of 1965 was to keep the subcommittee bill essentially intact and to prevent any major defections among the majority members of the committee. The explicit operating proposition was that if any of the important members of the subcommittee had taken vocal and visible stands against the bill it would have been severely damaged on the floor of the House. It was generally acknowledged that, on the majority side, Perkins

(the subcommittee chairman), Brademas of Indiana, and Hugh Carey of New York fit this category. As long as they hung together the rest of the full committee's Democrats could go along.

The consequence of this expectation was simple yet dramatic. The Democrats on the committee not only tolerated the settlement of the religious issue that had been arrived at "downtown" but had actively sought such a settlement. Not many people of influence on the Hill wanted to touch the education bill in 1965 until they were assured that such a settlement had been made.

There is a firm belief that, had these agreements come undone (for whatever reason), the bill would have died in the House. While Congress is not usually the locus of the kind of negotiations we described above, the principal members of the committee involved (Perkins, Brademas, and Carey) were brought in to help the Administration get the kind of agreements they were after. Any solutions that were arrived at would be reflected in congressional interference. It was the fear of such hindrance and the resulting loss of a golden opportunity that kept people in line when they felt the merits of the bill did not justify their support.

Another lesson from all of this is that the huge Democratic majority was in one sense irrelevant to the people who had to carry the legislative ball. They approached the legislative task as if, in the words of one of the Office of Education's leading spokesmen on this issue, ". . . the coalition was some sort of Chinese puzzle. With everyone in line we're all right. If one left the reservation we would lose the entire thing." This view of how tenuous the congressional phase of the process would be led to the major tactical decisions taken by the Administration and its congressional leadership: 1) the bill would be considered in House subcommittee with care, but with speed; and 2) whatever legislation was finally reported from the subcommittee would become the legislative vehicle that *had* to be accepted *without substantial change* by the full committee, the House itself, and with no change in the Senate.

The "no amendment" decision apparently developed naturally out of the particular legislative conditions surrounding the bill but was formerly proposed as specific strategy in the Senate by Wayne Morse. The "no amendment" tactic and the speed with which the legislation was considered (the subcommittee spent exactly three weeks with the legislation) led some Republicans to refer to the bill as the "Railroad Act of 1965."

5

THE HOUSE ACTS

After the executive has initiated the consideration of a legislative program and a bill has been introduced, the Congress begins to play its part as an arena of decision. Congress is structured to consider each proposal in serial fashion through a number of formal stages, the decisions in each of which influences the choices at the succeeding level. Subcommittee, committee, pre-floor action, and floor decision are convenient division points. The provision for multiple consideration of legislation both within and between both houses of Congress not only reflects the legislative penchant for rehearing every question several times, but also accurately parallels the distribution of expertise and, in part, power within Congress.

Briefly, after introduction in the House, a bill is referred to a standing committee for consideration by its subcommittee and full committee. Being favorably reported (perhaps with a minority report attached) it goes to the Rules Committee after which it will be placed on a House calendar which will affect the scheduling of debate. Finally, having made it to the floor of the House, the bill will only be debated if the House approves a rule specifying the conditions of the debate (normally the rule recommended by the Rules Committee). Following debate the bill is either passed, defeated, or recommitted to the committee for further work. There are usually differences between the

House and Senate versions of the legislation, so a conference committee will be appointed by the Speaker (usually key members of the majority and minority on the standing committee of jurisdiction) to meet with their counterparts from the Senate to "iron out" the differences. After the conference committee has reached agreement, the conference report is returned to the two members for consideration.[1]

These formal stages of the legislative process do not begin to suggest the complexities of the normative structure within Congress or the distribution of power that informally has so much influence on the course of events. The importance of seniority, expertise, partisanship, constituency pressures, party leadership, Presidential leadership, collegial relations, and the social context of congressional life all blend in their own way with the formal structure to produce "the legislative process."

For tactical reasons the House of Representatives became the arena of first legislative decision for the education bill of 1965. As the story unfolds, the interrelationship of this network of variables in the legislative process will be illuminated.

The Perkins Subcommittee, 1965

GENERAL SUBCOMMITTEE ON EDUCATION OF THE
HOUSE COMMITTEE ON EDUCATION AND LABOR

Carl D. Perkins, Kentucky, Chairman

Democrats	*Republicans*
John Brademas (Ind.)	Charles E. Goodell (N.Y.)
Ralph J. Scott (N.C.)	John M. Ashbrook (Ohio)
Hugh L. Carey (N.Y.)	Alphonzo Bell (Calif.)
Frank Thompson, Jr. (N.J.)	
William D. Ford (Mich.)	

[1] See Lewis A. Froman, Jr., *The Congressional Process* (Boston: Little, Brown, 1967), for a detailed discussion of the role of the rules and procedures in Congress as an important independent force in the legislative policy process.

On January 22 the House General Subcommittee on Education began hearings into the Administration's education program, HR 2362. There is no doubt that the major issue before it was the formula for distributing funds to school districts. While the church-state question remained a potentially explosive matter, it had been effectively neutralized by the interest group agreements.

The poverty-level formula had to face the charge that it did nothing to equalize the allocation of resources for education between the rich and poor states. Edith Green (D. Ore.) argued that the formula had the perverse effect of rewarding those states that did more for their school programs, thus increasing inequities between rich and poor.

The Administration's response to this criticism, voiced by Commissioner Keppel, was that the formula was meant to reduce the inequities that existed in the educational opportunities available for children from depressed or poverty backgrounds. The bill was never meant to remove all such inequities and was never intended to remove inequities between rich states and poor states but rather to get at educational differences within states. That is, Title I, in which the poverty approach was spelled out, became an important political defense for the bill.

The major change that occurred in the legislation the Administration sent to the Hill altered the so-called child-benefit theory which was the mechanism for side-stepping the church-state confrontation. The legislative legerdemain under the child-benefit theory provided in the original bill that the federal funds would go directly from the Office of Education to the local school (private or public) to be used for the children within the school. In this way children rather than institutions were to be aided. The subcommittee amended this conception of the child-benefit theory to read, as former Deputy Commissioner of Education Samuel Halperin called it, "the Public-trustee theory." The alteration in the Administration bill provides that all funds go directly to a public agency for distribution at the local level.

In Titles II and III, which provided for "Library and Other Instructional Equipment" and "Supplementary Educational Centers and Services" respectively, the original bill had conceived of a consortium arrangement in which the public and private school authorities would be partners along with other interested participants in the communities to administer the federal aid. The subcommittee changed this to provide that *only* the public school authorities shall administer these funds. The question of what agency, private or public, would administer the grants at the state and local level was a question that touched on both the constitutionality issue and on the major Administration defense of the bill designed to help educationally deprived children.

The potential trap the Administration faced in defending this part of the bill is reflected in testimony dating from the first day's hearings when Wilbur Cohen contradicted what the Secretary of Health, Education, and Welfare Anthony Celebrezze had said. Republican subcommittee member Charles Goodell (R. N.Y.) quoted Chairman Perkins as having asked, "Isn't it true that the aid goes to the pupil and not to the school?"; to which Cohen had indicated that the bill allowed the direct granting of funds to purchase texts to the local school or library. On January 28, Chairman Perkins had vainly tried to keep Goodell from pressing this point when he told Goodell, ". . . clearly, what Mr. Cohen stated—who was not the regular witness—was a slip of the tongue."[2]

Later in the subcommittee's proceedings, Frank Thompson (D. N.J.) had indicated the majority's willingness to correct the apparent inconsistency. He told one witness:

> There needs to be a clarification with respect to the title to the books. I would think the committee in its executive sessions would make perfectly clear that the

[2] "Hearings Before the General Subcommittee on Education of the Committee on Education and Labor, House of Representatives," Eighty-ninth Congress, First Session, on HR 2361 and 2362, p. 749.

title to the books *rests in the public agency and they are loaned as a service.* [Emphasis added.][3]

Congressman Carey (D. N.Y.) had already added his assurance that he had no objection to the principle of public ownership and control:

I do not feel that as to the non-public school students, that ownership of the materials or anything involved in this bill would be a vital issue, I favor public proprietary ownership of these materials to resolve any doubt of that kind.

Mr. Howard M. Squadron of the American Jewish Congress was seriously worried over the language in Titles I, II, and III. He told the subcommittee that, "Establishment of a universal free public school system has been one of the greatest contributions of our American democracy. It would be gravely threatened by the provisions of this bill."[4]

The fear that some liberals had about the constitutionality of Titles I, II, and/or III was expressed in their desire to have a judicial review section added to the legislation. The issue was a basic one. If the essence of Titles I, II, and III was to stand, then the groups that had traditionally opposed any aid for private education wanted a clause added to the legislation that would give a taxpayer sufficient standing to challenge the constitutionality of the legislation in the federal courts. In 1922 the Supreme Court had said that taxpayers with no other vested interest than their share of the tax dollar do not have sufficient standing to challenge the constitutionality of a federal appropriation.[5] It should be noted that this position of the Court subsequently was altered by a 1968 decision. But in 1965 one had to assume

[3] *Ibid.*, p. 1511.
[4] *Ibid.*, p. 1537.
[5] Frothingham v. Mellon, 1922. 1967 and 1968 decisions by the Supreme Court, however, changed the Court's attitude toward tax-payers' suits.

that the position taken by the court in 1922 was still in effect.

The Administration saw the effort by people like Mrs. Edith Green to get a judicial review section added to the legislation as a "divide and conquer" tactic. It was clear that the judicial review section was repugnant to the parochial school interests and was clearly the one amendment which could have split the bill's coalition of supporters asunder.

Mrs. Green maintained that a judicial review section was necessary to protect the bill. Her proposed amendment, which became the focus of the conflict, did not propose to let *any* taxpayer bring suit, but rather would have permitted individual school districts that felt they had been badly treated by the allocation process to have the question resolved in the courts. The climax of the Green fight to get judicial review added to the legislation did not come until the final night of debate on the floor of the House, but the issue did flair up in the subcommittee first when Commissioner Keppel declared that the matter was one for Congress alone to settle.[6]

Republican subcommittee member Charles Goodell and other critics of the Administration bill also raised the specter of federal control. The issue of whether proposed education legislation was going to open the door to "federal control" of the educational process at the state and local level had always been a focal point for those who resisted federal aid. The Southern Democrats who stood foursquare behind the concept of state's rights and the Republicans who campaigned on the need for returning governmental responsibility to the state and local level were always ready to fight federal aid on this issue.

The subcommittee did amend the Administration bill to square with objections of those who felt that public ownership and control was not assured in the original draft. This

[6] "Hearings," *op. cit.*, pp. 1740–1742.

change was obviously the most important from a constitutional view; but there was another major change—one of a technical sort but one which, nonetheless, reflected the temerity with which any amendment or change was approached by the bill's advocates.

The formula placed the poverty line at such a low level ($2,000) that it fell below the level of support some states were providing families on welfare. In a state like New York there were thousands of youngsters in families that subsisted on incomes of more than $2,000 per year from welfare payments, but they would not be included in the count for the formula in Title I.

Congressman Roman Pucinski (D. Chicago), a member of the full committee but not a member of the subcommittee, was the most forceful proponent of changing the formula to include not only children from families with incomes of less than $2,000 per year but all children from families on welfare regardless of how large the welfare payment might be.

This suggestion did not bother the bill's authors in principle. It would, however, cause an increase in funds that would be required to pay for the expanded numbers. The estimates were that this change would add $200 million to the authorization for the program.

When the President's budget was being prepared, $1 billion was allotted for the elementary program. This was given to the Democratic leadership as a rather strict limit given the expected rise in the costs of the Vietnam conflict. Chairman Powell and Pucinski and Cater got the President's approval for the budget increase when it was made clear that this change would preserve the coalition. As told by personnel in the Office of Education, the issue here was not so critical in real terms as it was symbolically. The White House did not want any significant defection from the coalition on the ground that an Administration steamroller was pushing the bill through without concern for what was being passed. Cater and the others knew they would get this

charge from the Republicans and they feared that one significant Democrat from a large Northern city (Pucinski) joining with the Republicans in this assertion could spell disaster for the bill.

In addition, by adopting the change, the Administration removed one substantive issue from the hands of the bill's critics. Goodell had already indicated early in the subcommittee proceedings that he was going to hammer at the exclusionary nature of the formula.

> . . . Some way we may have to devise a formula for coordinating into that a measurement of those on welfare.
>
> I do not know how it can be done. It does not quite seem right to set up a formula supposedly to help the children of the families on welfare in the area. That is a little contradictory.[7]

So it was that some changes were made at the subcommittee level. The issues that faced the subcommittee as it moved to executive session to report a bill to the full committee were varied. The tactical problem for the Democrats was to maintain the essence of the Administration bill that had the support of the major factions while not being so rigid as to lose any key committee Democrats. In many ways the high level of cooperation that seemed to characterize much of the subcommittee proceedings was illusory. At least there was evidence of how sensitive everyone was to the fragile nature of the coalition. This feature of the issue was a dominant theme in all of our interviews with people who worked to get the bill passed.

Late in the proceedings the calm was shattered when Hugh Carey of New York accused the American Civil Liberties Union witness, Mr. Lawrence Speiser, of having issued an "ultimatum to the committee" to the effect that they would oppose the legislation were certain changes not

[7] *Ibid.*, p. 955.

made.[8] Mr. Speiser objected that he was not offering any ultimatum but was rather representing the views of the ACLU and offering these views to the committee. Carey's rejoinder reflected the strategy that the bill's advocates were applying all through the hearings and the floor debate. Any witness or group that questioned the legislation was promptly told that he was somehow in violation of an important consensus in support of the Administration bill. There was no question in Congressman Carey's mind how seriously the ACLU's position was to be taken in the "year of the consensus," and he wasted no time in getting the message across.[9]

SUBCOMMITTEE MARK-UP

As the subcommittee went into mark-up sessions, the constitutional, legal, and substantive reservations which divided the Democrats faded into the background in the face of organized opposition of the minority party.[10] Charles Goodell was the principal spokesman for the minority throughout the subcommittee's hearings. Looking over the

[8] Titles II and III, in which the question of public ownership of materials used for textbooks and supplementary centers had been raised, was the focus of the issue. The Supreme Court had said in Cochran v. Board of Education, 281 US 370 (1930) and Everson v. Board of Education, 330 US 1 (1947) that shared time programs (in which private school students used public facilities or vice versa for part of the day) were constitutional if the program had a public rather than religious purpose, if the expenditure of public funds was under public control, and if there was no arbitrary or unreasonable discrimination in making the service or program available.

The ACLU was endorsing the shared-time concept, but objecting to Titles I and II.

[9] See "Hearings," op. cit., p. 1701, for Carey's statement.

[10] Mark-up sessions are closed-door meetings of the subcommittee or full committee at which final decisions on the content of the bill to be reported are taken. Often a "clean" bill

two thick volumes of subcommittee testimony it is hard to believe that any other member of the committee was present at more sessions.

Goodell lost no opportunity to drive home two points. First, he was attempting to show that the Administration and its committee leadership had conspired to push the bill through the Congress with barely enough time for the legislative amenities to be observed. Second, he was consciously building a history of opposition to the legislation on the several constitutional and legal objections that were being made to the bill. Goodell and his Republican colleagues were looking to the future when the bill was to be administered and the Office of Education would need to know the intent of Congress on important points, or when the federal courts might want to know the intricacies of the congressional debate before making a constitutional judgment on the bill; further, the Republicans wanted their record to be clear for political purposes for the congressional campaigns in 1966.

The answer to the charge of too much speed was inevitably that elementary and secondary education legislation needed to pass Congress even if it meant that it had to pass with some imperfections. There would be time for reconsideration at a later date. The closest anyone came to saying this in public was Andrew Biemiller, the chief lobbyist for the AFL-CIO and former member of Congress from Milwaukee, Wisconsin, who told the subcommittee on January 29:

> I repeat . . . let's get started . . . and get a bill through here, and begin to get some money into our school systems where we now know it is badly needed, and then we can take another good look and get closer

is introduced after all changes have been made, and the new bill receives a new number for purposes of placing it on the House Calendar.

to the goal that both you and I want; and we make no
bones about it, that we want a general education bill.[11]

At 8:45 P.M. on the evening of February 2, exactly twelve
days after the hearings began, Chairman Perkins announced
that the hearings had come to a close and that the first
mark-up session would begin the next morning at 10 A.M.

Goodell was angered that Perkins did not allow enough
time for witnesses favorable to the minority to be heard.
Goodell insisted that he had twenty-eight witnesses to call,
and they had to be crammed into the last day. Interestingly,
Goodell does not blame Perkins personally for this state of
affairs so much as he does the White House who, he main-
tains, was issuing the marching orders.

Goodell's personal position on the bill was a matter of
some moment. First of all, as the ranking minority member
of the education subcommittee he would handle much of
the floor debate for the Republicans when the bill reached
the House itself. Second, he was on something of a spot
because he had defended the higher education bill that
had passed in 1962 and which included the concept of aid-
ing students of private educational institutions. Goodell,
however, was opposed to the bill on the several grounds
already discussed, and adopted his legislative strategy to
meet "the inevitability of the bill's passage." The only time
Congress or one of its working groups made any funda-
mental changes in the bill was in the House subcommittee
mark-up session. As we indicated, the "public ownership"
issue was clarified in Titles II and III.

The Republicans boycotted the mark-up session as a sym-
bolic gesture to the futility of their having an impact on the
decisions that were about to be taken. They wanted to make
their protest clear and visible, and the boycott was their
tactic. Goodell said the boycott was a protest to the "hasty
and superficial" consideration given the bill in subcom-
mittee. On February 5 the bill was reported out of subcom-

[11] *Ibid.*, p. 977.

mittee with the above changes, and the full committee
began its consideration of the legislation.

Full Committee

The issues had been drawn in subcommittee. The deci-
sions had been taken in subcommittee mark-up. There was
little for the full committee to do but go through the
formalities. The qualified "no amendment" strategy was now
in full effect, and the Democrats were holding firm. The
bill and its coalition had survived its ordeal of close scrutiny
in the subcommittee and no one close to the education
issue was willing to risk losing the bill at the full committee
stage.

Some of the divisions of personality and party that plague
the Education and Labor Committee became visible at the
full committee stage. The story of Representative Edith
Green is relevant at this point. Mrs. Green had generally
been identified with those who supported the concept of
federal aid to elementary and secondary education. Indeed,
she did vote for the 1965 bill, but not until she had become
the focus of the most bitter personal animosity directed at
anyone during this bill's course through Congress.

Mrs. Green quickly came to support the position that a
judicial review amendment was required to maintain the
equity of the allocation process, and that the formula needed
to be amended to distribute the funds more directly to the
poor districts. She began to assert herself at the full com-
mittee sessions and quickly found herself articulating the
Republican position on these points. It never became clear
whether any organized cooperation developed between
Goodell, Albert Quie (R. Minn.), and Mrs. Green. It really
does not matter since the Democratic leadership and the
White House assumed she was organizing an effort with the
Republicans to sabotage the legislation, and responded ac-
cordingly. As one minority staff member of the House Com-

mittee put it: "There was no conscious Republican decision to exploit her dissidence, but we did agree that we would withdraw our amendments to the formula and let her introduce hers. We would support her amendments. In effect we made the decision to let her carry the ball for us whenever she wanted to."

A close associate of Mrs. Green's during 1965 said that she finally became disposed to cooperate with Goodell and Quie when she was made aware of the "no amendment" rule. This person characterized her relationship with the Republicans on the full committee as a "terrible irony . . . since it produced the sight of her working with people she never would have nodded to previously. It permanently damaged her effectiveness on the committee."[12]

Mrs. Green was compelled to push ahead with her fight to "improve the legislation." In the middle of March she sent a high-ranking Administration official a letter outlining her feelings about the bill:

> I hope I do not need to tell you of my own commitment to good education and my own conviction that there must be an increasing amount of aid on the part of the Federal government. I have supported almost

[12] This same respondent told us that Mrs. Green's persistent opposition to the bill:

. . . resulted in her estrangement from many people and groups. The USCC of which she was never very fond still does not speak to her or have anything to do with her office. By the way, many of the people around here, including some of her colleagues on the Subcommittee think her basic opposition to the bill was a deep seated anti-Catholicism . . . I do not.

Much more poignant was her breaking off of relations with the National Council of Churches. She had been a long-time and active member of the NCC, but she went after them tooth and nail for their support of the bill. She also was in the strange position of accepting support from and dealing with the Southern Baptist organizations which had been anathema to her previously.

every piece of education legislation during the Eisen-
hower and Kennedy years. It would pain me deeply to
have to oppose any education bill of the Johnson Ad-
ministration. As I told you, I am concerned not only
about the judicial review but a formula which seems to
be inequitable. I am also convinced that there is a way
in which we could accomplish all of the objectives of
this legislation—believing firmly that where there is a
will there is a way.

The Administration's concern with Mrs. Green was not
her single potential "no" vote. There was fear that her stand
would begin to take on symbolic meaning for many of the
liberal Democrats who were opposed to some parts of the
legislation but had been willing to adopt the Administration
strategy.

When the bill got to the full committee, the Office of
Education asked only one thing of Chairman Powell: that
he keep the subcommittee bill intact and not let Mrs.
Green's efforts get lengthy consideration. We were told
that "by and large he did a beautiful job of this." Ap-
parently the closest the majority came to falling apart in the
full committee was over the addition of welfare children to
the rolls for purposes of computing the formula. Pucinski
and others were fighting hard on this point, and they were
finally successful when the Administration supported the
change. It was the last significant change that was to be
made in the bill on its way to the President's desk for sig-
nature.

FULL COMMITTEE MARK-UP

The Republican view of the full committee's mark-up
sessions was one of total futility in the face of overwhelming
numbers. One Republican member of the committee re-
ported that he could not recall more than five Democrats
at any time supporting any amendment that was offered by
either Republican or Democrat.

In the full committee, according to this respondent, Carey and Pucinski carried the ball for the parochial school interests, just as Carey did in the subcommittee. He pointed out that members seemed to be avoiding the use of the word "Catholic" in favor of phrases like "parochial schools," "excluded groups," and the like, the theory being, the less specific the focus the less the likelihood of fireworks.

The full committee began its mark-up sessions on February 25, and on March 2 HR 2362 was reported from the full committee by a 23 to 8 vote. It was at this point that Powell delayed the proceedings, to the anger of the Administration and his Democratic colleagues, by taking a vacation at his Caribbean retreat on the island of Bimini.

The Republican Alternative

On March 8 the Committee report on HR 2362 was issued. That same day at 2 P.M., Congressmen Goodell, Ayres (R. Ohio and ranking minority member of the full committee), Thomas Curtis (R. Mo.), Quie of Minnesota, and Andrews of Alabama introduced their alternative proposal to HR 2362.

The minority leadership is not saddled with the substantive and mechanical responsibilities of congressional housekeeping. Hence it is allowed more time to shape its party's responses to the initiatives of the Administration and majority. Given the nature of the legislative process, the simplest and often most effective strategy for the minority is obstructionism. Obviously the minority's task is infinitely more difficult if it chooses to promote its own policy alternatives.

Frequently in the last thirty-six years, House Republicans have assumed the task of serving as the "king's loyal opposition." But this is a role which has been unpleasant for a good many members—especially the younger ones. Whether the Republicans have liked it or not, their minority status

has contributed to a negative image of the party. At least this is the impression of many House members. One GOP congressman described the problem by saying, "for years the people have known what the Republicans oppose, but if we ever want to become a majority party, they must know what programs we favor." In assessing the devastation of 1964, many House Republicans concluded that popular rejection was due to an image of "blind opposition."

The party's negative image became a major issue in Gerald Ford's campaign to unseat Charles Halleck as minority leader. After the leadership change, it was necessary for Ford and his chief lieutenants (most notably Goodell, Quie, and Griffin) to start developing a new positive posture. The elementary and secondary education bill was their first opportunity to present an alternative to a major administration program. Of course most Democrats were not impressed with the Republicans' efforts to accentuate the positive, and they later dubbed the new GOP proposals Constructive Republican Alternative Proposals, or CRAP!

This new strategy prevented the minority members of the Education and Labor Committee (especially Goodell, Quie, and Griffin) from dismissing the school bill out of hand or from challenging the basic concept of federal aid. From the start, Republicans attempted to make it clear that they did not disagree with the majority on the need for school assistance but rather were taking issue with the means proposed in HR 2362.

On February 5, the same day that HR 2362 was reported from subcommittee, Charles Goodell held an informal meeting in his office to discuss the minority views. Present at the meeting were Goodell, Quie, Griffin, and Charles Radcliffe, minority counsel for education on the Education and Labor Committee. Since Radcliffe was in charge of drafting the views, most of the time was devoted to offering him suggestions. There was no decision at this time on a specific policy alternative; however, there was agreement that the following points should be stressed in the report: 1) the

allocation formula of HR 2362 should be attacked for not providing enough assistance to impoverished areas; 2) the bill would transfer too much authority from the local level to the Office of Education; and 3) the bill would ignore certain obvious education needs especially in the area of preschool training.

Armed with these suggestions, Radcliffe set to work preparing the minority views while Goodell consulted additional Republicans on the proposed alternative. As the ranking minority member of the Perkins subcommittee, Goodell was in charge of coordinating the minority efforts; however, he periodically conferred with William Ayres, the ranking Republican on the full committee.

A week after the Goodell meeting, Ayres called a strategy session of all committee Republicans. At this meeting Goodell suggested that the alternative be based upon a tax credit plan. Ayres said that regardless of the nature of the proposal the Republicans should not appear to be ignoring school needs nor should they go out of their way to alienate the Catholics who were supporting HR 2362. He said, "We cannot let them [the Democrats] put us in the position of coming out foursquare against the Catholics." Goodell pointed out that the tax credit would apply to everyone paying local school taxes, including Catholics, and therefore the proposal could be viewed as an indirect form of assistance to those sending children to parochial school. Yet it would avoid the constitutional issue of church and state.

On March 8, the same day the committee report was issued, Congressmen Goodell, Ayres, and Thomas Curtis (from Missouri—the second ranking Republican on the Ways and Means Committee) called a press conference and announced a new "Education Incentive Act" which they said was designed to give the nation's families relief from state and local school taxes.

The first part of the Republican proposal was a provision called the National Equal Education Drive (NEED) which

allowed $300 million in direct grants to the states to provide preschool training to children between the ages of 3 and 7 from families of $3,000 income and less. In addition, the proposal included a tax credit of up to $100 based upon the amount paid in local school taxes and a tax credit up to $325 per student to families with children enrolled in college. In the event a taxpayer was unable to claim a tax credit, the proposal authorized the secretary of HEW to make a direct cash payment equal to one-half the school taxes paid by them, up to a maximum of $100.

The Republicans announced to the press that they would ask the Rules Committee to withhold a rule on HR 2362 until the Ways and Means Committee had a chance to review the proposal. They pointed out that their bill would require action by both the Education and Labor and the Ways and Means Committees, but that this type of joint committee action had been previously used on the Interstate Highway Act and the Manpower Retraining Program.

At this point the Republicans were no longer simply opposing the Administration bill, they now had an alternative that would become a focal point of important choices the House would make within the month.

The Democratic leadership saw the Republican proposal as no more than an effort to delay the Administration bill. The Democrats believed that Congressman Ayres had talked to Chairman Howard Smith of the Rules Committee asking him to hold off on hearings on HR 2362 until the new Republican program was considered by the Education and Labor Committee. The implication was that Smith had told Ayres he would cooperate with such a plan.

By 6 p.m. of March 8 the Democrats on the Education and Labor Committee had met to consider procedures to rebuff the Republican education plan. Perkins, Thompson (D. N.J.), O'Hara of Michigan, Brademas of Indiana, and Ford (D. Mich.) issued a rebuttal statement. Their statement called the Republican alternative a mostly warmed-over

Goldwater proposal left over from the campaign. Titles II, III, and IV were attacked as having been repeatedly advocated by the defeated Presidential candidate.

THE DSG ACTS

The next day, March 9, at 3 P.M., there was a briefing on the education bill for members of the Democratic Study Group. It was estimated that about ninety members (out of a reported one hundred eighty members) were present. The briefing informed the Democratic Study Group of what was included in the committee bill. After formal presentations by several members of the Education and Labor Committee there was a question and answer session which lasted over an hour.

A staff member from the Administration present at the meeting concluded in a report to his boss that there was

> practically no support among the DSG for Edith Green and her proposed amendments. My only concern here is the Catholic-public school factor which could keep information on real feelings from surfacing. However, I will continue to "nose" around to see what I can uncover. After the above meeting, I talked individually with the members of the committee and received some answers to key questions other members are asking. I believe that we are all right if we can move the bill along without too much delay.

This same Administration aide followed this memo with another, summing up his view of where the bill stood before it entered the next critical stage—the Rules Committee, chaired by Congressman Howard Smith, addressed as "Judge" since his court days in Virginia:

> Judge Smith is being nudged by the leadership to hold a Committee meeting and report out the educa-

tion bill, but he is going through his usual deliberate speed moves. He just got the Committee report and claims he and others need time to study it etc.

The expectation is that Smith will call a hearing sometime next week—after he finds out he'll be outvoted anyway—and the guess in the House is that the bill will reach the floor either during the week of March 22, or March 29.

The reporters who have been following this bill very closely are cautiously optimistic about chances for passage. Their caution comes from past history when chances also looked good—1960 for example. Their optimism comes from the fact that the USCC and the NCC are together on this bill. Even those Jewish groups and the ACLU who had grave misgivings about the bill are less adamant about their positions since the Committee changes.

Among the Committee Democrats, the main ones unhappy about the bill are Edith Green and Sam Gibbons of Tampa. I am told that Gibbons' unhappiness stems from the HEW figures that show there are more poor kids in St. Petersburg then there are in Tampa. He doesn't believe it. Both he and Mrs. Green voted for the bill in Committee.

The idea of providing for a court review clause in the bill would be opposed by the Catholics, I am told, but not to the extent that it would kill the bill.

The Republican opposition to the bill apparently will be based on attacking the aid formula—with the contention that poor counties won't be helped as much as the rich counties.

The Rules Committee

Normally, considerable significance is attached to the Rules Committee and its role on controversial pieces of legisla-

tion.[13] However, with the rules changes and the enlargement of the Rules Committee, this seemed to be but another pro forma stage in the House consideration of HR 2362.

Technically, the Rules Committee makes a series of procedural decisions regarding the length of time that will be devoted to general debate, whether a bill can be amended, and the conditions under which proposed amendments will be considered.[14] In fact, the events that normally occur in the Rules Committee before a major and controversial bill reaches the floor for general debate constitute a microcosm of the impending larger debate. While the decisions the Rules Committee makes regarding the conditions of debate are procedural, it is clear that the lines that will divide the House over the issue are reflected within the committee. The questions that are asked and the committee's willingness to speed the course of the legislation or delay it are all judgments that follow an assessment of the merits of the bill. In many ways the testimony that is taken in the Rules Committee is a repetition of the arguments and questions that have been raised when the bill was in subcommittee and full committee. Consequently, one can get an idea of what the impending floor action will look like by following the Rules Committee's deliberations. Its proceedings, therefore, were of considerable interest to the principal proponents and opponents of the 1965 education bill, even though the new rules that the House had adopted two-and-a-half months earlier had assured that the bill would not be pigeonholed in the Rules Committee.[15]

[13] See "The Enlarged Rules Committee," by Robert L. Peabody and "The Decision to Enlarge the Committee on Rule: An Analysis of the 1961 Vote," by Milton C. Cummings, Jr., and Robert L. Peabody in Polsby and Peabody, eds., *New Perspectives on the House of Representatives* (Chicago: Rand McNally, 1963), pp. 129–195.

[14] See James A. Robinson, *The House Committee on Rules,* (Indianapolis: Bobbs-Merrill, 1964), for a comprehensive discussion of the committee and its powers from 1937–1962.

[15] See Chapter II for a discussion of the new rules adopted at the opening of the Eighty-ninth Congress, Before the Eighty-

THE RULE: THE STRUCTURE OF HOUSE DEBATE

On the afternoon of Monday, March 22, the Rules Committee reported House Resolution 285 (the proposed rule defining the terms of the debate for HR 2362) to the House by a vote of 8 to 7, calling for six hours of general debate to be equally divided and controlled by the chairman and ranking minority member of the Education and Labor Committee. When general debate was concluded the resolution called for amendments to be considered under the five-minute rule, which meant that each member could debate each amendment for five minutes.

The rule also routinely provided for the consideration of HR 2362 by the House in its smaller parliamentary entity known as the Committee of the Whole House on the State of the Union. This legislative "masquerade," as a close student of Congress once called it, enables the House

ninth Congress (and as it turned out immediately after it, because the Ninetieth Congress rejected the twenty-one- and seven-day rules), there were two principal mechanisms available to the majority party leadership to move a bill from a recalcitrant committee to the floor of the House: the Discharge Petition and Calendar Wednesday. Under its present operation, a petition with a majority of the members of the House signing (218) can compel a committee to send a bill directly to the House. A discharge petition cannot be initiated until a bill has been in a standing committee for thirty calendar days or in the Rules Committee for seven calendar days. The Calendar Wednesday procedure provides that each Wednesday the roll of the House committees will be called alphabetically, with the committees allowed to bring forth any bill earlier reported that lacks privileged status. Both the Discharge Petition and Calendar Wednesday, however, are ineffective techniques in real terms. The history of both rules shows that they are rarely invoked, and even less frequently successful.

Generally speaking the House is very reluctant to take any action that compromises the integrity of its standing committee, and surely there are few things more compromising to a committee than to lose control over its docket.

to hold general debate on legislation under more liberal quorum requirements than is the case when it meets as the House of Representatives.[16] Roll call votes and final passage decisions are taken in the House of Representatives with a majority of the members constituting a quorum.

The legislative work leading up to a final passage vote (general debate, debate on amendments, and votes on amendments) takes place in the Committee of the Whole House on the State of the Union under whose rules only one hundred members need be present to maintain a quorum. Furthermore, in the Committee of the Whole House no roll call votes are taken. Votes on amendments are taken either by voice, standing division, or teller methods. In the voice vote the yeas and nays are heard by the chairman, and he rules on the majority. Any member can call for a division of the House if he doubts the outcome of the voice vote. In this case the members on each side of the question simply stand and are "counted" by the chairman. The most visible of the amendment votes is the teller method. Here each member on the aye side of the question walks between a pair of tellers representing both sides of the issue who report the results of their count to the chair. Similarly the nay votes parade through the teller lines and the results are then announced from the chair.

When the Committee of the Whole House has completed its business, the bill with all amendments is then reported to the House itself. The rule on HR 2362 provided, as is usually the case, that the House could take a separate vote on any amendments adopted in the committee on the demand of any member of the House. Finally, the rule provided, again as is typical, that the House could entertain one motion before final passage to recommit the bill to the Education and Labor Committee with or without specific instructions as to how the committee should proceed. It was clear that the Republicans would make a motion to

[16] Bertram M. Gross, *The Legislative Struggle* (New York: McGraw-Hill, 1953), p. 338.

recommit the Administration bill with specific instructions
to the Education and Labor Committee to report back the
Republican substitute.

The Role of Party Leadership

At the point the legislation entered the Rules Committee's
jurisdiction the party leadership in the House became more
visible and active than it had been to this point in the
process. Essentially, party leadership in the House plays
a broker's role between the various elements in the legis-
lative environment trying to influence congressional deci-
sions. At times the role of broker takes the form of acting
as liaison between two or more factions. On other occa-
sions the role calls for the active participation of the
leadership in the bargaining among and between the rank
and file party members, the White House, senior committee
personnel, and private groups seeking to fix common grounds
of action.

The explanation for why party leadership has this role to
play lies in the complexity of the Congress itself. There is
simply no other place within the congressional system
where as much is expected or demanded in the way of
centralized information about what is going on. As a con-
sequence members tend to provide the party leadership
with the kind of information that is necessary for it to do
its job.

The offices of party leaders are constantly being visited
by other members, staffers, reporters, and representatives of
the executive branch and private groups as each offers and
seeks information on coming events and explanations for
past occurrences. Through subcommittee and full committee
hearings, the Democratic leadership (Speaker McCormack,
Majority Leader Albert, and Majority Whip Boggs) acted
almost exclusively as liaison between the House Democrats
and the White House. The nature of work distribution in
Congress and the evolved role of party leadership over the

past fifty-nine years have placed such autonomy on the proceedings of the standing committees that no leader would presume to attempt to take control of the internal committee process.

On the third day the bill was in the Rules Committee (March 18), Hale Boggs (D. La.) sent a "whip notice" at the request of the Speaker to all Democrats in the House informing them of the business of the House for the week of March 22. Among the items listed, HR 2362 was scheduled for Tuesday and the balance of the week.[17]

The formal announcement of the scheduling of HR 2362 for House consideration set in motion a series of events preliminary to formal debate on the bill.

The first business of the Democratic leadership was to begin assessing the level of support among House Democrats on the legislation. The House organization available to the leadership for making such assessments is the whip office. Hale Boggs has a full-time staff of one secretary and an administrative assistant in the whip office. The House Democrats are divided into seventeen geographic zones. There is some effort to create zones that are geographically contiguous, but the most pertinent factor is that a zone's leading member—the assistant whip or zone leader—be reasonably happy with its membership. The seventeen assistant whips or zone leaders are selected by a variety of devices ranging from the application of the seniority rule to election by the zone members.[18]

[17] The other business the House dealt with the week of March 22, 1965, was as follows:
1. HR 5688 Omnibus Anti-Crime Bill for the District of Columbia
2. HR 5721 Tobacco Acreage-Poundage Marketing Quotas
3. HR —— 1966 Appropriations District of Columbia
[18] A complete description of the whip systems for both Democrats and Republicans in the House can be found in Randall B. Ripley, "The Party Whip Organizations in the United States House of Representatives," *American Political Science Review* (September 1964), 561–576.

In operational terms the whip systems provide an administrative mechanism through which relatively hard information about voting intentions can be secured for each party. The network of communication channels through which information is passed in Congress is complex and subtle. It is difficult to know with assurance, even under the best of circumstances, how a floor fight is going to turn out.

The whip mechanism can provide gross indications of whether legislation is assured of passage or defeat, or is in an uncertain condition. It can pinpoint some individuals or delegations with serious reservations. But it cannot, because of the shifting conditions of legislative politics, provide precise, immutable data. In part this is the case because the parliamentary conditions under which votes are taken, as well as the substance of the issues involved, can alter the voting patterns of members of the House.[19]

The polling process on HR 2362 for the Democratic leadership lasted several days. It began with Speaker John McCormack instructing Democratic Whip Boggs to take a poll of the membership. Boggs's staff placed phone calls to the seventeen assistant whips who assumed responsibility for polling the individuals in their zones. The assistant whips were told that the whip's office would like some reports within twenty-four hours. By March 22, the whip's office had indications that on final passage, if the bill remained in the form that it was in as it came out of committee, an estimated two-hundred Democrats would vote for the legislation. The whip poll showed 173 firm "yes votes," 18 "noes," 16 "leaning for," 6 "leaning against," 24 "undecided," and 58 not reported.

At 2:00 P.M. on Tuesday the twenty-third, a meeting of the Democratic leadership was convened in Speaker McCormack's office to discuss floor strategy for the bill. At that meeting Lawrence O'Brien, then special assistant to the Pres-

[19] Lewis A. Froman, Jr. and Randall B. Ripley, "Conditions for Party Leadership: The Case of the House Democrats," *American Political Science Review* (March 1965), 52–63.

ident for congressional relations, reported that the White House poll of Democrats showed 225 "yes votes." O'Brien also reported that the National Education Association had its members polling Congress, and they had been told by 255 House Democrats that they would support the committee bill.

There is a lesson to be drawn from these figures. The further removed the polling source was from the House membership, the larger the number of supporters they had reporting. This indicates that some members are more inclined to give noncongressional types reason to believe they have their support when in fact they are undecided or opposed; or as is more likely, it may reflect the pollers' willingness to accept partial endorsement as complete support. The Democratic whip polls are very conservative. Unless a member has given specific assurance of his support, his name is recorded as opposed or undecided. It has been said that a man's word is the coin of exchange in Congress.

When the official whip organization is polling, members are not likely to say they will support a bill unless they are prepared to make a strong commitment. In the absence of such a commitment the member is likely to reply that he is undecided or opposed.

After the polls were compared it was quickly agreed that the issue was not final passage anyway. The leadership again reviewed their fears of the bill being crippled by any one of several amendments that were to be offered by Edith Green or the Republican leadership. The Speaker made the point that the problem facing the leadership was making sure enough Democrats stayed on the floor during the amendment votes. Members might be opposed to the bill on final passage but willing to take the Administration position on the amendments. Often the less visible amendment votes afford members the flexibility to cooperate with the leadership while it is understood that the member will vote against the bill on final passage.

The question was raised of having several names in "re-

serve," that is, making available certain members who would
support the Administration position of their votes were de-
cisive. It was agreed that the vote was not going to be close
on final passage, and therefore it would not be necessary to
secure any such "reserves" on this bill. The question was,
could the leadership prevent the committee's bill from being
amended.

The Speaker asked Boggs to call a highly unusual meeting
of the assistant whips for Thursday morning to inform them
of just how important the amendment stage would be. Ma-
jority Leader Albert told Boggs that he would attend the
meeting to talk to the assistant whips.

Ray Madden was asked by the Speaker to convene a meet-
ing of the steering committee, which represents the Dem-
ocratic caucus in the House, in order to enlist its services
in keeping Democrats on the floor during amendment vot-
ing. This also was an unusual move. Congressman Spark
Matsunaga of Hawaii, the secretary of the Steering Com-
mittee, was to send out a letter to all Democrats urging their
support of the education bill.

In addition it was decided that a telegram would go out
over the leadership's names to all Democrats who had al-
ready indicated their support, requesting their attendance.
Normally, the leadership sent telegrams to all Democrats
requesting their attendance, so this departure reflected the
leadership's uncertainty about the fate of this legislation.

The atmosphere of the meeting was composed, although
there was an undercurrent of tension attesting to the uneasi-
ness of the bill's supporters on the eve of debate. Lawrence
O'Brien made this observation:

> In many ways this bill is the cornerstone to the en-
> tire Administration legislative program for the Eighty-
> ninth Congress. It contains so many different funda-
> mental issues—church-state, rural-urban, north-south—
> that affect Congressmen so deeply that it could easily
> fall apart. If we can hold the troops together on this

{ one it will surely make things that much easier during
the remainder of the session.

The most important decisions made at the leadership
meeting concerned legislative tactics. There was a general
consensus that time would be critical. The longer debate
was allowed to drag on, the greater the chances of the
smoldering reservations about the bill igniting in active op-
position with large numbers of Democrats. Consequently
it was decided that all general debate would be held on
one day, Wednesday the twenty-fourth. Thursday would be
reserved for the five-minute rule when amendments could
be considered. This decision was taken because it would be
easier to keep members on the floor for just one day; it
would be much more difficult to keep enough votes on the
floor if the debate and vote on amendments dragged on
through several days.

Optimism began to run high in the meeting, and it was
felt that with luck they could move to a vote on final pas-
sage Thursday evening. The Speaker announced that Claude
Pepper, who had debated Mrs. Green when she appeared
before the Rules Committee, had been asked to participate
in the floor debate when the proposed formula was being
discussed. In addition the church-state question was raised.
It was felt that an influential Jewish member of the House
would be needed to calm the liberal Democrats who were
wavering under the force of Mrs. Green's arguments. The
assumption was that, since in the past the Jewish com-
munity had generally opposed federal aid to private and
parochial schools, it would be of considerable assistance to
the Administration cause to have a respected Jewish mem-
ber of the House who had previously opposed such aid now
speaking in its behalf.

Congressman Sidney Yates of Chicago was mentioned as
such a member, but it was decided to call on the venerable
chairman of the Judiciary Committee, Emanuel Celler, to
handle this chore. The coincidence of advantages was com-

pelling. He is the most senior member of the House and is chairman of an important committee whose jurisdiction includes constitutional questions. Speaker McCormack reached for the telephone while the meeting was in progress and secured a commitment from Celler to argue the question of the bill's constitutionality in general and the reasons why no judicial review section was needed in particular.

The meeting adjourned about an hour after it had begun when the Speaker was called to the floor of the House to preside over a vote. The participants left the meeting feeling they had done what was necessary to prepare the way for HR 2362. All of the expert testimony, years of frustration, and hard work would once again be on the line.

Later in the afternoon of the twenty-third, telegrams were sent to those members selected to receive them, and Congressman Matsunaga's letter was brought to the whip's office for final editing. The assistant whips were notified of the meeting to be held in Boggs's Capitol office the next morning at 10 A.M. The whip staff went over their polls again with representatives from the Office of Congressional Relations in both the White House and the Department of Health, Education, and Welfare. Names were compared and phone calls made to those members who had not yet committed themselves one way or the other.

The member who is committed for or against is generally free from this kind of pressure. The ones who are leaning but undecided are subject to all the persuasiveness at the command of the various factions. The liaison between the White House, HEW, the Democratic leadership on Capitol Hill, and the relevant private groups on this bill was never more obvious or effective than in the last hours before the House convened to take up the education bill. All the stops were out, and phone calls were being made from all over the country from influential constituents to particular members whose vote was considered important by the leadership. The legislative process is generally not noted for its speed or agility, but when all the pieces are put together it can

mobilize a complex network of organizations to effective purpose. Such was the case as the House moved to the point of decision on HR 2362.

On the morning of Wednesday the twenty-fourth, it was discovered that the American Civil Liberties Union was sending telegrams to selected members urging that the bill be amended to meet the Union's constitutional objections. The National Education Association was soon at work sending follow-up telegrams countering the ACLU's efforts. With the telegram from the leadership "demanding" that members be present for general debate and amendments, it all added up to a great deal of pressure on the members and a boon for Western Union.

Later in the morning a report was received from the Republican caucus, which had been held at 10 A.M. The House Republicans were instructed to support an amendment that Mrs. Green would offer seeking the addition of a judicial review clause and any other she might later decide to offer. They were also urged to follow the Republican leadership on the recommittal vote with instructions to report back the Republicans' alternative education proposal. On final passage the Republicans were told that as far as the leadership was concerned "you can vote your districts, and do what you want to."

Floor Action

At noon the House convened for the fifty-third time in 1965. With all the preliminaries completed Congressman B. F. Sisk, Democrat of California and a member of the Rules Committee, was recognized to call up House Resolution 285 —the proposed rule for consideration of the education bill. Under the rules of the House the debate on a proposed rule is limited to one hour.

The debate on whether to adopt the rule lasted the full hour, but it was routine, and the six-hour open rule was

adopted by a voice vote. Had the House chosen to do so it could have defeated the resolution calling for adoption of the rule and thereby in effect have defeated the education bill before it was considered.

Next Chairman Powell moved that the House resolve itself into the Committee of the Whole House on the State of the Union, which was agreed to without dissent. The Speaker, as is normal under this parliamentary shift, relinquished the chair and appointed Congressman Richard Bolling (D. Mo.) to become chairman of the Committee of the Whole House. Bolling accepted the gavel from the Speaker and assumed the chair of the presiding officer which he would occupy until the committee had finished its deliberations. The ceremonial mace to the right of the Speaker's chair was removed from its station—this being the only physical sign that the House was no longer in session but had resolved itself into its committee status.

By unanimous consent the first formal reading of the bill was dispensed with, and Chairman Powell began the general debate with a description of the major features of the legislation and ending with a call for the enactment of HR 2362 with words that immediately focused the issue on the church-state question:

> Let us not forget the words of the great brooding father when he said that this Nation "will never perish from the earth" as long as we maintain a government of the people—black and white—for the people—Jew and Gentile—and by the people—Protestant and Catholic.[20]

Carl Perkins then assumed the brunt of the leadership for the Democrats. He cited the need for federal aid legislation and offered broad supporting comments on the significance of the particular bill before the House. After he gave up the floor, the Republicans (Quie of Minnesota and Griffin of

[20] *Congressional Record,* Daily Edition (March 24, 1965), p. 5559.

Michigan), led by Goodell of New York, hit hard at what they thought were the weak spots in the legislation.

The Republican attacks on the formula and other aspects of the program began to have telling effect on the Democrats. Goodell had Perkins, Powell, and Hugh Carey disagreeing among themselves about what the bill was intended to accomplish and just how specific programs would work under the law.

To answer the charge that the bill had been railroaded through the House Committee without careful consideration, the Democrats had prepared a statement listing the amendments to the original bill that had been accepted in both subcommittee and full committee. According to this listing the bill was amended forty-one times between its introduction and reporting to the floor of the House.[21]

But even with all the research and preparation, the Democrats were reeling under the attacks of the Republicans. Perkins had been an effective subcommittee chairman by many accounts, but to several observers and participants he was not in control of the floor situation. It was precisely this kind of situation that the Democratic leadership wanted to avoid. They did not want the key sections of the bill to appear indefensible to that body of liberal Democrats unsure of what they were about to support.

For the Democrats to be taking a verbal beating from the Republicans at such an early stage of the proceedings did not augur well for the Administration cause. For example, Goodell summed up a lengthy colloquy over the extent to which private institutions would be involved under various programs: "All right, then we have a nice, clear legislative history to proceed with. Nobody knows what this bill is going to do."[22]

The Democrats needed a spokesman who both knew the bill in detail and possessed the skills and presence to preserve

[21] *Ibid.*, pp. 5562–5563.
[22] *Ibid.*, p. 5572.

the atmosphere of control over the proceedings with which they had started the debate a scant hour earlier.

Whether by design or by chance such a figure began to assume informal dominance on the Democratic side of the aisle. John Brademas of Indiana, a member of the subcommittee but only the tenth ranking member of the full committee, rose and with good humor managed to get the principal Democratic figures on the floor to at least agree over the meaning of Title I of the bill. He told the House:

> I am the Methodist nephew of a hard-shell Baptist preacher. My mother belongs to the Disciples of Christ Church. My father is Greek Orthodox; and before coming to the Congress of the United States, I taught at a Roman Catholic college. If I can find myself a Jewish bride, I would represent the finest example of the ecumenical movement.[23]

With a series of leading questions put to his Democratic colleagues Brademas developed an interpretation of the "special educational services" feature of the bill with which Carey and Perkins could agree. Indeed, when Brademas asked Carey if he found his interpretation acceptable, the New York Democrat was so relieved to close the breach opened by Goodell that he responded with an "amen."[24]

While all of this was occurring, the Administration's education strategists were sitting in the gallery of the House, "scared to hell" as one of them put it. Cater and Samuel Halperin from the Office of Education were sitting together unable to understand why Carey and Perkins were having such a bad time with a bill they had been with for several months. They went to Carl Albert's office and worked on a statement to rebut the Goodell, Quie, and Griffin attack. The results of their work were delivered a few moments later by Congressman Frank Thompson of New Jersey who told the House that after "listening with great interest" to the

23 *Ibid.*, p. 5573.
24 *Ibid.*, p. 5574.

debate about special educational services he had "precisely the answer to the . . . problem," which he proceeded to offer.

Again Carey and Perkins appeared relieved to have an interpretation of Title I with which they could agree. Carey told Thompson that he thought the language was so to the point that it was "almost as if I reiterated it." Perkins told Thompson that he thought "the gentleman from New Jersey [had] eloquently stated the proposition."[25]

One member of the committee maintains that the Brademas-Thompson ascendency in debate was a deliberate move by members of the committee to regain the initiative they had so clearly lost. This member told us that the floor action from the Administration view was:

> . . . fouled up from the word go. It was a catch-as-catch-can process. Perkins and Carey started with primary responsibility, but Perkins was obviously weak and Carey had the religious ax to grind. When Goodell and Quie started taking Perkins and Carey apart we had to put together a more competent team to handle the floor debate.

Whatever the facts, it was clear at the time, and remains clear from the printed record, that the Brademas initiative followed by Thompson and others (O'Hara of Michigan, for example) blunted the Republican attack, and it was not to be the last time that this kind of intervention would be important to the majority cause.

The first day's debate went more slowly than expected. At mid-afternoon, Speaker McCormack made an agreement with Minority Leader Ford to adjourn the House at 6 P.M. whether or not general debate was concluded. This directly contradicted the agreement reached at the leadership meeting in the Speaker's office to conclude all general debate on the first day no matter how long it ran into the night. The Speaker's unilateral action drew considerable anger from the

[25] *Ibid.*, pp. 5582–5583.

President when O'Brien told him of the development. The early first day's adjournment assured a third day of debate on the bill, and this ran counter to every tenet of the Administration strategy, i.e, to speed the process before presumed latent objection manifested itself.

While there was widespread consternation among the Democrats over the unexpected change in timing, the Republicans did not see the change as either significant or a victory of any proportions. They simply had an official Republican affair that evening in Washington, and their leader secured agreement from the Speaker to adjourn with enough time for them to get there.

The tenor and quality of the first day's debate reflected the intensity of feeling about the bill and gave some people reason to feel that the Administration might have to accept an amendment to get passage.

It was not at all clear how widespread that feeling was, and how long the bill's supporters would be willing or able to stay together in their loosely-knit coalition. The next day would be in many ways the most significant day in the life of HR 2362, since the amendment votes would undoubtedly be taken. If the bill could survive the amendment stage, it was foregone that it would be overwhelmingly passed by the House.

The night of the twenty-fourth was a busy one for the Administration forces. Vice President Hubert Humphrey had been quietly working behind the scenes for several days with members of the House who needed encouragement on the Administration bill. Late in the day of the twenty-fourth, after the House adjourned, his office received a call from Henry Hall Wilson of the White House liaison office asking the Vice President to call ten Democratic members of the House who had reservations about the impending judicial review amendment Mrs. Green was to offer.[26]

[26] On the afternoon of the twenty-fourth the Republican Policy Committee officially voted to support Mrs. Green's amendment. The ten members that the Vice President was to call were: Sisk, Holifield, and Cameron of California; Foley of

The next day began with the Democratic whip's meeting at 10 A.M., held in the office of Hale Boggs. The seventeen assistant zone whips, John Moss of California (the Deputy Whip), and Majority Leader Carl Albert were all present.

Boggs led off the meeting with a low key pep talk stressing the importance of the events that would transpire that day. The gathering was told in no uncertain terms that the fate of the President's education program would be decided that afternoon in what the House did. The whips were told that their principal obligation that day would be to keep their forces on the floor for a good part of the afternoon when the amendment votes would be taken. The leadership was estimating that the first important vote would come around 3:00 P.M. They were told that the leadership expected all the assistant whips to be on the floor from that time on, and to make certain that all their zone members could get to the floor within minutes of a whip call. There was no objection to that assignment from anyone present at the meeting. Albert spoke after Boggs stressing the matter of attendance and asked that the zone leaders keep as many of their members as possible on the floor as long after three as they could be held there.

Torbert Macdonald of Massachusetts raised questions about the judicial review amendment that Mrs. Green was offering. It was clear from Macdonald's question that he was not wholly resistant to the idea of such a clause being added to the bill. Albert answered the question with a five-minute statement stressing the history of the negotiations that had gone into the bill and the tenuous nature of the coalition supporting it, and urging the whip to help the leadership pass

Washington; Ichord and Jones of Missouri; Herlong and Rogers of Florida; and Marsh and Hardy of Virginia. In addition, the Vice President was asked to speak with O'Neal, Hagan, Flynt, Tuten, and David of the Georgia delegation, who were apprehensive about the relationship of the education bill to Title VI of the Civil Rights Act of 1964.

the bill. Albert told Macdonald at the end of his answer that the matter was really very simple at this point: "If members can't support federal aid in the form it is presently in, then there is no way Congress will be able to provide federal aid."

The meeting broke up around 11 A.M. The House convened at noon. After a few brief preliminary items, Adam Clayton Powell took the floor and the House resolved itself into the Committee of the Whole House on the State of the Union. At that moment the Democrats had one hour and four minutes of time remaining for general debate, and the Republicans had one hour and eleven minutes.

The substance of the debate on the second day was much like the day before. There was much repetition, and the debate did not have the same tension surrounding it as on the previous day. In fact most of the action was not taking place on the floor itself but rather in the cloak rooms off the floor and in the halls surrounding the House chamber. The pattern was repetitive. A member or group of members would be called off the floor to meet with one of the interest group spokesmen in the House reception area, known as the Sam Rayburn Room.

By 3 P.M. the bill was ready to be read for amendments. The reading clerk of the House first read the substitute committee bill as the original bill for the purpose of amendment. That is, the bill which was reported out of the committee as amended, and not the original bill introduced by Congressman Perkins, was the legislation that would be accepted, rejected, or amended by the House. At the appropriate time in the reading of the bill, Mrs. Green offered her amendment to the formula. She had raised the issue of what she viewed as the formula's inequities during the general debate earlier in the day. The thrust of the Green "formula" amendment would be to eliminate the proposed weighting of what is presently spent per capita for education in the particular state or school district. Her amendment would have divided the money ". . . so that every poor child, no matter where he lives, gets an identical amount so that

the educational service in this district could be improved."[27]

Claude Pepper rose immediately after Mrs. Green's statement to oppose her amendment. He did not waste any time in reminding the House that the issue before it was whether the House was to implicitly defeat federal aid by adopting an amendment which would undo the coalition that had brought it this far:

> Mr. Chairman, the gentlewoman from Oregon has so distinguished herself in the contribution she has made to the cause of higher education, we all esteem her so highly, that it is with the greatest diffidence that I rise to oppose anything she advocates in this House. *However, this is a very vital matter which is now involved. The outcome of the vote on this amendment may have a very material influence on whether or not this bill will be enacted.* [Emphasis added.][28]

Under the five-minute rule, any one member must limit his contribution to the debate on any single amendment to five minutes, unless he is granted additional time with the unanimous consent of the House. Pepper used his five minutes quickly in an exchange with Mrs. Green, but was granted additional time on a motion by the majority leader, Mr. Albert.

Somewhat later in the debate over the formula amendment, Congressman O'Hara (D. Mich.) rose in support of the bill and reminded his colleagues that there were members of the House who were supporting Mrs. Green's amendment, but only because they hoped that if successful it would destroy the bill. He told the House: "This is the best formula that could be obtained for the South and for everyone else. *If we want this bill we had better protect this formula.*" [Emphasis added.][29]

[27] *Congressional Record*, Daily Edition (March 25, 1965), p. 5810.
[28] *Ibid.*, p. 5810.
[29] *Ibid.*, p. 5813.

The intensity of the debate was at its highest. There was no one listening to the proceedings who could not have been aware that the essence of the issue had been brought to the surface at the time of decision. The combination of circumstances lent drama and meaning to what was happening. Both parties were unleashing what they hoped would be their most effective weapons. Minority leader Ford entered the debate in behalf of Mrs. Greeen's proposal telling the House he was pleased to find himself on the same side of an issue as she.

With just ten minutes of debate left, several members— Sam Gibbons (D. Fla.) among them—took the floor in support of both the Green amendment and the bill, whether the amendment passed or not. This was precisely the approach the Administration was most afraid of, but there was little time left to exploit it. Just prior to the vote, Congressman Martin (R. Ala.) introduced a preferential motion asking that the bill be reported back to the House with instructions to delete the enacting clause in the bill, that is, to kill the legislation.

The Martin motion caught the Administration supporters off guard. While there probably was little chance for the motion to carry, the Speaker of the House entered the debate against the motion. Speaker McCormack spoke, briefly but with feeling, about the House having been an inevitable graveyard for education legislation and urged the House to move while in "in a position to put an effective bill through."

The motion to delete the enacting clause was quickly defeated by a voice vote.

The ten minutes for debate on the amendment had expired and Powell and Goodell were assigned to act as tellers for the vote. They reported that there were 136 votes in support of the amendment and 202 opposed. After two hours and thirty minutes the Green amendment had been defeated.

Powell then quickly moved that "all debate, and amendments thereto Section II of Title I of this Act close at six

o'clock." (When this motion was made there was a little more than thirty minutes left.) Another teller vote was demanded and again the Administration's supporters carried the day. The vote was 178 to 78. Albert Quie offered another amendment which occupied most of the remaining time. It was defeated by a simple voice vote. Several additional amendments were introduced without debate and were held over until the next day.

At a few minutes after six o'clock the committee rose and resolved itself into the House of Representatives, having finished general debate and having defeated the first of several key amendments to the elementary and secondary education bill. The Democratic leadership had had a good day.

The House convened at noon the next day, and the mood was one of finality. There were no irrelevant preliminaries before the major issue was confronted, as had been the case the previous two days. As soon as the prayer was read, Congressman Goodell noted the absence of a quorum. The Speaker noted that the journal of the previous day's proceedings had not yet been read and inquired if Mr. Goodell meant to ask for a quorum at this unusually early point in the events. Goodell indeed was aware that the journal had not yet been read, and a call of the House was ordered. In fact, twice more in rapid-fire order the House was called to a quorum. Each call consumed an estimated thirty minutes; and after the third call, Congressman Albert moved that the journal be considered read and approved, a motion which elicited a parliamentary complication and resulted in two votes, one a roll call. When it was all over, the journal of the previous day's proceedings was approved, and nearly an hour and a half had elapsed.

Minority Leader Ford expressed the reason for the Republicans' delaying tactics:

> It seems to us on this side of the aisle that because of the importance of this legislation there ought to be a maximum, but yet a reasonable, time for a full dis-

cussion of these critical issues [the education bill].

The only reason that we on our side have done what we have done so far today is because of the limitation on debate that was voted yesterday, which we think is unfair and inequitable and which precluded debate on Title I.[30]

Congressman Albert took the opportunity to follow Ford's comments with a sarcastic reminder to the Republicans that the House would have been further along in its deliberations, and with more time to spare, had they not adjourned at 6 P.M. two nights earlier at the specific request of the Republicans. Further, Albert unleashed a blistering attack on what he felt was the overwhelming evidence of Republican noncooperation during the Eighty-ninth Congress. Albert suggested that the Democratic leadership was hopeful that the House could finish consideration of the education bill by four o'clock that afternoon, leaving enough time for members and their families to attend the previously announced reception for the American astronauts recently back from a space flight.

With this flurry of fireworks, the House moved to the Committee of the Whole House on the State of the Union to resume consideration of amendments to the bill. Powell immediately moved that all debate on the section under consideration be limited to ten minutes. A bitter exchange between Goodell and Frank Thompson (D. N.J.) followed, but the motion was agreed to. In that ten-minute period of time four Republican amendments were introduced and defeated.

The committee then moved to the next section of the bill, and Powell moved that debate be limited to five minutes. That motion was adopted 97 to 92 on a division vote, but increased to 156 to 97 when tellers were called.

The Democratic majority was moving with speed, agility,

[30] *Congressional Record*, Daily Edition (March 26, 1965), p. 5892.

⌊ and power. Mrs. Green stood and asked that the enacting
clause of the legislation be struck. The debate on her mo-
tion lasted only five minutes but again touched on the
question of the Republicans being denied the right to de-
bate the bill. Speaker McCormack entered the debate for the
second time in two days to tell the House that he did not
like the implications of the Republican's remarks—that some
prior agreement, which he as Speaker was a party to, was
being unilaterally abrogated. He told the House:

> We adjourned on Wednesday night at six o'clock.
> That was done at the request of the Republican leader-
> ship. We adjourned last night at 6:30 P.M. He [Minority
> Leader Ford] spoke to me, and I was glad to adjourn
> at that hour. I try to have an understanding mind, but
> I think the principle of understanding minds is a two-
> way street.
>
> So far as the question of arbitrary action is concerned,
> I do not want to charge anybody with trying to force
> something down on me; but I am aware of the fact that
> some kind of implied intimidation is being made, and I
> do not like it.

The Green motion was then defeated on a voice vote.

By a teller vote another Powell motion next limited de-
bate on amendments to the following section of the bill to
five minutes. Congressman Quie offered an amendment to
Title II on library services, and it too was quickly defeated
by a voice vote.

Another amendment offered by Congressman Griffin (R.
Mich.) was defeated on a division vote, 65 to 133. The com-
mittee moved through several more sections of the bill with
minimal debate, and it seemed for awhile that the bill would
indeed come to a final vote by the 4 P.M. deadline that Ma-
jority Leader Albert had suggested.

However, when section 207 on the judicial review proce-
dures contained in the bill was discussed, Congressman John
Anderson (R. Ill.) made a strong appeal to the House to

slow down its pace and to give closer consideration to the important constitutional questions involved in federal aid legislation. He deplored the lack of concern that he felt was being shown the church-state implications in the bill.

When Anderson had finished his statement, Frank Thompson (D. N.J.) took the floor and accused Anderson of demagoguery on the question of the bill's constitutionality. He said:

> I might suggest further you can beat this dog all you want for political purposes; you can demagog however subtly and try to scare people off at the expense of the Nation's schoolchildren with your demagoguery . . .[31]

Congressman Goodell rose and accused Thompson of violating one of the canons of House procedure: to not impugn the motives of another colleague. He asked that Thompson's "words be taken down," which in effect would rule them out of order and strike them from the record.

The Committee of the Whole House had to rise, and the Speaker returned to the chair to rule on whether Thompson's statement was out of order. He ruled that the latitude of debate did not rule out the kind of comment that Thompson made and that no rule of the House had been violated. The point of order that Goodell had raised was not sustained. The Committee was reestablished with Richard Bolling assuming the chair.

Thompson said later that he had made the remark deliberately to intercept what he felt were some effective points that Anderson was making. His strategy was to rely on "Goodell's hot temper getting the best of him." That is, Thompson hoped that someone would ask for a ruling on his statement to interrupt the proceedings long enough for the Democrats to regroup their forces. Whether Thompson was deliberately trying to slow things down is a good question. What is of importance is that another half hour of time

[31] *Ibid.*, p. 5905.

was consumed and the thrust of the Republican attack was blunted. It probably is safe to say that little but oratorical success would have come from the attack in any event.

When calm had been restored, another five amendments, considered en bloc, were defeated and the committee rose to recess. Because of the loss of time taken in parliamentary hassles and the slow teller vote, consideration barely had moved to Title II of the bill when recess was called. It was 4:45 in the afternoon when recess came, subject to the call of the chair.

At nine minutes after 6 P.M. the House reconvened. Many of the members had not been able to get anything to eat since the bulk of the hour's recess was taken with the reception.

Before business was resumed Chairman Powell and the Speaker discussed how much time ought to be allowed for debate on a judicial review amendment when it was introduced. The Democratic majority had so far effectively controlled the time devoted to any amendment. They permitted on the average of five to fifteen minutes of debate before Powell would move, successfully, to close debate.

The Speaker noted the importance of the judicial review issue and the danger of being accused of gag-rule tactics. He suggested that, in light of these matters, Powell permit the debate to run "at least twenty minutes." Powell was amazed and wanted to know why the speaker was being so generous. He told the Speaker, "It will only raise all the old church-state issues that we have been afraid of all along." The Speaker half facetiously told Powell, "Adam, you're a dictator." The issue was not resolved with that conversation. The Speaker wanted to know who would offer the judicial review amendment, and Powell indicated the expectation was that Mrs. Green would introduce it.

After several other amendments were introduced, debated, and defeated, Congressmen Anderson (R. Ill.) and Smith (D. Va. and Chairman of the Rules Committee) introduced competing judicial-review amendments. It was

now 8:30 p.m., and members were getting tired. Judge Smith was willing to defer to Anderson and have his amendment stand as the one of record and decision.

Smith and Anderson (when his substitute became the item on the agenda) led the forces in favor of the amendment; and as scheduled, Emanuel Celler (D. N.Y. and chairman of the Judiciary Committee) spoke in opposition. The sight of these two venerable figures—as knowledgeable as any in the House of the nuances of floor debate, and in the twilight of their careers—was impressive. One indicator of the significance of the debate and the stature of the men leading it was the capacity crowd filling the press gallery above the floor of the House. There had been representatives of the media in the gallery off and on during the three days of debate, but at no time were there as many as for this debate.

Congressman Albert asked for and received unanimous consent for each side to have ten minutes to offer their statements. Celler's argument in opposition to the judicial review amendment was essentially that it was unnecessary given the prevailing common law on testing the constitutionality of acts of Congress. Congressman Griffin agreed with the thrust of Celler's points and opposed the Smith amendment.

The divisions occurred over the Anderson amendment. The essence of Anderson's substitute amendment was to broaden the definition of those who would be given standing before the courts in testing the bill's constitutionality. Anderson protested that the existing judicial review procedures in the bill (following three sections) were inadequate to the problems, since they only referred to disputes that might from time to time arise between states and the Commissioner of Education.

While Anderson was talking his time expired, and additional time was sought to enable him to finish his statement. Powell stood and objected to a request for five additional minutes. Since the request was premised on

unanimous consent the time was not allotted. But Speaker
McCormack then entered the fray asking for four addi-
tional minutes for Anderson. No one (including Powell)
objected to this request, and Anderson's time was extended.
However, it was clear that the forces against the amendment
were ready to act.

By ten minutes to nine, a teller vote was taken defeating
the amendment, 154 to 204. This was the last major vote on
amendments to be taken. When it was all over, the House
adopted only one amendment to the bill that was reported
from the Education and Labor Committee, a relatively in-
significant passage that created an advisory counsel to advise
the commissioner in carrying out his functions under the
bill. Indeed, the amendment, authored by Congressman
Griffin (R. Mich.) was so noncontroversial that it was even
supported by Chairman Powell. The end was in sight after
three grueling days, so Powell must have felt nothing would
be lost by his supporting the amendment. He told the
House: "I would like to go out in a blaze of glory and I
accept the gentleman's amendment." The Griffin amend-
ment was the only amendment adopted out of nearly fifty
that were introduced.

By 9:30 P.M. all the proceedings in the Committee of the
Whole House were complete. The bill as amended was
ready for the final votes in the House. Richard Bolling
turned the gavel back to the Speaker and received a stand-
ing ovation from both Republicans and Democrats for his
judicious handling of what was a very partisan and com-
plex bill.

When the House was sitting, the next-to-last order of
business was a motion to recommit the bill back to the
Education and Labor Committee with instructions to that
committee to report the bill back to the House with certain
amendments. The proposed changes were the major changes
the Republicans had been seeking all along. Mr. Goodell
offered the motion to recommit and, as an opponent of the
legislation, was eligible to do so as it came from the com-

mittee of the Whole House. The rules of the House prevent any of the bill's supporters from making a recommittal motion.

The yeas and nays were taken on the recommittal motion with 149 votes supporting recommittal and 267 opposing. Seventeen members did not vote. Immediately the Speaker put the bill to its final vote in the House. It passed, 263 to 153, again seventeen members not voting. And as it is so magnificently understated in the *Congressional Record* for March 26, "So the bill was passed."

The final vote came at 10:30 P.M., ten-and-a-half hours after the House had convened that day. In the House the relief at being done was visible to most observers. The debate had been long and at times acrimonious. The members were glad it was over; and when the Speaker announced the resulting vote on the final passage, there was a loud cheer. Leaving the chair upon adjournment, the Speaker told a bystander as he walked to his office, "I am so glad I was Speaker when this historic bill was passed."

In passing the first elementary and secondary aid bill in the House some seventy-seven members had participated in the debate. Twenty-four members had taken in opposition, and fifty-three in favor. This is something less than 20 per cent of the membership, and it reflects the strong pressures on members to participate in debate only when they are knowledgeable on issues involved or when a statement for political reasons is necessary. This means that most debate time is taken by members of the standing committee and subcommittee.

The history of the education bill in 1965 demonstrates that Congress generally and the House in particular are not simply numbers divided by party labels. There were a series of interesting and significant divisions within the House that gave the decision-making process a complexity barely visible to the observer who looks only at the debates or other formal processes.

One of the Congressional liaison officers in the White

House who worked on HR 2362 summed up his feelings about the bill in a way that accurately reflects our view of why the events surrounding the bill's legislative history in the House are both significant and fascinating. He said:

> The education bill was the most interesting bill of the first session of the Eighty-ninth Congress, because of the broad base of opposition that could have resisted it, and the interesting way in which the bill was put together to negate each segment of the potential opposition. It was essentially an interesting technical problem in legislating.

However, the legislative phase of the bill was only partially complete. The bill had yet to pass its test in the Senate. Perhaps it is safe to stay that, when the bill passed the House, the legislative phase was more than half over but less than complete since the House had been so often the graveyard for such legislation in the past. But Congress acts bicamerally, and there is much of interest in the Senate phase of this bill's history. The strategies and tactics that had worked in the House had now to be applied in the Senate; a legislative institution that likes to refer to itself as "the greatest deliberative body in the world." We turn now to the Senate's deliberations.

6

SENATE ASSENT

Before tracing the progress of HR 2362 through the Senate, it might be helpful to pause for a moment and reflect on some of the more significant institutional differences between the two houses of Congress.

There is little face-to-face interaction between the two bodies. Aside from a few joint committees composed of members from both wings of the Capitol and the *ad hoc* conference committees called to iron out House and Senate differences on bills, members of the two houses rarely see each other to discuss legislation. Senators are more apt to see House members somewhere other than Capitol Hill. Such occasions might include a briefing at the White House, a Washington social affair, a political party function, or a campaign back home. Even though floor privileges are interchangeable, one rarely sees a representative on the Senate floor, or vice versa. About the only time senators are on the House floor is when they go en masse for a joint session to hear a Presidential message.

Each chamber consciously strives to preserve its institutional integrity and to improve its public image. Though the members of each are constitutionally co-equals, at present a Senate seat is thought to be more prestigious than one in the House. The Washington press corps seems to

think that senators make "better copy" than House members, and this has shaped their mass image. In recent years numerous senators have been considered for the Presidency or Vice-Presidency, but not so for House members.

The prevailing view of the Senate has been largely a twentieth-century development. During the early days of the Republic, and throughout most of the nineteenth century, the House often overshadowed the Senate. Despite the lack of complete accuracy, the picture of a senator was that of a cigar chomping, vest-clad, political hack who had bought his seat from a state legislature. A twentieth-century event which helped change this image and enhanced the prominence of the Senate was the adoption of the Seventeenth Amendment in 1913 providing for the popular election of senators.

Congressmen recognize their inability to compete with senators for public attention, and as a result they have developed a slight inferiority complex. In an effort to compensate for this feeling, House members boast that they are the "work horses" and the senators are the "show horses." As one congressman commented, "We contribute most of the experience, expertise, and man hours while the Senate sits back and poses for the cameras." Although this comment is an exaggeration, the House in fact does contribute more to the collective product of legislation than the Senate.[1] This was certainly true of HR 2362 as well as most of the other major proposals of the Eighty-ninth Congress. Some of the reasons for this disproportionate share of the workload of the House can be seen in a comparison of the two institutions.

[1] The House members may pursue their legislative tasks more thoroughly than senators, but this should not be taken to mean that legislation is their major interest. The primary interest for most House members is in those activities directly related to getting reelected. For support of this point see: Charles L. Clapp, *The Congressman: His Work as He Sees It* (Washington: The Brookings Institution, 1963), chs. 2, 3.

We must start with the obvious fact that the House is almost four-and-a-half times larger than the Senate. Most of the spadework on legislation is done in the twenty standing committees of the House and the sixteen in the Senate. In the allocation of committee assignments, House members need not be spread as thin as senators. Congressmen on the Appropriations Committee, for example, do not sit on other committees, while in the Senate an assignment on Appropriations is merely one of several. In the House the Speaker and Minority Leader specialize in their leadership roles to the exclusion of committee positions. But in the Senate the Majority Leader is a member of two major committees, and the Minority Leader is on two major committees and two joint committees.[2] It is natural for members of the House to become legislative specialists, while senators are more apt to be generalists.

Because of its size the House is forced to operate under a more rigid set of rules than the Senate. In fact, the most pervasive tradition of the Senate is the agreement not to adhere strictly to formal rules unless absolutely necessary. The Senate conducts a sizable share of its business under a suspension of the rules which is made possible by securing unanimous consent of the members.

The difference in the size of the constituency represented in the two houses of Congress shapes the peculiar character of each. The smaller constituencies represented in the House are more likely to be homogeneous and will present fewer

[2] In the Senate, committees are categorized as major and minor committees. Major committees include: Foreign Relations, Finance, Commerce, Judiciary, Appropriations, Armed Services, Agriculture and Forestry, Interior and Insular Affairs, Banking and Currency, Labor and Public Welfare, Public Works. Minor committees include: Government Operations, Rules and Administration, Post Office and Civil Service, District of Columbia, Aeronautical and Space Sciences. For a list of both houses, see Malcolm E. Jewell and Samuel C. Patterson, *The Legislative Process in the United States* (New York: Random House, 1966), p. 206.

conflicting demands than would be true of the typical state represented in the Senate. This means that there are usually more interests vying for the attention of a senator, who of necessity must develop the perspective of a generalist.

The Constitution and tradition have shaped the character of the two houses differently. For example, the Constitution requires that all revenue bills originate in the House. By tradition the House also acts first on appropriation bills. As a result of these procedures the Senate has become an unofficial "appeals board" to review and revise decisions made by the House.

The Introductory Phase

In his State of the Union message the President outlines his legislative program to Congress in broad brush strokes. He then supplements these general requests with special messages on specific major programs. Hence on January 4, 1965, President Johnson made general reference to the need for federal assistance to elementary and secondary education in his State of the Union message. On January 12, a messenger delivered to each house an additional message specifying his request. The President can propose legislation, but only members of Congress can introduce bills. Hence on January 12, Senator Wayne Morse (D. Ore.) introduced the Administration's bill (S 370). This bill was identical to HR 2362 introduced in the House on the same day by Carl Perkins (D. Ky.). In the Senate, unlike the House, it is possible to have multiple sponsorship. Often a senator will leave his bill "on the table" for several days and invite his colleagues to join in sponsorship. This was done by Senator Morse, and S 370 wound up with a total of thirty-six sponsors.

After introduction, Morse (as chairman) notified the other members of the education subcommittee of the Labor and Public Welfare Committee that hearings on S 370

would commence January 26. This was five days after Perkins had scheduled hearings in the House.

The Role of Subcommittees

The general pattern in both houses is to allow the subcommittees to do most of the extensive spadework on bills referred to the committee. The full committee retains the right to take final action on each bill, but with rare exception the recommendations of the subcommittees are accepted.

The manner of processing major bills by Senate committees is similar to the procedure in the House. It includes the following steps: 1) a bill is referred to committee; 2) the bill is assigned to one of the subcommittees and hearings are held; 3) the subcommittee meets in executive session to consider the bill—called a mark-up session; 4) if the bill is reported out of subcommittee, a mark-up session is then held by the full committee; and 5) if the bill is reported out of full committee, it is usually accompanied by a report containing an explanation and supportive arguments on the bill.[3]

The degree of autonomy possessed by subcommittees will depend upon the temperament of the chairmen (sub and full) and the traditions peculiar to each committee. Within most subcommittees the chairman is the dominant figure. He is the communications link between the full committee and his subcommittee. He shapes the character of the hearings by setting its time and duration and by controlling the slate of witnesses. He presides over the hearings and subcommittee mark-up sessions.

The chairman of the Senate Labor and Public Welfare Committee is Lister Hill (D. Ala.). He is a highly revered

[3] Of course it is possible not to find supportive arguments in a Report, but rarely does a committee report a bill without it having majority support.

and effective chairman though he does not try to rule the subcommittees with an iron hand. He is often referred to as "Mr. Health," and he devotes most of his attention to the health subcommittee of which he is chairman. He is the second ranking Democrat on the education subcommittee of which Wayne Morse is chairman. Hill allows Morse a free reign in guiding his subcommittee.

The Morse Subcommittee, 1965

SUBCOMMITTEE ON EDUCATION OF THE
SENATE COMMITTEE ON LABOR AND PUBLIC WELFARE

Wayne Morse, Oregon, Chairman

Democrats	*Republicans*
Lister Hill (Ala.)	Winston Prouty (Vt.)
Pat McNamara (Mich.)	Jacob Javits (N.Y.)
Ralph Yarborough (Tex.)	Peter Dominick (Colo.)
Joseph Clark (Penn.)	
Jennings Randolph (W.Va.)	
Robert Kennedy (N.Y.)	

It is customary for committee hearings to start with top executive officials, and the lead-off witness on S 370 was Secretary of Health, Education, and Welfare Anthony Celebrezze. After a low-keyed presentation of essentially the same material Celebrezze had offered the week before, Morse and his colleagues were ready to start their interrogation. In accordance with traditional procedure the chairman has first crack at the witness, and then the questioning is alternated by party affiliation and according to seniority rank on the committee.

Since all but one of the Democrats (Hill) were co-sponsors of S 370, the Administration witnesses expected most of the intensive quizzing from the Republicans. This was generally true with the notable exception of the newest Democrat on the committee—the late Robert Kennedy of

New York. Senator Kennedy was a staunch supporter of the bill, to be sure, but he made it clear from the outset that he intended to give it a serious examination. Following Celebrezze's testimony, the next witness was Education Commissioner Francis Keppel. When Keppel had finished, Kennedy started a three-way colloquy by swiftly moving to the heart of the bill—the allocation formula in Title I. Commissioner Keppel seemed slightly surprised when Kennedy launched into the following line of questioning:

> *Senator Kennedy:* Now is the child an educationally deprived child if it receives an education which is substantially inferior to the average U.S. education at that grade level?[4]
>
> *Mr. Keppel:* Certainly, sir.
>
> *Senator Kennedy:* Is an educationally deprived child necessarily, therefore, from a family of low income—a low income family?
>
> *Mr. Keppel:* No, sir. Clearly, there can be deprivations and are in our society for a host of tragic family reasons. I think it is fair to say that the proposal made by the Administration is to start where we can be utterly sure the need is desperate—that is the case of children of families earning under $2,000 a year income.
>
> *Senator Kennedy:* I don't know if it would be possible to work out a stricter definition, but I think it would be of help to the committee. You describe, and I think forcefully, the family and home background of a child and I think that does make for difficulty and creates the kind of problems that you have described.
>
> I think also would you agree, that it is not restricted to that, that from your experience of studying the school systems around the United States, that the school system itself has created an educationally deprived system?
>
> *Mr. Keppel:* I am sorry to say that is true.

[4] The following colloquy is found in *Senate Hearings on S 370*, pp. 510, 511.

As Kennedy continued to challenge the basis of the al-
location formula he expressed concern that the federal funds
would miss the mark if the school systems remained un-
changed. Eventually Secretary Celebrezze became involved
in the discussion when Kennedy asked the following:

> *Senator Kennedy:* Would not you agree, Commis-
> sioner and Secretary, that one of the really great prob-
> lems we have in the country, being blunt about it, is
> the school boards of some of these communities, in
> some of these states, and the commissioners of educa-
> tion in some of the states, that they are just not going
> to take the necessary steps to deal with the problem?
> *Secretary Celebrezze:* That is the price of democracy.
> If you want to keep your education on a local level
> without concentrating it in the Federal government.
> *Senator Kennedy:* It may be the price of democracy
> but we don't have to accept it.

The Washington press corps followed the words and
deeds of Robert Kennedy more carefully than those of any
freshman senator in recent history. Reporters were especially
interested in comments which seemed at odds with the
White House line. Columnists Rowland Evans and Robert
Novak interpreted Kennedy's exchange with Celebrezze and
Keppel as a rift with the President and argued that "the
soft underbelly of President Johnson's much praised program
of aid to education is being attacked by none other than
the Senate's most famous freshman: Senator Robert Ken-
nedy of New York."[5] Chances are Kennedy was more in-
terested in demonstrating that he was not going to be a
meek and passive member of the committee than in chal-
lenging Johnson or his education proposal.

CHURCH-STATE TESTIMONY

The third day of hearings was devoted to the delicate
issue of aid to church-supported schools. The testimony had

[5] *The Washington Post*, February 23, 1965.

historical significance because it subtly indicated a more moderate position by groups on both sides of the issue.

In previous years Msgr. F. G. Hochwalt, spokesman for the United States Catholic Conference, had appeared on Capitol Hill to voice his opposition to school aid legislation. But in 1965 he appeared as a supporting witness. In restrained praise he said, "the Administration's proposal offers a workable compromise" and added, "we indicate our willingness to cooperate with their legislative proposal because of the assurance that all children in need will benefit from the program."[6]

In 1965 the Jewish community no longer presented the bloc of opposition to private school aid that was true of previous years. The more orthodox Jewish groups continue to maintain their own private schools and the lure of federal funds is more tempting than it once was. The Jewish division is reflected in testimony offered by both sides.

Harrison Goldin, speaking for the nonorthodox American Jewish Congress said, "the plan would necessarily blur the line which separates public from parochial education," and added that his group could not support the measure as drafted.[7] The antidote for this nonorthodox Jewish opposition was provided by Rabbi Morris Sherer speaking for Agudath Israel of America, an orthodox Jewish organization. Rabbi Sherer was delighted to endorse the bill and called it "a major step forward in meeting the educational needs of the school children of our nation."[8]

Historically, the Baptists have been one of the most implacable foes of federal assistance to private schools—especially Southern Baptists. In 1965 they did not change their position, but the intensity of opposition seemed to have diminished. Since the desegregation decision of *Brown v. Board of Education* in 1954, there has been increased interest in private education, especially in the South. The expansion of private education in the South is reflected by

[6] *Senate Hearings on S 370*, pp. 2535, 2536.
[7] *Ibid.*, p. 2560.
[8] *Ibid.*, p. 2567.

the Internal Revenue Service's decision in August 1967 to extend tax exempt status to forty-two additional Southern private schools. This might explain part of the changing attitudes of Southern Baptists.

The director of the Baptist Joint Committee on Public Affairs, Dr. C. Emanuel Carlson, objected to the bill as it was written, especially the "vagueness" of those sections involving private schools. Yet he prefaced his remarks by saying the approach taken in the bill "brings us something new in scope, and we hope that it is the creative piece that will be able to solve the problems that we have faced for a number of years in this field."[9]

PLEA FOR A TEACHERS CORPS

On the last day of the hearings (February 11) Senators Edward Kennedy (D. Mass.) and Gaylord Nelson (D. Wis.) appeared before the committee and suggested an amendment to S 370 providing for a federally financed teachers corps to be used in impoverished school districts throughout the country. Their proposal was essentially the same as a suggestion offered by Harvard economist John Kenneth Galbraith a year earlier.[10] Kennedy and Nelson seemed reasonably confident that their idea would be favorably received by the Democrats on the committee. But for Chairman Morse and his Democratic colleagues, it was not a question of the desirability of the proposal but one of opening S 370 to amendment. For reasons that will be discussed later, Morse, before the session even started, had made up his mind that the school aid bill must clear both houses in the same form. For the time being the committee merely assured Kennedy and Nelson "that their proposal would be

[9] *Ibid.*, p. 2516.
[10] This was a suggestion made by Professor Galbraith to the National Committee for Support of the Public Schools, meeting in Washington, D.C. See: *The New York Times*, January 16, 1964.

given careful consideration" before final action on the bill.

On February 11 the Morse subcommittee concluded hearings on S 370. In all there were seven days of hearings scattered over a period of several weeks. There were 103 persons who appeared before the committee, and prepared statements were received from an additional 42. Their testimony filled six volumes, more than 3,200 pages.

Unlike the hearings in the House, the Senate sessions were almost devoid of partisan conflict. A major reason for the contrast was the simple fact that the senators were not working under the same pressure of time as their counterparts in the House. The decision had been made in advance of the session to allow the House to act on the school aid bill first. This gave the Senate the advantage of conducting its hearings at a more leisurely pace. Hence the Senate Republicans had less of an argument that the bill was being "ramrodded" through committee.

THE PRE-MARK-UP PHASE

Before the Eighty-ninth Congress convened Senator Morse had decided, with the concurrence of President Johnson and the Democratic congressional leaders, on two major points of strategy: 1) the Senate should postpone action until final passage in the House, and 2) no amendments should be accepted at any stage of the process in the Senate. The reasons for these decisions were obvious. Historically the House had been the burying ground for school aid legislation. The leaders felt that in 1965 it still remained the toughest hurdle and should be approached first. They felt that the Senate should not allow any amendments so that the House and Senate versions of the bill would pass in identical form; this would avoid the need for a conference committee to iron out the differences.

In 1960 it was the failure of the House Rules Committee to authorize a conference that killed the federal aid bill. Although the House amended its rules in 1965 to allow the

Speaker to by-pass the Rules Committee in sending bills to conference, the leaders were not taking any chances; besides, avoiding the conference committee would also speed the final enactment of the bill. The President wanted the bill out of the way as soon as possible so Congress could turn its attention to other major problems of the "Great Society."

Given the fact that the Republicans numbered less than a third of the Senate, Morse knew that he would have little trouble staving off their attempts to amend the bill. Yet he did not want to handle them in a cavalier fashion. He prides himself on maintaining harmonious relations with the minority members of his committee, and he wanted to avoid dismissing their suggestions out of hand. An even more difficult task was dealing with the Democrats who favored the bill but wanted it modified. His task of keeping the bill intact without alienating its supporters was a worthy test of leadership skill and overall political acumen. Between February 11 and March 30, Morse waited for final action by the House before calling his committee into executive session. During this time he was barraged with demands and suggestions on the bill from members of both parties.

On the Republican side of the subcommittee there were a couple of members—Winston Prouty (Vt.) and Jacob Javits (N.Y.)—who wanted S 370 specifically to cover physically handicapped children. Obviously neither Morse nor the Administration was anxious to come out foursquare against crippled children (which is probably what Prouty and Javits had in mind) but they did not want to risk amendments. Finally Senator Morse handled Prouty and Javits by asking Assistant HEW Secretary Wilbur Cohen and Commissioner Keppel to write an opinion on the matter. Just as Morse expected, both assured the committee that the bill was broad enough for this type of coverage. Their letters were incorporated into the committee report and thus became a part of the legislative history of the bill. An item becoming a part of the history is of some significance because executive

agencies charged with applying the law, and federal courts interpreting the law, both need permanent sources to assist them in determining the intent of Congress. Committee hearings, reports, and the *Congressional Record* are used as such sources.[11]

During this period Morse was also receiving a steady stream of requests from the Democrats on the full committee. While HR 2362 was still being held by the Perkins subcommittee in the House, it was possible for Morse to funnel a few of the requests to that side of the hill before their mark-up session was held.

Senators Nelson and Kennedy continued to press for their teachers corps amendment. After several discussion sessions with them, Morse was able to dissuade them from pushing their amendment with the assurance that it could be attached to the higher education bill scheduled for Senate action later in the session.[12]

Committee membership did not constitute the only source of suggestions for amendment. Senator Morse and the professional staff of his committee were contacted by numerous other members—mostly Democrats. The President had several White House assistants on the hill drumming up support for the bill, and Morse found it useful to employ their help in explaining to Democratic senators why S 370 could not be amended. One White House aid, Mike Manatos, was especially helpful in this regard. This eased the burden on Morse and gave the Administration a meaningful role in assisting the bill.

[11] Since it is possible for members of Congress to alter slightly their remarks in the *Congressional Record* and to improve their grammar in the hearing reports, some have argued that these sources are not a completely accurate record of the legislative history of a bill. Nevertheless, it is about all one can use.

[12] A couple of months later Morse was successful in attaching the teachers corps to the 1965 Higher Education Act. But the teachers corps did not go into operation for lack of appropriations.

THE SUBCOMMITTEE MARK-UP

The day after the House passed HR 2362, President Johnson said he was certain that the Senate would "move with dispatch and enthusiasm to speed the final passage of the bill."[13] In retrospect the President's confidence was well founded. Within a period of two weeks the bill cleared two mark-up sessions, was debated on the floor, and was delivered to the President for his signature.

The bill passed the House on Friday (March 26) of one week, and on the next Tuesday the Morse subcommittee went into executive session. The only decision of any note on the first day was the committee's agreement to work with HR 2362 instead of the Senate version S 370. In the second mark-up session, held the following day, the bill narrowly missed being amended by two bipartisan proposals offered by Ralph Yarborough (D. Tex.) and Peter Dominick (R. Colo.). The vote on each was 6 to 4. Both amendments were designed to increase aid to the more impoverished states by decreasing assistance to the wealthier ones. Those favoring the amendments were full committee chairman Lister Hill (D. Ala.), Yarborough (D. Texas), Dominick (R. Colo.), and Winston Prouty (R. Vt.). Those opposed were subcommittee chairman Morse, Joseph Clark (D. Penn.), Jennings Randolph (D. W.Va.), Robert Kennedy (D. N.Y.), Pat McNamara (D. Mich.), and Jacob Javits (R. N.Y.). Had each voted the strict interest of his state, only one vote would have changed—Jennings Randolph. Under the amendments, his state of West Virginia would have received a larger share of assistance but he voted "no" because he felt these changes might "open up the flood gates" and threaten the fate of the entire measure. After long hours of discussion the subcommittee finally decided by a unanimous vote of 10 to 0 to report the bill without amendments. In his comments to the press after the meet-

[13] *The New York Times*, March 28, 1965.

ing, Morse lavished praise on all the members and added, "I think we have a minimum amount of partisanship on this bill."[14] The unanimous vote was indicative of Morse's harmonious relations with the Republicans on the subcommittee rather than of their attitudes on the bill. In fact, the GOP members—especially Dominick and Prouty—were unhappy with the unamended version of the bill. They were willing to go along with the Democrats in reporting the bill because they knew it would clear regardless of how they cast their votes. Hence they thought they might as will give Morse the personal satisfaction of having a unanimous report. The time-honored canon of politics applied in this case was that one should not go out of his way to make enemies if it is obvious his side is going to lose anyway. This strategy eventually paid off for the Republicans when the bill was on the floor and they needed the cooperation of Morse in handling the debate.

The unanimous vote also reflects a respect and admiration held for Morse by his subcommittee colleagues. The public image of Morse is often that of an outcast and troublemaker. His critics argue that "every time he opens his mouth on the floor he loses his cause ten votes." One must admit that when Morse publicly becomes involved with issues, he seems to possess an uncanny knack for causing his opponents' blood to boil. But when he is out of the spotlight of publicity and working with his fellow senators as a chairman and colleague, his relations are warm and cordial. In the words of a Southern Democrat, he is regarded as "a man of high integrity who is fair, open-minded, honest, and reliable." One conservative Republican remarked:

> He's the kind of guy that if you tell him you are not going to be able to attend a committee session, he will tell you that he will protect your interests while you are gone—and he will. I can't always go along with him because he can spend another billion dollars without batting an eye. But if he has a difference of opinion

[14] *Ibid.*, April 2, 1965.

with you, he will sometimes even give you an argument or two to support your own position.

FULL COMMITTEE MARK-UP

In both the House and Senate the full committee will usually accept the decisions of the subcommittees. The case of HR 2362 before the Senate Labor and Public Welfare Committee was no exception. When the full committee met to consider the bill five days after the subcommittee had finished, efforts were renewed to amend it. Once again Senator Dominick offered his amendment to allocate more funds to poorer states and once again it was rejected—this time by a vote of 10 to 6. Senator Javits voted "no" and the rest of the Republicans plus two Democrats (Hill and Yarborough) voted "yes." Two other Dominick amendments were defeated by voice vote. Both touched on the issue of church-state. One limited the distribution of textbooks and library materials to public schools; the other specifically prohibited the use of federal funds for private school construction and teacher's salaries.

The bill emerged unscathed and once again was reported out by unanimous vote. When the bill cleared committee without a single amendment, Morse attempted to soothe the bill's critics and to indicate some of his own reservations by saying, "There is adequate time later this session or next year for us to amend the bill if it is needed."[15]

The next day the report (No. 146), which had been prepared by the committee staff, was made available. It contained an explanation of the bill, supportive arguments, and the minority views of the Republicans.

ROUTE TO THE FLOOR

After a bill has cleared committee, the chairman (usually subcommittee) formally reports the bill on the floor. Oc-

[15] *Ibid.*, April 7, 1965.

casionally a senator reporting a minor bill will request
unanimous consent for immediate consideration. Normally
bills go on the calendar in the order they are reported.

Unlike the House, which segregates revenue and appro-
priation bills from other public bills on separate calendars,
the Senate has only one calendar. Also unlike the House,
the Senate does not have a Rules Committee to regulate
the flow of legislation onto the floor. After the morning
business is completed each day, the Senate proceeds to a
consideration of the calendar. In order to regulate the work-
load to meet the interests of most of the members, there is
a need to select bills out of sequence off the calendar. In
other words, someone needs to control the agenda. In the
Senate this is the job of the Majority Leader who usually
works in close consultation with the Minority Leader.
Normally the Majority Leader will announce in advance
the bills he intends to call off the calendar. This is done to
give the members a chance to plan their personal schedules
around the business to be taken up on the floor. One must
always keep in mind that the Senate conceives of itself as
a body of equals and that within limits the interests and
desires of each member should be taken into consideration.
Thus the Majority Leader will strive to plan an agenda
which will provide maximum convenience for most of the
members. It is difficult to determine what future floor busi-
ness will be until the Majority Leader announces his inten-
tions. Before the announcement the Majority Leader will
have consulted the Minority Leader, the floor manager of
the bill, and probably the White House. Periodically
the official calendar is printed and distributed, but it is an
incomplete and often misleading guide to future business.

In order to expedite action on minor and noncontro-
versial bills that have been passed over on the calendar,
once or twice a month the Majority Leader calls them off,
and usually they are passed in rapid fashion. Since so much
of the business is conducted with the use of unanimous
consent agreements and voice votes, the minority party al-

ways tries to have one of its members on the floor to keep the majority and its leader honest.

In regard to HR 2362, Senator Morse, President Johnson, and Majority Leader Mansfield all agreed that floor action should commence as soon as possible. In fact, it was called up the same day it was reported (April 6). But for the benefit of the members who were anxious to make plans for dinner, Mansfield announced, "For the information of the Senate, there will be no further voting tonight." With those words, there was an immediate mass exodus from the floor.

Floor Action

FIRST DAY

If one were to judge the significance of the business on the Senate floor by the number of members present, the inescapable conclusion would be that this august body rarely considers anything of consequence. Attendance is especially light when debate is just starting on a bill. When Morse started his explanatory statement on HR 2362, the chamber was empty except for two senators huddled in a corner deep in conversation. Senator Allen Ellender (D. La.) wandered onto the floor and took note of this. In fact, he remarked to Morse, "I notice present only one or two senators to listen to my friend explain this $1.3 billion bill. I just came from committee, myself, by chance."[16] Senator Morse was neither offended nor surprised that his colleagues did not turn out to hear his opening statement. He said he was "speaking for the record" and added that he was sure that the others would read his comments if they were interested.

One need not spend much time observing Congress to learn that the Senate floor is rarely the scene of intense drama. Tourists are often disappointed when they travel half-

[16] The exchange between Morse and Ellender is found in the *Congressional Record*, Eighty-ninth Cong., First Sess. (April 6, 1965), pp. 7055, 7056 (Daily Edition).

way across the country to visit the nation's Capitol and rush to the Senate gallery only to find an unknown senator speaking in a monotone to an empty chamber. This disappointment erroneously leads some to think that the members are somehow shirking their responsibilities. The problem is that the bulk of the work is visible only in committee rooms and the members' offices. In fact, if a senator spent most of his time on the floor, his colleagues would soon wonder how he managed to do his work!

Senator Morse concluded his introductory statement by saying that he had been "authorized by the President to ask that the bill pass unamended." This comment gave Senator Ellender a chance to engage in the favorite Senate game of verbal horseplay. With tongue in cheek, Ellender said, "This is the first time I have ever heard the Senator from Oregon make the statement that he does not believe a somewhat controversial bill should be amended in any respect." He added with a smile, "I presume the Senator is taking this position because the President wants the bill on his desk as soon as possible." Senator Morse, who was obviously enjoying the bantering, responded by saying, "I find myself in agreement with the President but the Senator from Louisiana is quite mistaken if he thinks that represents a cause-to-effect relationship. That is my independent judgment." Given Morse's reputation and record as being an outspoken individualist, his comments were credible. Senator Ellender ceased the levity by saying, "I want the distinguished Senator to understand that the questions I am propounding to him are merely to clarify the issues." This was a signal to Morse that Ellender was willing to stay on the floor and help "make the record" on HR 2362 via a friendly dialogue. The friendly dialogue is a common device used on the Senate floor especially during the early stage of discussion of a bill. It is an exchange between the bill manager and an inquisitor sympathetic to the bill. The bill manager finds it helpful to clarify a bill by responding to questions posed by one of his allies. It also gives him a

chance to make a record on a bill before the adversaries start unleashing their torpedoes.

The remainder of the first day was taken up with senators presenting prepared speeches on the bill. Typically this type of address is primarily designed for home consumption.

SECOND DAY

The second day of debate on HR 2362 was an exhausting session which lasted more than eleven hours. In all there were four recorded roll call votes on amendments, and there was an additional amendment pending on the floor when the senators finally went home at 9:15 P.M.

Of course most of the members did not spend the entire day on the floor listening to the debate. They had to stay within range of the Senate bell system, however, to know when recorded votes were coming up. While most of them knew something about the bill, not many were completely familiar with the amendments that were being offered. Hence if the members do not plan to spend much time on the floor, they need an intelligence source to keep track of the pending business. Both parties have a secretary (the job formerly held by Johnson protégé Bobby Baker) who can brief the members as they come onto the floor to vote. On busy days many senators will have someone from their office staff to cover the floor (which is a job one of the authors performed with great delight during the 1965 session).

The first vote of the day was on an amendment offered by Peter Dominick designed specifically to require state approval for the establishment of the local supplementary education centers proposed under Title III of the bill. It was defeated by a vote of 39 to 49 with all Republicans except one (Case, N.J.) voting "aye." There were ten Democrats absent on the vote, and the outcome was sufficiently close to cause the majority leadership to redouble its efforts to keep their troops on the hill and ready to vote. Their

efforts paid off and subsequent amendments were defeated by wider margins.

The second amendment, advanced by Winston Prouty, called for a change in the allocation formula using the number of school children and per capita income figures for each state instead of basing it on the number of school children and state population figures. Had the amendment passed, it would have decreased aid for eighteen states (mostly in the northeast and midwest) and increased assistance for the other thirty-two states. This caused some anxiety among Democratic leaders because—at least in theory —if each senator voted the specific interest of his state, the amendment would carry by a vote of 64 to 36. It was defeated, however, by a vote of 38 to 56. The vote indicated that twenty-four non-Southern Democrats and one Republican voted against their state's specific interest by opposing the amendment. The rest of the votes were in line with each state's financial interest.

The third amendment of the day was proposed by James Pearson (R. Kan.). It called for a gradual tapering off of federal funds for school districts affected by the closing of federal installations. To no one's surprise it was quickly rejected by a vote of 32 to 59. Senator Pearson was due for reelection in 1966, and it was generally thought that he was offering the amendment for constituency consumption (sixteen districts in Kansas were being affected by the 1965 cutback in federal installations).

The last amendment of the day was sponsored by Peter Dominick. It too would have altered the allocation formula and would have resulted in channeling more aid to the poorer states. It was rejected by a vote of 38 to 53.

THE THIRD DAY

When the Senate convened the next morning to finish debate on HR 2362, the pending business was Sam Ervin's (D. N.C.) judicial review amendment. It was designed to

test the constitutionality of assisting parochial schools by allowing any taxpayer to file suit in a federal court challenging the method of dispersing funds under the bill.[17]

In previous years, Morse had been a staunch supporter of judicial review proposals, but once again he urged his colleagues to refrain from amending the bill lest it jeopardize its passage, Federal aid supporters from both parties managed to hold the line, and the amendment was defeated 32 to 53 (Democrats, 16 to 39; Republicans, 16 to 14).

With the Ervin hurdle cleared, it was obvious that Morse had enough support to ward off any amendment and the members began to get a bit restless awaiting the final vote. For the rest of the day most senators drifted onto the floor just long enough to vote "nay" on a pending amendment. In all there were six amendments offered on the last day, and each was rejected by an increasingly larger vote.[18]

The Senate majority leadership had hoped to finish the bill by early afternoon before President Johnson was scheduled to leave for Houston to attend the opening of the astrodome. But a few senators were still droning on at 3:30 when the President's helicopter took off from the White House lawn.

Bringing a bill to a final vote in the Senate is a mystical process. It is possible to curtail debate under Senate Rule 22 (cloture), but this rarely happens. The institution prides itself on its tradition of unrestricted debate and therefore one never knows for certain exactly when discussion will cease. It is not so much a matter of deciding on a time to vote but rather a decision on the part of each member to

[17] In 1923 the U.S. Supreme Court held that a taxpayer's interest is too minute and remote to challenge a national act unless this right is specifically provided by Congress. But as noted earlier this position of the Court has been modified by a decision made in June, 1968.

[18] A summary of all Senate amendments on HR 2362 can be found in the *Congressional Quarterly Weekly Report No. 16* (April 16, 1965), pp. 690, 691.

stop talking. Unless it is a case of a filibuster, senators will gear the length of their remarks to the temperament of the body. Debate will start tapering off when it becomes apparent that most members are ready to vote.

In the case of HR 2362, by 7:30 P.M. it was obvious that the troops were ready to call it a day. After checking with the floor leaders and finding that no one else wanted to offer an amendment or insert a speech, Senator Morse let the presiding officer know that the members were ready to vote. The presiding officer then announced, "the bill having been read the third time, the question is, shall it pass? The yeas and nays have been ordered, and the clerk will call the roll." Within a few minutes it was announced that the bill passed by a vote of 73 to 18 (Democrats, 55 to 4; Republicans, 18 to 14). The group voting "no" was a collection of Southern Democrats plus Midwestern and Western Republicans.

A TEMPORARY VICTORY

Even though HR 2362 passed the Senate and was signed into law two days later by the President, federal aid advocates could not afford to bask too long in the warm glow of their victory. The signing ceremony by no means meant an end to the historic federal aid struggle. In fact it merely launched a new phase in a continuing struggle which started a quarter-century before the passage of HR 2362 and has continued thereafter.

The public policy process is a never-ending flow of decisions. The currency of this process is the policy proposal, and thus far we have seen that any proposal is an extremely fragile object which can be easily destroyed or modified beyond recognition. In order for a proposal to become law it must pass a trial by fire in the environments inside and outside the political system. As the case history of HR 2362 demonstrates, even when a proposal has sufficient support

in the external environment, it may be destroyed or completely changed in the system. Countless proposals are killed each year by the bureaucracy, the White House, congressional committees, single legislators, and members of the leadership, plus the houses of Congress themselves. Once a proposal has cleared this obstacle course it still can be destroyed or modified by a Presidential veto, an adverse decision by the courts, the manner in which it is administered by an executive agency, subsequent repeal by Congress, or it may die for lack of funds. Most programs that are enacted into the law are given only a temporary authorization and appropriation by Congress. Hence, in reality, laws are nothing more than temporary bench marks and law-making a continuing and incremental process.

In the next chapter the authorization process which followed the passage of HR 2362 will be discussed, but before turning to that task, it might be helpful to focus on another dimension of policy-making—the appropriation process.

Since the implementation of most policies requires an expenditure of money, the appropriation process is as vital to the existence and continuance of a program as the authorization phase. It is possible for a program to be enacted into law and yet never operate because of lack of funds. For example, in 1965 Congress enacted a national teachers corps which has only sporadically functioned since then because of appropriation problems. In 1965 Congress also authorized the controversial rent supplement plan to ease urban housing, but it was delayed in being put into operation because of congressional refusal to appropriate the money.

The President and the congressional leaders were reasonably confident that Congress would appropriate the funds needed to implement HR 2362, but this did not diminish the gravity of the appropriation decision. The stakes were too high for them to stub their toe on this hurdle. They fully realized that if they could not get sufficient funds to implement HR 2362, they would have won the authorization battle but lost the war.

The Appropriation Process

In Congress there is a careful distinction drawn between the authorization and appropriation functions. The major committees (Labor and Public Welfare, Agriculture, Judiciary, etc.) are responsible for authorizing the programs and setting appropriation ceilings. But it is the job of the House and Senate appropriations committees to allocate the funds. A program authorized by Congress cannot be implemented until the appropriation is forthcoming.

Two weeks after the passage of HR 2362, President Johnson asked Congress to appropriate $1.345 million to implement it for the first year. A White House communiqué said that this request would not increase the size of the total budget for fiscal year 1966, because this amount was included in the budget requests sent to Congress in January.

HOUSE ACTION

In mid-August the House Appropriations Committee approved a $1.2 billion supplemental appropriation bill covering various education and welfare programs. In included $967 million for elementary and secondary schools. The chairman of the HEW appropriations subcommittee, the late John E. Fogarty, pointed out that the $967 million figure was $328.6 million less than that authorized. The cut was made because two months of the fiscal year had lapsed, and it was also thought that some of the schools would not request all the funds to which they were entitled. The bill was reported out of committee without a formal vote; however, the ranking Republican on the subcommittee, Melvin Laird (Wis.), made it clear that he would challenge the bill on the floor.

Once the bill reached the floor, Laird did not attack any specific appropriation items but argued that he was opposed to separate supplemental bills. He said he favored lumping

all supplemental appropriations into a single bill to drama-
tize to the taxpayers the collective cost involved. Before the
bill was brought to a final vote, Laird offered a motion to
have it recommitted to the appropriations committee for
further study. This motion was defeated, 263 to 139. Of the
members present and voting, 81 per cent (108) of the
Republicans supported the Laird motion and 88 per cent
(238) of the Democrats voted against it. The thirty-one
Democrats supporting Laird were all Southerners. The bill
was then approved on final passage by voice vote. As was
true in this case, the motion to recommit a bill to com-
mittee is often used by the minority as a last ditch effort
to scuttle a bill before the final vote.

SENATE ACTION

In the Senate the supplemental appropriations bill passed
through the subcommittee with minimal discussion and was
reported out of the full committee without any recorded
opposition.

Once the bill was on the floor, its manager, Lister Hill,
offered several amendments designed to increase the total
cost by $184 million over the House version. The amend-
ments were accepted and the bill passed by voice vote.
Senator Hill then promptly moved that the Senate insist on
its amendments and request a conference with the House.
The motion was agreed to and the presiding officer ap-
pointed Hill and seven other senators as conferees.

When a bill passes each house of Congress in a different
form, there are two commonly used methods for resolving
the differences: 1) If a bill is amended in the second house,
the house of origin is given an opportunity to concur with
the amended version. If it does so, the process is ended and
the bill is ready for Presidential action. 2) If both houses
insist on keeping their own versions of the bill, there is need
for a conference committee. The conference committee is
an *ad hoc* body composed of an equal number of members
from both houses. Conference members are appointed by

the presiding officer of each house. By tradition they are the ranking majority and minority members of the committee which handled the bill. The purpose of the conference committee is to iron out Senate and House differences. If an agreement is reached, the conference recommendations are embodied in a conference report which is submitted back to each house. Neither house can amend the report but occasionally one or both of the houses will reject the report, thus necessitating the creation of another conference. Since legislation must pass both houses in identical form, ultimately the amendments of one house must be accepted by the other. Though it is an infrequent occurrence, it is possible for a bill to pass both houses and clear the conference committee yet die for lack of agreement on the conference report.

Senator Hill's decision to take the supplemental appropriations bill to conference did not indicate irreconcilable differences between the Senate and House. The Senate version of the bill was the higher of the two, and Hill felt it was worth going to conference to see if the House would accept at least some of the Senate increases. But if he and his colleagues found that the House conferees could not be budged, he knew the Senate could always settle for the lesser amount. This maneuver is common in the Senate on appropriation matters. Most senators feel that if a bill goes to conference, they might be able to salvage some of their amendments—otherwise the House would win by default. Of course the Senate will usually leave a little "fat" in the bill which can be cut later in the bargaining session with the House conferees.[19]

THE CONFERENCE

The passage of the 1965 HEW supplemental bill was typical of most appropriation measures, but the conference committee decision was not. Rather than adopting a higher

[19] Richard F. Fenno, Jr., *The Power of the Purse: Appropriations Politics in Congress* (Boston: Little, Brown, 1966), pp. 661, 670.

figure, the conference committee decided to reduce the bill back to the original House figure of $1.223 million (this did not affect the elementary-secondary school appropriation). The conference report was submitted to the respective houses and was quickly accepted in each by voice vote.

THE DISSIPATION OF CONFLICT

As one might imagine, conflict on the floors of Congress is more intense during the authorization process than during the appropriation phase. This does not mean that once a program is authorized, opposition evaporates. Conflict may continue, but much of it is internalized within the appropriations committees and is usually not allowed to spread to the floor.

Most members of Congress recognize the fact that once a program has been authorized the odds are overwhelming that it will be given at least partial funding. If a program is especially controversial and is authorized by a narrow vote (e.g., the teachers corps and rent supplement program in 1965), the opposition may successfully block its appropriation. But such a case is unusual. Moreover, a bill becomes less controversial as it passes through the appropriation process itself.[20]

The only significant challenge to the 1965 HEW Supplemental Appropriations Bill was the Laird motion to recommit the bill to the House appropriations committee. This motion was defeated by a decisive vote of 263 to 139, and the bill passed without recorded opposition. Eventually the conference report was accepted by voice vote. Thus the combined authorization-appropriation process covering the school aid bill was launched amid intense controversy and ended nine months later by a routine voice vote. This temporarily ended the federal aid fight, but the forces were already regrouping for a future battle.

[20] *Ibid.*, pp. 670–671.

PART III

The Policy Process

7

THE RESULTS OF
FEEDBACK

Most of us think of an act of Congress as being something permanent and final. But if we look at congressional acts over a period of time, we find that they rarely remain on the books without subsequently being modified or repealed altogether. An act of Congress represents a political decision made at one point in time. It may reflect the values of a majority in Congress at the time—though this need not always be the case. In any event, the act is not designed to be a once-and-for-all resolution of a conflict. Most often the conflict continues, inside and outside Congress, and new laws are proposed which reshape the issues and ground rules of previously fought battles.

Public policy is continually evolving. This point is made by Kenneth Boulding, who has observed that,

> In one sense, in a successful political process all decisions are interim. We live in a perpetual state of unresolved conflict. A decision is a partial resolution of conflict. It should never be a complete resolution. The majority does not rule; a majority decision is simply a

setting of the terms under which the minority continues the discussion—a discussion which presumably goes on forever or at least for the lifetime of the organization.[1]

The major job of Congress is to offer temporary solutions to existing problems, but this is no mean task. Congress must start with an accurate assessment of the problem. It must then select a prescription which is appropriate to the problem. Not only must the remedy meet the ill, but it must be properly administered. This latter task is assumed by an executive agency, although ultimately Congress must review the administration of the remedy. Compounding the difficulty of Congress to fulfill its prescriptive and over-sight functions is the fact that the problems which require legislative solutions are continually reshaped by changing conditions inside and outside the national political system. When Congress offers a prescription, it is virtually impossible for it to anticipate all future contingencies. A legislature generally must leave some discretionary power to the judge or administrator for interpreting the terms of the prescription in specific application. Congress must reserve the right to change its mind—and it often does. It is, therefore, understandable why it is reluctant to extend its decisions too far into the future. For example, the Elementary and Secondary Education Act of 1965 was authorized for a one year period only. The federal aid advocates had won a stunning victory, but they knew full well that they would have to renew the battle again the following session. The federal aid opponents had the consolation that they would have another crack at the act within a year. In this way Congress forces itself to reassess prior decisions. In fact, Congress spends much more time evaluating the results of existing programs than it does in devising new ones.

[1] Kenneth E. Boulding, *The Image* (Ann Arbor: University of Michigan Press, 1956), p. 103, quoted in Malcolm E. Jewell and Samuel C. Patterson, *The Legislative Process in the United States* (New York: Random House, 1966), p. 9.

The Concept of Feedback

In one sense the task of guiding public policy is much like that of catapulting a space vehicle to the moon. In both cases one is not apt to hit a predetermined target without correcting the course after the launching phase. Uncontrollable conditions make it unlikely that one can score a "hit" if there is complete reliance on a pre-set course. In both cases the built-in capacity for change and adjustment is the result of some of type of *feedback* mechanism.

In the case of the space vehicle, messages concerning the course and condition of the missile are transmitted back to earth via radio signals. These messages are received and evaluated by a ground crew. Based upon this intelligence source, the course and speed of the vehicle can be corrected in mid-flight by signaling back commands to automatic devices in the missile.

In directing the outputs of the national political system, Congress, the executive agencies, the President, and the courts may alter the course and speed of policies once they have been launched. The political decision makers must be apprised of the interference of unforeseen obstacles. They must be informed if the policy overshoots or falls short of the target. They must assess the intentional and unintentional by-products of the policy and survey the changes it has made in the surrounding environments. In short, there must be a feedback mechanism.

Feedback must rely on some type of communications system which allows for a two-way flow of information. The basic units of such a system include transmitters, receivers, and channels. One can easily appreciate the enormous difficulties in constructing a communications system to track a space vehicle. But we should not assume that the task of establishing a network to trace public policy is any easier. We must remember that physical technology de-

velops at a faster pace than social technology, and this is
certainly the case with perfecting feedback systems.

Like most social institutions, the communications chan-
nels which link Congress to the outside world are crude
and often difficult to examine. Most of these channels can
be lumped into major categories of formal and informal.
The formal channels include the various Presidential mes-
sages and executive reports, judicial decisions and opinions,
congressional investigations, and committee hearings.
Frequently used informal channels are phone calls, letters,
telegrams, requests, memos, and—most important of all—
face-to-face contact with colleagues, agency personnel, con-
stituents, lobbyists, and so forth. If the stability of the sys-
tem is to be preserved, communication channels (includ-
ing those used for feedback) must be sufficiently flexible to
adjust to changing conditions.

Changes Between 1965 and 1966

To maintain a sense of the dynamic nature of public policy
making, one must keep in mind the constant environmental
changes inside and outside the political system. In Chapter
2 we attempted to uncover the environmental changes
which provided an atmosphere conducive to the passage of
the 1965 school aid bill. In this chapter we will focus on
the environmental alterations between 1965 and 1967. Each
new policy promoted by the system contributes to the di-
lemma of the policy makers because it is apt to reshape
both environments.

Education must vie for the attention and resources of the
national government with numerous other problem areas.
The allocation for education is determined in part by a
sliding scale of policy priorities shaped by the crises and
demands of the moment. The escalation of the Vietnam
war was the most important factor changing this sliding
scale between the first and second sessions of the Eighty-

ninth Congress. In January, 1965, there were less than 25,000 troops stationed in South Vietnam; but by the opening of the second session there were almost 200,000. The mounting expense of the war made it increasingly difficult for Johnson to please the potential recipients of his "Great Society." It also gave him less room to bargain with Congress.

Another trouble area which had implications for education legislation was the changing nature of the civil rights movement. Prior to 1965 when one thought of civil rights and the Negro-white conflict, his mind turned to the states of the Southern Confederacy. But in recent years it has become patently obvious that the South does not hold a monopoly on the problem. Since the summer of 1964 there have been sporadic racial crises in non-Southern cities from New York to California. Although civil rights leaders condemned these violent outbursts, many Americans assumed a cause-and-effect relationship between the civil rights movement and the race riots. As a result, the cause of civil rights suffered a decline in popularity. Nowhere was this more evident than on Capitol Hill. Racial wounds were reopened on the floors of Congress during the debate on the 1966 Elementary and Secondary Education Amendments.

Compounding President Johnson's difficulties in dealing with the issues of Vietnam, inflation, and race was his diminishing popularity with the American people. When Johnson faced the first session of the Eighty-ninth Congress, his landslide victory of the previous November was still fresh in their minds. But by the beginning of the second sessions, his popularity had begun to slip, and it continued to plummet throughout 1966.[2]

In addition to his image problem with the American

[2] According to the Gallup opinion index, Johnson's popularity was approximately 70 per cent when the school bill passed in 1965. But when the 1966 measure passed, his popularity had sunk below the 50 per cent mark.

people, President Johnson found it increasingly difficult to work his will with Congress. During the final days of the first session, there were ominous indications that his honeymoon with Congress was coming to an end. Opposition to his programs increased throughout the second session. Midway through the 1965 session Johnson often was touted by the press as the most successful legislative leader since Franklin Roosevelt. There seemed to be an endless stream of superlatives describing his techniques of persuasion with Capitol Hill. Yet in one short year, many of the same Washington observers wondered if the President's congressional batting average was going to slip below that of Dwight Eisenhower—who had spent most of his two terms facing a Congress controlled by the opposition party.[3]

The fact that 1966 was an election year (an off-year election at that) had an impact on the congressional environment. Despite what we may hear or read about congressmen relying on the White House for election assistance, the fact is that each member is responsible for his own survival. In 1966 each member of Congress, including the Democrats, was preoccupied with his own reelection. The membership took positions which they felt would enhance their bid for reelection whether or not it coincided with the wishes of the President. The party in power is likely to lose congressional seats in an off-year election, and the Democrats were prepared for a loss. As it turned out, the Republicans gained forty-seven House seats—ten seats above the average for the minority party over the past sixty years. Given Johnson's slump in popularity, some congressional

[3] According to the Congressional Quarterly Service, Mr. Johnson's Presidential support score was a record 93 per cent in 1965, but this dropped fourteen points to 79 per cent for the 1966 session. His 1966 score was the lowest of any President since 1960—Eisenhower's last year with a Democratically controlled Congress. President Eisenhower's score that year was 65 per cent. For 1966 Presidential support score data see: *Congressional Quarterly Weekly Report* No. 51 (December 23, 1966), p. 3048.

Democrats were inclined to view him as a liability rather than an asset.

Between the passage of the first and second education bills, there were two significant personnel changes within the Department of Health, Education, and Welfare. In July 1965, Anthony J. Celebrezze was replaced by John W. Gardner as HEW Secretary. In September 1965, Francis Keppel shifted his position within HEW from Commissioner of Education to Assistant Secretary. Harold Howe II replaced Keppel as Commissioner of Education. Mr. Gardner was a former president of the Carnegie Foundation and had headed the President's special task force on education in 1964. Prior to his appointment as commissioner, Mr. Howe had extensive experience in school administration and was former director of the Learning Institute of North Carolina.

The appointment of Gardner was warmly received by both sides of the aisle in Congress, and he became an asset in aiding the President with his 1966 education proposals. But Mr. Howe became a distinct liability. In order to understand congressional hostility toward Howe, one must keep in mind that he assumed office during a period of increasing anxiety over the issue of de facto segregation. In the spring of 1966, he assumed the distinction of being commissioner when the first federal funds were cut to twelve school districts in the South (under Title VI of the 1964 Civil Rights Act) for failure to comply with desegregation guidelines. Subsequently he alluded to the evils of de facto segregation in several public speeches. By the time the 1966 school bill was debated in Congress, the Southern members were ready to hang him from the nearest tree. It was once said that the Secretary of Agriculture had the most thankless job in the national government, but at this point in time the Commissioner of Education probably has taken this dubious honor. The fact that inevitably the administrative officer has the duty of interpreting the general language of the statute in applying it to specific situa-

tions makes members of the law-making body aware of his point of view. Regardless of the administrator's interpretation, he always runs the risk of reigniting a smoldering legislative controversy. Hence the early years of applying a statute or implementing a program are usually the most difficult for the executive agency involved.

Before discussing the federal aid controversy of 1966, it might be helpful to make a brief assessment of PL 89–10 during its first year of operation.[4]

The First Year of PL 89–10

When HR 2362 was before Congress in 1965, the most intense controversy centered on aid to parochial schools maintained by religious sects. In addition to questioning the constitutionality of the bill, its opponents feared that it would encourage a destructive competition for funds at the local level between public and private schools. Those harboring this fear argued that the bill would produce community strife and disrupt the schools.

After the first year of operation of PL 89–10, most indications were that this type of conflict had not occurred. During the Senate and House hearings of 1966, committee members of both parties repeatedly asked public and private school administrators to comment on public-private competition for federal funds. Without exception school administrators expressed their amazement over the high degree of congeniality and cooperation between public and private schools.

Some feared that the religious parochial schools would

[4] After HR 2362 was enacted it became public law 89–10 (PL 89–10). Since 1957 the public law numbers are determined by the number of the Congress and the sequence of public laws enacted. Hence in PL 89–10, the prefix (89) identifies the Congress and the number (10) means there were nine public laws preceding it.

try to extract from the federal treasury every cent they possibly could. But here again this apprehension was not supported by the first year's experience with the act. In fact, the Catholic schools were entitled to considerably more aid than they requested. In May 1966, the National Advisory Council on the Education of Disadvantaged Children (appointed by President Johnson) reported "some early indications that the disadvantaged children in private and parochial schools are receiving less help than Title I intended them."[5]

The private schools were not alone in their failure to take full advantage of available federal assistance—the same was true for most public schools. A report issued by the Office of Education in September 1966 indicated that only a few states had requested their maximum share of aid under PL 89–10. At the end of the first fiscal year there was $132 million left over.[6] In 1966 the members of Congress reviewing PL 89–10 were no longer worried about public versus private school competition for federal funds. They were concerned with means that could be used to encourage schools of both types to apply for more assistance.

While HR 2362 was being considered by Congress in 1965, most of the criticism of the bill's opponents was leveled at the allocation formula of Title I. They argued that the bill allocated too much money to the wealthy areas and not enough to the impoverished districts. After one year of operation it was obvious that there was some validity in their charges. The minority members of the House committee included a table in their section of the 1966 committee report which clearly showed that the ten most

[5] Quoted in *The New York Times*, May 10, 1966.
[6] Eleven states used less than 80 per cent of their allotment, including two of the most impoverished states in the union. Mississippi used only 69 per cent of the available funds and Louisiana applied for only 66 per cent. On a maximum utilization scale, Florida ranked first with 100 per cent and Massachusetts was low with 55 per cent.

wealthy counties in the nation received more aid during the first year than the ten poorest counties.[7]

In 1965 the emotion-packed issue of federal control of education dominated discussions on the school bill. As previous chapters indicate, Republicans and Southern Democrats were especially exercised over the issue. In 1966 the federal control issue was not ignored, but it did not spark the same partisan conflict that it had in previous years. During the committee hearings in 1966, public school administrators were asked repeatedly about the control and interference of Washington in local school affairs. Virtually all the school administrators said that they had not experienced any undue pressure or control by the Office of Education. The most interesting development in 1966 on this issue was the new wave of concern among non-Southern Democrats. Probably the de facto school segregation controversy accounted for most of this new-found concern.

Feedback from the White House

Among all participants in the policy process the President is primarily responsible for planning and balancing the long-range policy goals of the national government. As conditions change and demands shift, the President must make a continual reassessment of national policy priorities.

[7] One of the wealthiest suburbs in the nation, Bel Air, California, qualified for assistance under the act but embarrassed the Office of Education by publicly refusing it. In another instance, Representative Henry Reuss, a liberal Democrat from Milwaukee, was distressed to learn that a wealthy Milwaukee suburb qualified for a $25,000 Title I grant. In a protest speech on the House floor, Mr. Reuss said that "Title I was set up to help high concentrations of low income families, not to divert funds to wealthy suburbs able to pay for their own programs. Moreover, he threatened to have his Government Operations Subcommittee investigate Title I allocations. This threat, however, was never carried out. See the *House Committee on Education and Labor Report on HR 13161*, 1966, p. 117.

This continuing reassessment is outlined by the President each year in his State of the Union message. Specific policy proposals are funneled to Congress in supplemental messages. Because the President is the chief policy coordinator, the legislators, of necessity, must consider his requests. Congress does not always give the President what he wants, but most often it is forced to consider policy within the general framework he has outlined. As a result, the White House is a vital link in the flow of information used by Congress to consider new policies and reevaluate existing ones. By 1966, as was true the previous year, Congress deferred action on federal aid legislation until it received President Johnson's proposals.

When President Johnson delivered his State of the Union message in January 1966, he attempted to assure Congress and the nation that domestic programs would not be sacrificed because of Vietnam. On this question he said, "I believe that we can continue the Great Society while we fight in Vietnam." But, could this be accomplished and still remain within the $112.8 billion budget the President planned to present? In regard to this question, Johnson said, "If the necessities of Vietnam require it, I will not hesitate to return to Congress for additional appropriations or additional revenues if they are needed." Members of Congress of both parties were dubious about the President's ability to reconcile the domestic and defense demands and remain within his budget.

The President's State of the Union message did not contain specific recommendations on school assistance. It did contain a vague reference to the need for fulfilling and improving the educational programs of the previous year. Federal aid advocates withheld judgment on the President's new education proposals until they were given a list of particulars. Eventually this list was included in the President's special health and education message sent to Congress on March 1. The President proposed the following: 1) Extension of the Elementary and Secondary Education

Act for an additional four years (In 1965 it was given only a one-year authorization.); 2) Repeal and reduction of several provisions in impacted areas legislation (This proposal was designed to eliminate aid to 1,200 of the 4,100 districts covered with a reduction of funds from $466 million in fiscal 1966 to $206 million for fiscal 1967.); 3) Repeal the incentive grant provision of Title I (the provision designed to grant bonus federal grants to school districts which increased local expenditures in 1964 and 1965); 4) Increase the coverage of the act (starting in fiscal year 1968) by raising the family income figure for allocating aid to the disadvantaged from $2,000 to $3,000; 5) Grant an additional $5 million for districts planning school construction to deal with problems of obsolescence and de facto segregation; 6) Earmark additional funds for children of American Indians and migrant workers.

Congressional Reaction

In the minds of most members of Congress, President Johnson's 1966 education package was, at best, a "mixed bag." When the recommendations were issued, it was difficult to find even Northern Democrats who were willing to voice unequivocal support for every proposal. In fact, there was something in the President's package which was bound to alienate nearly everyone. On some points there was an immediate negative response. On other proposals, hostility was uncovered during the hearings. Congressional reaction in 1966 was in marked contrast to the warm reception given to Johnson's program by the Democrats the previous year.

FOUR-YEAR AUTHORIZATION

President Johnson's proposal to extend authorization of the Elementary and Secondary Education Act for a four-

year period was not received by Congress with enthusiasm.
House subcommittee chairman Perkins favored the four-
year extension, but his other committee colleagues either
remained silent or voiced their opposition. But this reac-
tion is typical of congressional attitudes on most major
programs. Members on most major committees are reluctant
to grant an authorization for an extended period of time
because it interferes with the committee's freedom to re-
peal and modify. There is a general feeling, especially on
massive new programs, that an authorization in excess of
two years gives too much latitude to the executive agency
responsible for administering the program and diminishes
the influence of congressional committees.

On the other hand, executive agencies and participants
in the programs argue that authorizations for longer periods
are necessary to facilitate planning and administration.
Executive agencies contend that it is difficult to launch a
program and keep it running smoothly without assuring
the participants that it will be in existence for several
years. In 1966 the Administration witnesses and all public
school administrators who appeared before the two educa-
tion subcommittees strongly endorsed the four-year authori-
zation. The members listened politely but in the end were
not willing to extend the act for more than two years.

IMPACTED AREA CUTS

The most intense and widespread hostility in Congress
was directed toward the President's proposal to curtail aid
to federally-impacted areas. The first impacted areas legis-
lation passed Congress in 1950. Since then, this type of
assistance has been continued and expanded. It is one form
of federal aid to education which, over the years, has won
the support of even the most conservative Republicans in
Congress. In fact, it is one of the most popular of all do-
mestic programs of recent years.

Senator Morse and Representative Adam Clayton Powell

went through the ritual of introducing the Administration's bill, but both made it clear that they did so with reservations. In reference to the provision for cutting impacted areas funds, Powell told the press that he would not support it and added, "The President is not running for reelection this year—we are."[8]

Certainly the President was aware of the strong feelings in Congress toward this program. Surely he must have expected intense opposition. But he issued his proposal anyway. How does one therefore explain Johnson's motive? The most plausible and widely held explanation is that the President's proposal was a calculated scheme to put Congress over a barrel. The President wanted a larger budget than the one he submitted, but he did not want to be saddled with the unpopular task of requesting a tax increase to support it. Therefore, he cut those items which he thought Congress was most likely to restore. Hence, if the restorations were made, the President could blame Congress for necessitating a tax increase.

INCENTIVE GRANT REPEAL

After the House and Senate hearings were underway it soon became clear that certain Democratic members of Congress were disgruntled over other provisions in the Administration's bill. For example, the large city congressmen from wealthier states opposed repeal of the incentive grant provision of Title I. This opposition was led by Representative Hugh L. Carey (D. N.Y.), who was author of this provision in the 1965 act. The incentive grants were originally intended to woo large city congressional support. In recent years the urban school districts have been rapidly expanding local expenditures for education. Therefore, they stood to gain the most under the provision.

In 1965 the Administration witnesses were taken to task by the Republicans on the House subcommittee. But in

[8] *The New York Times*, March 3, 1966.

1966 Secretary Gardner and his entourage of assistants found the committee Democrats more troublesome than the Republicans.

SIZE OF THE AUTHORIZATION

While the House Democrats were asserting their independence from the White House, on the other side of Capitol Hill Senator Robert F. Kennedy (D. N.Y.) was leading the Senate committee Democrats in an attack on the Administration witnesses for not requesting more money. Often we have the picture of the executive branch wanting to spend as much money as Congress will allow. But this is not always so. There are times when Congress wants to spend more money than the executive agency involved. Such was the case with the 1966 elementary and secondary education amendments.

Of course, when an Administration witness appears before a committee it is difficult to determine if his testimony reflects his own feelings or merely the Administration's line. In 1966, the Bureau of the Budget (presumably acting with the consent of the President) reduced the size of Title I requests. The Office of Education originally requested approximately $1.3 billion, but the Bureau of the Budget made a cut of $230 million—leaving the figure at $1.07 billion in the Administration bill. Commissioner Howe appeared before the Senate subcommittee to defend the President's requests. Senator Kennedy attempted to test the sincerity of Howe's testimony by asking him how he could support the lower request figure when, just a few months before, his office had submitted a request substantially larger. This line of questioning was an attempt to place Howe on the horns of a dilemma. Either the commissioner would have to admit that his original request was inflated, or he would have to challenge the President. Commissioner Howe chose neither alternative, and decided to be noncommittal. After several evasions, Senator Kennedy finally said to Howe,

"Let me just ask you a question: Are you, in fact, saying that the Bureau of the Budget was right and you were wrong in this request?" Mr. Howe's response was, "I am saying I really don't know."[9]

THE ALLOCATION FORMULA

While the congressional Democrats were castigating the Administration for repealing the incentive grants and not requesting more money, the Republicans were focusing their criticism on the allocation formula. They renewed their charge that the wealthy school districts were receiving too much aid and the impoverished schools were not getting enough. Much of the questioning by GOP members during the hearings centered on the allocation formula. This became the central complaint of the minority members in the committee reports of both houses.

In 1966 the Office of Economic Opportunity (OEO) had jurisdiction over preschool (Headstart) and adult education programs. Most Republicans favored transferring jurisdiction of these programs from the OEO to the Office of Education. They argued that such programs should be administered by professional educators and should not be a part of the controversial poverty program. The House Republicans were unsuccessful in their attempt to amend the Administration's bill making this transfer; however, the Senate committee accepted a proposal which shifted authority over adult education programs from OEO to the Office of Education.

The House Decision

The congressional Democrats and President Johnson forged the 1965 school aid bill by deftly amalgamating numerous and diverse interests. The major question facing federal aid

[9] *Senate Hearings on S 3046*, p. 345.

advocates in the next session was—would the bonds welded in 1965 be strong enough to support the 1966 amendments? The President and most members of Congress were certain that the 1965 act would be continued. But at mid-session it was difficult to determine exactly what form the amendments would eventually take. It was clear by mid-session that the education alliance of 1965 increasingly was showing signs of wear. For example, there was a rift among House committee Democrats on the issues of repeal of the incentive grants and the allocation formula. One faction, led by Hugh Carey, was composed of urban Democrats from affluent states. This group favored retaining the grants and was satisfied with the formula. The other faction was composed of rural Democrats from impoverished areas and was led by Carl Perkins. This latter group favored abolition of incentive grants, and eventually aligned with the Republicans to amend the allocation formula.

A month and a half after the hearings had ended, the Perkins subcommittee had its first mark-up session on HR 13161 (the 1966 Elementary and Secondary Education Amendments). The bill cleared the subcommittee with all major provisions intact. There were a few modifications which resulted in boosting the total authorization by $120 million. The subcommittee's action was a victory for the Administration. But those attuned to the conflicting demands of the committee Democrats expected substantial changes at the full committee mark-up stage. Four months later these expectations were fulfilled.

After several days of intense squabbling, the full committee finally reported out HR 13161—but not before making several significant changes. The subcommittee had gone along with the Administration's request to extend authorization for four years, but the full committee cut this down to two. The subcommittee was able to keep the total cost of the bill within $120 million of the President's request, but the full committee's version of the bill exceeded his request by nearly $500 million.

At the subcommittee stage the large city forces led by
Hugh Carey were unable to restore the incentive grant
provision, but they were successful in amending the alloca-
tion formula. Under the 1965 act, children from families
receiving Aid to Families with Dependent Children
(AFDC) were included in the allocation formula based
upon 1962 data. The Carey amendment required the use
of up-dated data. It was estimated that this would increase
the cost of the bill by approximately $98 million for fiscal
1967. Despite the opposition of the large city faction, an-
other significant change in the allocation formula was made
at the full committee stage. Albert Quie (R. Minn.) and
Carl Perkins (D. Ky.) pushed through an amendment de-
signed to increase aid to the poorer states beginning in
fiscal 1968. Under the 1965 act, the allocation formula was
determined by taking one-half of the average expenditure
per pupil in the state times the number of children (ages
5 to 17) in families with annual incomes less than $2,000.
Under the Quie-Perkins amendment the allocation is based
upon one-half the average expenditure per pupil in the state
or in the nation (whichever is greater). This increases
assistance to those districts where the state per pupil ex-
penditure falls below the national average.[10]

The full committee accepted the President's request to
increase the family income figure in the allocation formula
from $2,000 to $3,000 beginning in fiscal 1968. But as ex-
pected, it ignored Johnson's request to curtail federal as-
sistance to impacted areas. In fact, this provision was lib-
eralized by extending aid to an additional 1,000 school dis-
tricts at an estimated annual cost of $35 million.

The committee accepted the provision earmarking aid to
children of migrant workers and American Indians. It

[10] For example, in 1966 the national average expenditure was
$500, while the state expenditure of Mississippi was only $273.
In this case, the base figure for Mississippi would be increased
from $273 to $500. In 1966 there were twenty-nine states with
per pupil expenditures below the national average.

also adopted the President's proposal for allocating $5 million to districts planning school construction to deal with problems of obsolescence and racial imbalance.

After HR 13161 was reported out of the Education and Labor Committee, it was sent to the Rules Committee. The federal aid opponents on Rules, most notably Chairman Howard Smith (D. Va.) and William Colmer (D. Miss.), had little hope of blocking the bill. But they did take advantage of the Rules Committee hearings to attract congressional attention to the most controversial aspects of the bill—especially the provision for assisting schools interested in eliminating racial imbalance.

FLOOR ACTION

HR 13161 did not reach the floor until October 5, which was late in the session. The fact that it was late increased anxiety for the President and the sponsors because it is more difficult to handle a bill at the end of the session. By the time Congress prepares for adjournment, nerves are frayed thin and the members are anxious to return home.

Because of the racial disturbances in the cities during the summers of 1965 and 1966, plus the new enforcement of Title VI of the 1964 Civil Rights Act, congressional leaders feared the school desegregation controversy would be fused with the federal aid issue and thereby threaten the fate of HR 13161. The federal aid coalition of 1965 was designed to withstand the pressures of the private versus public school question, but its strength had not been tested on the issue of school integration.

Shortly after Chairman Powell and floor leader Perkins opened the first day's session, discussion moved to school integration. The question was opened when North Carolina Democrat Horace Kornegay asked Perkins, "Is there any provision in the bill, as we have it here now, that would authorize or is there any provision in the bill that will authorize funds which can be used for the purpose of bus-

ing school children from one school to another or from
one administrative unit to another?"[11] Mr. Perkins attempted
to assure Kornegay that funds could not be used to force
racial balance by busing school children. But it soon be-
came clear that his assurance was not going to satisfy most
of the members concerned with the issue.

The next member to voice his anxiety was Paul Fino—
a Republican from the Bronx. By October 1966 the ques-
tion of de facto segregation and school busing had become
a heated political issue in New York City, and Fino seemed
determined to make a record of his opposition.

When the second day of debate opened, Fino renewed
discussion on racial balance in schools and launched a scath-
ing attack on Commissioner Howe denouncing him as a
"sociological quack." Despite the efforts of Perkins and
other committee Democrats to quell the issue, it was ob-
vious that something was needed to quiet the opposition.
As E. E. Schattschneider points out in *The Semi-sov-
ereign People* (New York: Holt, Rinehart and Winston,
1960), political conflict has a tendency to be contagious.
And on the House floor what may start as a small brush
fire of dissension could easily grow into a major conflagra-
tion. Recognizing this fact, James O'Hara (one of the bill's
staunchest backers and a civil rights advocate) offered an
amendment prohibiting any department, agency, officer, or
employee of the federal government from requiring "the
assignment or transportation of students or teachers in order
to overcome racial imbalance." The amendment was quickly
adopted, but the controversy was not ended.

After the House adopted the school busing amendment,
O'Hara offered a second amendment designed to eliminate
the provision in HR 13161 that gave special consideration
to schools desiring to eliminate racial imbalance. Here again
O'Hara was attempting to protect the bill by eliminating

[11] *Congressional Record*, Daily Edition (October 5, 1966),
p. 24334.

a provision which had the potential of igniting uncontrollable hostility. When the amendment was introduced, O'Hara stated his intentions by saying:

> Mr. Chairman, there has been a good deal of "flap" over this, which I believe to be entirely unwarranted because if a school district has a serious problem of racial imbalance within its schools which it wants to correct because it believes doing so would improve its educational system, I think it might be entitled to a little special consideration, but since an effort has been made to take this simple provision and turn it into some sort of ogre I am offering to take it out.[12]

This amendment was swiftly adopted by voice vote. But once again it did not satisfy the fears harbored by many House members that the Office of Education might be unreasonable and arbitrary in its efforts to promote integration and racial balance in local schools.

After rejecting a series of amendments offered by committee Republicans to scale down the cost of the bill, the House once again turned its attention to the racial question. The preoccupation of the members with this issue was cause for some alarm among federal aid advocates and the Democratic leadership. They felt they had enough votes to defeat any amendments to the bill *except* those involving race.

Before debate on HR 13161 came to a close, Representative H. L. Fountain (D. N.C) proposed an amendment prohibiting the Commissioner of Education from withholding funds for alleged practices of segregation without a hearing and an "expressed finding on record" of noncompliance with Title VI of the 1964 Civil Rights Act.

The Administration's position was defended by the venerable and revered chairman of the Judiciary Committee, Emanuel Celler (D. N.Y.). According to Celler the Justice

[12] *Ibid.*, (October 6, 1966), p. 24543.

Department had advised the Commissioner of Education that funds for new programs could be deferred—without holding hearings—until the desegregation guidelines set by the office had been met. Mr. Celler maintained that the Fountain Amendment would "emasculate" Title VI of the Civil Rights Act because "obviously the administration cannot refuse funds after they have been paid."[13] Therefore it is necessary, he argued, to delay payments for a limited period until an administrative determination is made. Despite the pleas of Celler and several Democratic members of the Education and Labor Committee, the Fountain amendment was adopted by a vote of 221 to 116.[14]

After the Fountain amendment was accepted, the Republicans moved to have the bill recommitted to the Education and Labor Committee with instructions to cut the first year's authorization by $343 million. This motion was rejected 150 to 185 (Democrats, 57 to 172; Republicans, 93 to 13). The bill was then passed in its final form 237 to 97 (Democrats, 190 to 38; Republicans, 47 to 59).

The Senate Decision

During the period from March to October, while HR 13161 was being considered by the House, its counterpart —S 3046—was proceeding through the legislative maze in the Senate. During the hearings conducted by the Morse subcommittee in April, it became clear that each committee member—including Chairman Morse—took exception to at least one provision in the Administration's bill. In 1965

13 *Ibid*, p. 24563.
14 Voting in the affirmative were 63 Southern Democrats, 54 Northern Democrats, and 103 Republicans. Voting in the negative were 4 Southern Democrats, 108 Northern Democrats, and 4 Republicans. The bloc of 54 Northern Democrats provided the winning margin for the amendment.

Morse had been willing to hold the line on all amendments in order to expedite and protect the school bill. But in 1966 it was obvious from the start that he would not practice the same restraint. In fact, the 1966 bill was amended more in the Senate than it was in the House.

There were early indications in statements made to the press that the Senate probably would surpass the House in raising the cost of the bill. The longer the session continued, the more concerned the President became over the probable increases and the more he sounded like a fiscal conservative. In April, President Johnson warned those members of Congress who were seeking to increase the authorization for the school bill that "we can make mistakes in going too far too fast." He later remarked, "we shall not be stampeded into unwise programs."[15] Several months later in an appearance before a Senate subcommittee, HEW Secretary Gardner alluded to his difficulties in keeping a ceiling on the costs of the school bill and said, "Congress occasionally tries to force more money on his department than it can intelligently handle."[16]

When S 3046 cleared the Morse subcommittee on July 15, the bill contained first year authorizations which exceeded the Administration's requests by approximately $1.5 billion. The next day Johnson held a meeting at the White House for congressional committee chairmen. The President called the meeting to request the chairmen to keep authorizations and appropriations within the limits of his budget. Senator Hill promised Johnson that he would try to cut back some of the increases in the education bill voted out of the Morse subcommittee the previous day. The following day the President called a press conference and warned that continued congressional spending would "overheat" the economy.

When S 3046 finally cleared the full committee in late

[15] *The New York Times,* April 23, 1966.
[16] *Ibid.,* April 19, 1966.

September, its total first year authorization was $2.7 billion. This was less than the subcommittee version, but it still exceeded the Administration's requests by almost $1 billion. Moreover, it was approximately $600 million more than the bill in the House.

The House and Senate versions of the 1966 education bill differed in substance as well as in cost. The most significant differences were in Title I. The Senate committee raised the low income eligibility factor from $2,000 to $2,500 for fiscal 1967 and to $3,000 for fiscal 1968. But the House went along with the President's request and left the eligibility factor at $2,000 for fiscal 1967 with a proposed increase to $3,000 for fiscal 1968. This meant there would be more children covered under S 3046 in fiscal 1967 at an additional cost of $200 million.

The Senate committee adopted an amendment authorizing an additional $56 million (over HR 13161) for supplementary education centers. Moreover, the Senate committee (once again with GOP assistance) added a new section covering handicapped children at an annual cost of $154 million. Like the committee version of HR 13161 (before it reached the House floor), the Senate bill contained a provision granting assistance to encourage schools to eliminate overcrowded classrooms, building obsolescence, and racial imbalance. Like their House counterpart, the Senate committee liberalized payments to impacted areas, but the Senate qualifications were more restrictive. Under HR 13161 a school district could qualify for impacted aid if there were either 3 per cent or one hundred children in the district with federally connected status. Under S 3046 the qualification was 3 per cent or one thousand children.

In the House there were several unsuccessful attempts to transfer adult education programs from the Office of Economic Opportunity to the Office of Education. This transfer was provided for in the Senate bill. Also the Senate committee adopted an amendment similar to the Quie-Perkins amendment broadening the allocation formula.

FLOOR ACTION

When S 3046 reached the floor of the Senate on October 5—the same day the House took up HR 13161—Wayne Morse took charge as the bill manager. This was the same role he skillfully played in 1965. But circumstances had changed during the intervening year both inside and outside Congress, and the Morse strategy and tactics were completely different the second time around. In 1965 the Morse strategy was to protect the Administration's bill down to the last comma. In 1966 the Morse strategy was to oppose any attempt to bring the bill into line with the President's original requests. In 1965 Morse scrupulously avoided those issues which would point up his policy differences with the President. In 1966 Morse deliberately focused on policy differences with Johnson—especially on the Vietnam war. This was done as an effort to blunt Administration attempts to change the committee's bill. Morse opened debate by saying that his country should not attempt to pay for Vietnam at the expense of our school children, and he served notice to the President that he would oppose any effort to reduce the cost of the bill.

Since Senator Morse was not going to serve as the Administration's advocate on the floor, he was curious as to who would fill this role. The day before debate he asked Majority Leader Mansfield who was going to serve as Johnson's "mouthpiece" on the education bill. Mansfield smiled and said, "You will find out." When the second day of debate started, Morse found out. It was none other than the eloquent minority leader, Everett McKinley Dirksen! This revelation came when Dirksen offered the first of a series of amendments intended to bring the bill into line with the Administration's requests. In light of the strategy employed by Morse the previous year, his response to the first Dirksen amendment is more than slightly amusing. He said,

In essence, the amendment of the senator from Illinois [Mr. Dirksen] seeks to substitute the President's budget figures for the figures recommended to the Senate by the committee. Therefore, let us face it, it is a question as to whether or not the Senate, this afternoon, is going to substitute the President of the United States for the Senate, by rubber-stamping the President and make him the legislative body also.[17]

Here we have the peculiar spectacle of a Democratic bill manager accusing a Republican leader of rubber-stamping a proposal made by a Democratic President!

In all, Senator Dirksen offered four amendments to the bill, and each was rejected by a decisive vote. Finally Dirksen proposed a motion to recommit the bill to the Labor and Public Welfare Committee with instructions to bring its authorization into line with the President's budget requests. This motion was defeated by a vote of 23 to 48 (Democrats, 12 to 38; Republicans, 11 to 10).

The bill did not clear the Senate, however, without stimulating a brief debate on two emotionally charged issues—school prayer and racial integration. In June 1962, the Supreme Court prohibited the state of New York from composing and prescribing a prayer for recitation in its public schools. Between June 1962 and October 1966 there were almost two hundred resolutions introduced in Congress aimed at reversing this decision. For several years the effort in the Senate to legalize school prayer has been led by Minority Leader Dirksen. Two weeks before debate started on S 3046, the latest attempt to secure Senate passage of the Dirksen prayer amendment failed (by nine votes) to receive the two-thirds vote necessary for constitutional amendments. The controversy was momentarily reopened when Vance Hartke (D. Ind.) introduced an amendment to S 3046, declaring, it is the sense of Congress that any school district could provide time for "prayerful meditation"

[17] *Congressional Record*, Daily Edition (October 6, 1966), p. 14457.

providing no public official prescribe or recite a prayer. Senator Hartke claimed that his amendment was simply designed to clarify the 1962 decision. Senator Mansfield quickly moved to table the amendment, and his motion was adopted by voice vote.

After the Hartke amendment was dispensed with, Paul Fannin (R. Ariz.) introduced an amendment prohibiting the Commissioner of Education from giving special consideration to local school proposals dealing with "racial imbalance." Despite the pleas of several committee Democrats to defeat the Fannin amendment, Wayne Morse accepted it, saying, "It would serve the best interest of the principle of guaranteeing non-Federal interference in the operation of local schools. . . ."[18] It was adopted by voice vote.

The Senate finally passed S 3046 by a vote of 54 to 16 (Democrats, 41 to 8; Republicans 13 to 8). But unlike the experience of the previous year, it was necessary to call a conference committee to iron out the differences in the Senate and House versions of the bill.

THE CONFERENCE COMPROMISE

After two full days of negotiation the Senate and House conferees were able to hammer out a compromise. The conference bill authorized $2.4 billion for fiscal 1967. This represented a compromise between the $2.7 billion Senate bill and the $2.1 billion authorized by the House. In typical fashion the Senate went to conference with the higher figure, and the compromise gave them the edge.

The conferees decided to eliminate the Senate amendment that raised the low income factor to $2,500 for fiscal 1967 and adopted the House provision which left the income factor at $2,000 for fiscal 1967, increasing it to $3,000 for fiscal 1968. But the conference did accept two important Senate provisions: one providing for new programs for handicapped children, and the other transferring basic

[18] *Ibid.*, p. 24479.

education programs from OEO to the Office of Education. On the impacted aid section of the bill, a compromise was reached allowing aid to districts with four hundred or more federally connected children. The figure was one hundred in HR 13161 and one thousand in 3046. Although the conference sessions included the usual amount of bickering over money, the most difficult problem centered on the House (Fountain) amendment prohibiting the Office of Education from withholding funds for alleged practices of discrimination without a hearing and an expressed finding. This amendment had not been adopted in the Senate. Most conferees from both houses were of a mind to eliminate it completely, but they feared that such an action would jeopardize passage of the conference bill in the House, which had adopted the Fountain amendment by a solid vote of 220 to 116. As one conferee put it, "Our job was to decide what kind of a compromise the House would buy."[19] Finally a compromise was effected and accepted by all conferees except Representative Ralph J. Scott (D. N.C.). The new provision, which was written by Senator Jacob Javits (R. N.Y.), allows the Commissioner of Education to defer funds for a ninety-day period, during which time a hearing is to be held.

The conference bill was accepted by voice vote in the Senate. In the House it provoked some opposition on the floor, mainly from Southerners, despite the fact that Representative Fountain sent word to the floor that he accepted the compromise language. The bill finally passed by a vote of 185 to 76.

Involvement of the Judiciary

Thus far attention has been focused on the roles of Congress, the President, and the bureaucracy in the policy process. However, we should not overlook another important

[19] Quoted in *The New York Times*, October 19, 1966.

participant—the judiciary. Typically the President initiates and proposes policy. Congress prescribes the general policy framework. But the final success and character of the policy cannot be determined until it has been implemented by the executive agencies and interpreted by the courts.

Since policy making is a continuous process, the judiciary is an important participant at every stage. We often think of the importance of court decisions in modifying and terminating policy, but it should be remembered that the courts play a role at the initiation stage. For example, in 1965 the Office of Education and Congress had to review previous court decisions for constitutional guidelines to follow in drafting the school bill—especially those sections involving assistance to private schools. Since the passage of the act, the courts have been requested to determine its constitutionality. Eventually these court decisions will become a part of the feedback flow of information to be used in future policy formulation.

THE COURT SUITS

The political system responds to demands made upon it by various segments of the external environment. Most often these demands are articulated by political interest groups. Since the system is a myriad of decision points, there are numerous channels through which demands flow.[20] When groups are not satisfied with a decision made in one part of the system, they will carry their grievances to another part.

The court suits filed in recent months challenging the constitutionality of the 1965 education act are an ex-

[20] David Truman points out that American politics is characterized by a "multiplicity of co-ordinate or nearly co-ordinate points of access to governmental decisions." Truman adds that "this diversity assures a variety of modes for the participation of interest groups . . ." David B. Truman, *The Governmental Process* (New York: Alfred A. Knopf, 1959), p. 519.

ample of how patterns of demands made by interest groups change as a result of what they consider to be an adverse policy decision.

Perhaps the most bitter controversy stimulated by federal aid proposals has been over the inclusion of church-related schools in such aid. The 1965 education bill was an ingenious scheme to secure congressional passage, but it did not, by any means, resolve the church-state controversy. Group support for the 1965 bill represented a new level of consensus, but there remained a substantial number of groups which were not satisfied. Some of the more significant dissenting groups were Protestants and Other Americans United for Separation of Church and State, the American Civil Liberties Union, and the American Jewish Congress.

While the 1965 and 1966 bills were being considered in Congress, spokesmen for these groups voiced their opposition in testimony before the House and Senate committees. But by the summer of 1966 it was clear that Congress was not going to change its mind about assistance to private schools. Hence the local affiliate of Protestants and Others United for Separation of Church and State chose July Fourth (presumably for its symbolic sake) to file suit in the Federal District Court of Dayton, Ohio, challenging the constitutionality of the 1965 education act. The suit challenged those provisions which allow federally financed library and educational materials to be used by children in church related schools. In 1966 similar suits were filed in Pennsylvania and New York.

It is not surprising that the groups opposing the 1965 act had to resort to the courts to press their grievances. Congress deliberately left the church-state question vague, and the agencies responsible for its administration are unable to clear the ambiguities. The state education agencies argue that they are merely middlemen used to channel the funds to local schools and, therefore, are in no position to resolve the controversy. The Office of Education claims that

it cannot make a final determination of the issue either. At a news conference in November 1966, Commissioner Howe said that the courts will have to clarify the question, and until this is done his office and the state education agencies will continue to have trouble.[21]

Until the courts resolve the church-state controversy, it will be difficult for the Office of Education and state education agencies to establish routine administration of the 1965 education act.

Impact on Administration

The 1965 administrative reorganization of the Office of Education (USOE) illustrates the impact of policy on the structure and organization of a unit within the system. Recently, USOE has undergone a transformation from a small, obscure, rather low-keyed operation to one of the busiest, most controversial, and far-reaching agencies in the national government. Passage of the 1965 education act was instrumental in accelerating the tempo of this transformation.

After the election results of 1964 were tallied, strategists in Congress, the White House, and the Office of Education were reasonably confident that the federal aid revolution was going to become a reality during the first session of the Eighty-ninth Congress. This prospect caused Commissioner Keppel to consider the administrative remodeling within USOE which would be necessary to enable it to shoulder new massive responsibilities.[22]

[21] David Truman describes the nature of Howe's predicament by saying, "The administrator's position in controlling the access of competing interest groups is made more difficult if the terms of his mandate from the legislature are highly ambiguous. . . . The administrator is called upon to resolve the difficulties that were too thorny for the legislature to solve. . . . What the administrator is forced to seek is a means of converting the controversial into the routine." Truman, *op. cit.*, pp. 443–444.

[22] Stephen K. Bailey, "The Office of Education: The Politics

The effort to reorganize USOE was launched in March 1965 when Keppel appointed Henry Loomis—the former Director of the Voice of America—as Deputy Commissioner of Education in charge of remodeling the office. With the support of Keppel and the assistance of a special task force composed of administrative experts from high level government posts outside HEW, "Loomis put the Office of Education through the wringer of almost total reorganization of structure and staff."[23] This swift ax of reform created temporary administrative chaos and produced intense personal animosities, but within a year USOE was converted into virtually a new agency. Under the new arrangement, the Office of the Commissioner has been sufficiently strengthened to enable him to control and coordinate the activities of four newly created operating bureaus.

The 1965 Elementary and Secondary Education Act was not the only factor which contributed to the reorganization of the Office of Education.[24] But, at the very least, it was the last of several straws which finally broke the back of an outmoded bureaucratic structure.

1967—The Battle Continues

Raymond Bauer, Ithiel de Sola Pool, and Lewis Dexter have observed that:

A legislative enactment is seldom a clean decision of

of Rapid Growth," a paper prepared for delivery at the 1966 Annual Meeting of the American Political Science Association (Statler-Hilton Hotel, New York City, September 6–10, 1967), p. 20.

[23] *Ibid.*, p. 22.

[24] Among other factors which contributed to the structural crisis within USOE were: 1) The addition of new education programs since 1958; 2) The new push for federal aid under the Kennedy and Johnson administrations; and 3) Title VI of the 1964 Civil Rights Act.

important issues. It is normally a verbal formula which the majority of congressmen find adequate as a basis for their continuing a policy struggle. It sets up new ground rules within which the issues may be fought out. The ground rules will reflect the balance of forces, but the minority is seldom so weak on a major issue that it has to accept a once-and-for-all decision. The formula must usually offer them the chance of later reversal, keeping the big issue alive.[25]

A similar observation was made earlier in this chapter in the discussion of congressional reevaluation of the 1965 education act during the 1966 session. This same notion of shifting battle lines in a continuing struggle is useful in understanding congressional reevaluation of education policy during the first session of the Nintieth Congress in 1967.

Between 1966 and 1967, conditions changed, "setting up new ground rules" within which the education issue was fought. The biggest change occurred in the House. As a result of congressional victories in the 1966 off-year election, the GOP was able to swell its ranks from 140 to 187 members. With this new party balance, its was now possible for the Republicans to block or amend "Great Society" legislation if they chose to align themselves with Southern Democrats and revive the so-called "conservative coalition." The potency of this coalition was demonstrated on opening day of the 1967 session when 69 Southern Democrats joined 157 Republicans to repeal the twenty-one-day rule which had been incorporated into the House rules two years before. Minority Leader Gerald Ford made it clear, however, that he had no intention of actively forming an alliance with Southern Democrats. In his "GOP State of the Union" address on January 19, Ford said, "We welcome every Democratic vote . . . but Republicans will make no deals."

[25] Raymond A. Bauer, Ithiel de Sola Pool, Lewis A. Dexter, *American Business and Public Policy* (New York: Atherton Press, 1963), pp. 426–427.

He went on to say that GOP would offer their own alterna-
tives to "Great Society" programs which he hoped would
attract support of the Democrats generally. As far as Ford
was concerned, a coalition might periodically emerge as an
informal meeting of the minds but it would not be an
organized plan of strategy.[26] Nevertheless, the Republicans
were encouraged by their victory in repealing the twenty-
one-day rule, and they set their sights on revising the 1965
education act.

When the school aid bill (HR 7819) emerged from com-
mittee in April, it was clear that its sponsors would have
rough sledding on the floor, for the following reasons. First,
the urban-state Democrats added a proviso which altered
the allocation formula. Under the 1966 act there were two
provisions which were to go into effect in fiscal 1968. One
raised the family income factor from $2,000 to $3,000 and
the other stipulated that the federal contribution was to be
based on either 50 per cent of the state average per pupil
expenditure *or 50 per cent of the national average.* The new
proviso stated that these changes would not go into effect
unless appropriations were commensurate with the funds
authorized. Second, funds were authorized under the bill
for the controversial National Teachers Corps, which had
been kicked from pillar to post in Congress for the past two-
and-a-half years. Third, twelve of the fourteen Republicans
on the committee said they would attempt to completely
revise the allocation formula by recommending "block grants
for a broad range of education programs, leaving state and
local school agencies to establish their own priorities and
to devise patterns for using the funds which best fit both
their needs and their structure of education finance." This
proposal was referred to as the Quie amendment and had
been introduced earlier as a separate bill by Albert H. Quie

[26] Ford's position on an alliance with Southern Democrats
is one he has consistently taken for several years, and he made
it an issue in his campaign to unseat Charles Halleck as Minor-
ity Leader in 1965.

(R. Minn.), the third ranking minority member of the committee.

As the showdown on the House floor drew near, the Southern Democrats continued to constitute an unknown quantity. It was difficult to determine Southern consensus on the bill as a whole, but it was clear that most of them wanted changes in the desegregation guidelines. The Southern Democrats still held the balance of power. Despite this fact, neither Republicans nor the Administration was willing to woo their support by making open concessions to them. On May 14—two weeks before the bill reached the floor— Gerald Ford reiterated his position on making deals with the South, only this time he used much stronger language. He said the Republican "strategy is to drive Southern Democrats in the House into the arms of the Administration, where they belong, on votes that will hurt them in their home congressional districts." He conceded that this strategy would cost the Republicans needed support on the floor, but he added, "I think it is far better to lose a few legislative battles and win the next election."[27] The next week, at a press conference, President Johnson was asked by a reporter if he was "horse trading" with the Southerners on the education bill, and he flatly denied it. Both the Republicans and the President were attempting to avoid the stigma of embracing Southern demands to slacken the desegregation guidelines.

THE FLOOR FIGHT

Unlike the experience with education bills the previous two years, in 1967 no one was certain of the final outcome. Shortly after debate started on the first day (May 23) tempers flared when the President's old nemesis, Edith Green (D. Ore.), introduced an amendment requiring that the desegregation guidelines under Title VI of the 1964 Civil Rights Act be enforced uniformly throughout the

[27] Quoted in *The New York Times*, May 15, 1967.

nation. The Northern Democrats, who were still nursing their wounds from previous encounters with the gentle-woman from Oregon, immediately branded the Green amendment as a smokescreen to destroy the bill. After a three-hour debate in which numerous members changed their position on the issue, the amendment was adopted by voice vote.

After the House had been put through the wringer on the Green amendment, H. L. Fountain (D. N.C.) offered an amendment prohibiting the Commissioner of Education from deferring funds for alleged practices of segregation without a hearing and an expressed finding. This amendment was identical to the one adopted by the House in 1966, which was later modified by the conference committee. Despite opposition from HEW and the committee Democrats, the Fountain amendment was easily adopted by a vote of 116 to 62.[28]

During the second day of debate there were several amendments adopted—two of which were sponsored by Edith Green. Both were designed to extend more control to state education agencies. One requires the state education agencies to assume the role of planning the innovative education programs under Title III. The other restricts the Commissioner of Education in setting standards for grants, under Title V, which are designed to strengthen state departments of education.

The House accepted by a vote of 221 to 195 the Gibbons amendment, which eliminated the urban-state proviso on the allocation formula and reinstated the 1966 language.

As expected, John Erlenborn (R. Ill.) introduced an amendment to delete the bill's authorization for the Teachers Corps. It was adopted by a vote of 186 to 136.

Of course the most significant development during the second day's session was the introduction of the long-

[28] The Senate did not accept the Fountain Amendment; it was dropped from the bill by the conferees.

awaited Quie amendment, which proposed substituting the ⌉
allocation formula for block grants to the states. The Quie ⌋
forces were aware of the fact that the amendment was
vigorously opposed by the NEA, the United States Catholic
Conference, the NAACP, and most large city school ad-
ministrators, but they were hoping for success based upon
a solid bloc of Republicans plus Southern Democratic de-
fectors. As expected, the Quie amendment ignited a shower
of fireworks on the floor. Hugh L. Carey, the articulate
spokesman in the House for the Catholic position, said the
amendment would "create a holy war" between parochial
and public schools. At the height of the debate Speaker
McCormack took the floor and urged his fellow Democrats
both North and South to vote down the amendment. In an
emotional arm-waving appeal, McCormack said it would
"upset the delicately balanced compromises" on the church-
state issue which were made in the 1965 act. Supporters of
the amendment said the church-state question was a "phony
issue." Quie said the issue was: "Are we going to give, step
by step, more control to the Commissioner of Education or
are we going to restore state control?"

When debate ended and the smoke had cleared, it was
announced that the Quie amendment was defeated by a
vote of 168 to 197. Since the vote was taken during a
"Committee of the Whole" session, the position of in-
dividual members was not recorded. But, by all accounts,
what killed the Quie amendment was the lack of Southern
support. The Southerners could have swung the vote either
way, and most of them chose to stick with the bill and their
party.

Before the final vote the Republicans offered a motion to
recommit the bill to committee. This motion failed by a
vote of 180 to 236 (Democrats, 46 to 190; Republicans, 134
to 46). Of the eighty-eight Southern Democrats, fifty-six
supported their party by voting against the motion. The
bill cleared on final passage by a vote of 294 to 122 (Demo-

crats, 195 to 42; Republicans, 99 to 80). On the final vote, forty-seven Southern Democrats voted "yea" as compared to thirty-one in 1966 and forty-one in 1965.

AN APPRAISAL

The 1967 House decision on the education bill was not a clear-cut victory for either the Administration or the Republicans, though both sides claimed they had won at least something. According to John Herbers of *The New York Times*, Albert Quie stood in the House lobby the next day and claimed partial victory, and Wayne Hayes (D. Ohio), who was lounging in the chair nearby, quipped, "If he won a victory, he was disguised as the lady from Oregon."[29]

The irony of the 1967 education fight was that Edith Green was more instrumental in preserving the basic form of the education act than both the President and the House Democratic leadership combined. For the past two-and-a-half years the congressional Democrats and the President have accused Mrs. Green of being the most troublesome "wrecker" of education legislation, but without her amendments on the 1967 bill, the Southern Democrats might well have shifted their support to the Republicans on the Quie amendment and thus changed the whole nature of the act. After the House accepted the Green amendment, expanding enforcement of the desegregation guidelines and those broadening the powers of the state education agencies, the bill was much more palatable to the South than it would have been otherwise. Of course the bill was also improved from the Southerners' point of view after the House accepted the Fountain and Gibbons amendments. Mrs. Green commented after the vote, "We had Southerners voting for this bill who have never voted for federal aid to education before."[30]

Even more interesting and significant than the House

[29] *The New York Times*, May 26, 1967.
[30] *Ibid.*

vote on the 1967 bill is the new level on which the federal aid issue is discussed. There is still a handful of die-hard Republicans and Southern Democrats in Congress who challenge the whole notion of federal aid. But in recent years (and this was especially evident in 1967) leaders on both sides no longer quibble about the basic concept. Controversy now centers on the amount and the means of distribution.

In a commentary on the Republicans' plan for block grants to the States, Tom Wicker of *The New York Times* commented, "The significant thing is that if the Republicans now intend to fight it out on this line then the 'real issue' of American politics is no longer whether government should act but how and at what level."[31]

Thus, not only have the battle lines shifted in the federal aid controversy, but the same thing can be said for the parameters of the war itself.

From Conflict to Consensus

Bernard Berelson and his associates have observed that:

> In their course across the political stage, viable issues seem to "move" through various phases—from near-unanimous rejection at first through sharp partisan disagreement to near-unanimous acceptance at the end, perhaps a generation later. Issues seem to have a characteristic *life history*.[32]

When one recalls the struggle for federal aid legislation outlined in the first section of this study, it is clear that part of its "life history" is similar to that described by Berelson. It passed from a phase of near-rejection to one of sharp

[31] *Ibid.*, May 25, 1967.
[32] Bernard R. Berelson, Paul F. Lazarsfeld, William N. McPhee, *Voting* (Chicago: University of Chicago Press, 1954), p. 207.

partisan disagreement. It may be evolving toward near-unanimous acceptance, but this question is still to be decided. It is clear that this last phase has not yet been reached. Partisan disagreement continues, but as noted earlier, its nature and intensity have changed.

THE POLICY
PROCESS:
An Overview

The process we have described is timeless. With essentially
the same issues, government structures, and in some in-
stances the same participants, the American political system
periodically has confronted the question of federal aid to
education for one hundred years. There has been no resolu-
tion of the issue, only a series of temporary decisions made
under changing circumstances. The forces of inertia and
precedent give some permanence to a major federal role in
elementary and secondary education. But the problems of
administration, funding, and alteration persist.

While we have confidence in the following conclusions
as they relate to the education experience, they should be
applied with caution to other issues at other times. Perhaps
these conclusions should be taken as hypotheses to be ap-
plied to other cases.

Public Opinion

Public opinion as a single force has no significance in the
workaday world of the policy maker. Public opinion has

relevance only insofar as policy elites attempt to rationalize the existence of an opinion favorable to their interest, and only insofar as public attitudes create general climates for or against action. But as a meaningful ingredient in the policy process, public opinion simply is not relevant. There is no mechanism for channeling changing public opinion to the policy elites, nor is there any reason why the elites ought to be responsive when opinions are known.

What about constituency pressures?
see p. 218

The members of the education policy system, for example, are the leading opinion makers on questions of education policy, but they are not likely to look outside their own circles for new attitudes. To them, a concept like public opinion, taken to mean the beliefs or attitudes of some undefined mass of Americans, has no meaning in negotiating decisions of government. The opinions that matter to the policy elites are their own and those of the groups they represent.

However, this is not to suggest that members do not invoke "public opinion" in other ways. It is not uncommon for an advocate to claim that his cause is supported by American public opinion. On several occasions people representing the entire spectrum of opinions on federal aid claimed that public opinion was with them and in the long run their cause would succeed.[1]

Private Groups

Unlike some other forces in the congressional environment, pressure groups have clearly defined policy preferences. They expend their energy and resources promoting specific goals. The attention legislators give particular groups is dependent on the interest the member has in particular subjects.

[1] For a good survey of the state of public opinion research, see: Bernard C. Hennessy, "Public Opinion and Opinion Change," *Political Science Annual*, I (1966), 243–296, J. A. Robinson, ed. (Indianapolis, Ind.: Bobbs-Merrill, 1966).

Pressure groups are not uniformly important to all members of Congress all the time, and as a consequence their visibility and activity in the policy process have dramatic peaks and valleys. The effectiveness of a private group is, in part, dependent on its great specificity of issue interest. Policy makers pay attention to relevant private groups when issues germane to the groups' concern are before them. Furthermore the attention paid representatives of the interests is not passive. Members of Congress will actively solicit the comments and participation of concerned private groups while they are deliberating on relevant matters. We have seen the significance of this kind of participation in the Keppel-initiated negotiations, which involved both congressmen and representatives of the education pressure groups. But, despite the frequent contact between Congress and representatives of private interests, the interests remain essentially external to the congressional process. The success of a group is measured by its ability to gain access to the policy process and thereby affect policy outcome.[2]

There is a tendency to view lobbyists as movers and shakers behind the scenes, dispensing favors in return for favorable legislative action. This view is not only factually incorrect but also reinforces an erroneous notion that interest groups are homogeneous forces mounting irresistible pressures against the policy makers. Private groups have to contend with the same kind of factionalism that has always characterized the American political party structure.

The National Education Association is a classic case of the federated organization with state affiliates which individually may or may not subscribe to the "national's" policy positions. When national positions do not square with local attitudes, the organization may have to spend

[2] Lester Milbrath in the *Washington Lobbyist* (Chicago: Rand McNally, 1963), p. 277, reports that most lobbyists do not even attempt to persuade members of Congress on the record as opposing their group's views. Specificity of focus then not only refers to issues but to likely targets for persuasion.

time and energy convincing the local group of the merits of the national position. The possibility of a variety of positions being represented by people identifying themselves with one organization became a reality during consideration of the education program. Several Southern Congressmen were visited by delegations from the "white" affiliates of the NEA in Southern states trying to stave off federal aid (seen as further federal attempts to integrate Southern schools) in contradiction of the national office's lobbying efforts. While the NEA had to deal with its local affiliates, the United States Catholic Conference was able to present a united front with a single position.

Constituency

The constituency is an ever-present force that is usually undefined for the Congressman as to its specific policy preferences. There are broad categories of issues that can arouse the interest and anger of a congressional district, but in most cases the heterogeneity and complexity of the district precludes a single and unified constituent response. People tend to form smaller groups reflecting their particular social or economic interest. Furthermore the legislator—like all species of mankind—receives messages through his own perceptual screen. This screen does not treat all messages in the same fashion. In most cases the decision maker will be aware of only those things he has been socially conditioned to see and hear.[3]

Many members of Congress feel there are only a few issues that can hurt their chances for reelection. This im-

[3] Warren Miller and Donald Stokes, "Constituency Influence in Congress," *American Political Science Review* (March 1963), 45–56. Also see Lewis Anthony Dexter, "The Representative and His District," in *New Perspectives on the House of Representatives*, ed., Robert L. Peabody and Nelson W. Polsby (Chicago: Rand McNally, 1963), pp. 3–32.

plies that Congressmen have taken a complex world and simplified it by assuming that the large bulk of their votes and actions will not be watched carefully back home, and that even if watched will not make much difference. For many members the school bill would have become one of the two or three important "constituency issues" only if the religious question had not been resolved. Since education was not "a constituency issue," members were open to appeals from a variety of sources and less likely to "vote their constituency."

In the sense that it is typically used, "constituency" means at least three things to the member. There is first a general image of the district as either rich or poor, industrial or white-collar, urban or rural, Northern or Southern, etc. It amounts to a summation—a simplification—of the more complex reality; and it seems to be associated with voting patterns in the House. For example, 98 per cent of the Northern Democrats supported the education bill compared to 43 per cent among Southern Democrats.[4]

Second, the district image for a member is shaped by the personalities with whom he deals. The people he meets and talks with will articulate the district's interests, needs, and attitudes. The member makes his decisions on whatever information he receives and how he understands that information. Studies on political participation indicate that few people will take the time or trouble to communicate with

[4] The regional voting bloc (particularly Southern) has been identified and watched by congressional observers for a long time. The so-called conservative coalition of Southern Democrats and conservative Republicans has long been identified as the dominant voting bloc in the House during most recent Congresses. (See *Congressional Quarterly*, No. 48, for week ending 26 November, 1965, pp. 2399–2402, for a discussion of the "issues that divide" Northern and Southern Democrats; and No. 46, week ending 12 November 1965, pp. 2295–2306, for a comparative discussion of the "conservative coalition" in 1965 and previous years.)

their Congressman.[5] This means that the member is likely to be hearing from the same people over and over again.

Third, the party leadership in the district will act as an interpreter of constituency opinion to the member as he determines his range of freedom to act on many bills. There is a distinction between the people who have ongoing and regular access to the member because of partisan affiliation and those who are "attentive" enough to write letters and sign petitions, but who lack face to face familiarity with the member. Most of the letter writing and telegram activity on the education bill was the product of well organized efforts by groups like the American Civil Liberties Union and the NEA.

[5] V. O. Key described this phenomenon in politics when he differentiated between "attentive publics" and "inattentive publics," *Public Opinion and American Democracy* (New York: Knopf, 1961), p. 265; also see Charles L. Clapp, *The Congressman: His Work as He Sees It* (New York: Doubleday Anchor Book, 1963). While Key argues that the attentive publics refer to the private pressure groups with established patterns of behavior and ideology such as the NEA or USCC, we want also to distinguish between the "private attentives" and the "constituency attentives." We think that the issue publics are a separate category and that there is an identifiable group in any electoral constituency that has the characteristics of the "attentive" publics Key ascribes to them; namely:

> These publics have their party line, their established positions, their ideologies, and in many instances, their professional spokesmen. . . . How well their spokesmen reflect the view of the group members may be another question, but the views of the spokesmen are usually well known in advance of action.
>
> These attentive publics have their patterns of reaction that serve as bases for predictable response.

We think that this is a very good definition of the local political party; a group with established patterns of expectations, behaviors, and reactions. What is more, the spokesmen for the local party are the people who probably had a lot to do with the member deciding to run and getting his party's endorsement in the first place.

In other words, when the Congressman is "voting his district," he is facing a complex social environment that means several different things at different levels. In 1965, with the new Democratic majorities, the willingness of the pressure groups to negotiate, the President's leadership, and the settlement of the church-state issue there was little room for the Congressional constituency to play any role of importance—no matter how that constituency was defined.

The News Media

One of the most vital communication links between Congress and its external environment is the news media. Most Congressmen have an insatiable appetite for newsprint. The press can influence congressmen not so much by editorializing on pet topics but rather by its selection of issues on which it chooses to inform the public. The timing and manner of presenting issues can affect policy. Political leaders regard the press as a link with the people because it enables them to see how the issues are being developed for public consumption.

A distinction can be made between two classes of papers: the local press and the national press. The local newspapers are those limited to the congressional district. These are the papers that the member will deal with most frequently. He will probably know the publisher and editor as well as the political reporting staff. News releases will be funneled to these papers and the member will do what he can to make the local paper a part of his personal publicity machine.

In addition, the local press becomes a major source of local political information for the member. He will watch the paper closely for names of new personalities becoming prominent in various civic and political activities back home. Any one of these is a potential political threat. On substantive issues, the local paper's contribution to the

process is primarily its editorial comment. Editorial position is important to the member as a reflection of the opinion of the leadership community.

Naturally there are three papers that are read every morning by virtually every member of Congress. These are *The New York Times,* the *Washington Post,* and the *Wall Street Journal.* Their focus is primarily national news. Together their syndicated columnists represent every shade of influential political opinion and can be considered as a force separate from the institutions that employ them. The stories that appear in these papers tend to be substantively focused and therefore become a part of the information that circulates through Congress. Members often first hear about important developments from one of these papers.

The news media did not play a particularly dramatic role in passage of the education bill even in shaping public opinion. This bill's history is not accurately characterized by any special role that either individual reporters or the press in general played because much of the important developmental work was deliberately handled quietly without media attention.

This issue was kept from the press to keep the number of knowledgeable participants small. After the groups had reached an accord on the major ingredients in the bill they were not anxious to risk expanding the possibilities of conflict by opening the debate with press attention.[6]

[6] See E. E. Schattschneider, *Politics, Pressure, and the Tariff* (Englewood Cliffs N. J.: Prentice-Hall, 1935), for a classic discussion of the relationship between Congress and pressure groups as they attempt to keep the area of conflict small when the major participants are agreed on the substance of decisions that will be made. It should be pointed out, however, that our observation of the education issue in 1965–67 does not accord with Schattschneider's major theme of the pressure groups coercing Congress into action along lines they desire. Rather we saw the network of forces surrounding the Congress and education pressure groups blending into a policy climate that required certain prior agreements among the pressure groups in order for Congress to act out its role.

Bureaucracies

Another force at work in the Congressional milieu, but considerably more internalized than any of the groups so far mentioned, is that of government bureaus and agencies. The agency's concerns give it regular association with particular congressional committees and members (usually chairmen).[7]

In many ways the substantive divisions among the federal bureaucracies match the substantive concerns of the private groups. The bureaucracies also parallel the organization of congressional committees. While the private association articulates the needs and wishes of special publics within society, the government agency is burdened by the need to adjust the competing demands of special publics with a broader conception of the public interest.

While it may be difficult or impossible to achieve any precise definition of "the public interest," as a concept it has meaning to the government officer who is in part motivated by this "elusive imperative."[8] Thus it has behavioral and decisional implications and cannot be ignored in explaining particular policy choices. One member of Congress told us that the education bill that passed in 1965, and for which he voted, was not his "formula for meeting the national interest in the education field." He had to make his choice between some idealized formula that had little chance of passage versus the agreed-upon bill that had powerful support and was likely to be the only formula that *could* pass. The special

[7] See J. Leiper Freeman, *The Political Process*, rev. ed. (New York: Random House, 1965), for a full discussion of this relationship.

[8] Charles Jacob, *Policy and Bureaucracy* (Princeton, N.J.: Van Nostrand, 1966), ch. 8. See also Frank J. Sorauf, "The Public Interest Reconsidered," *Journal of Politics* (November 1957), 616–639, in which it is argued that the public interest, rather than being a substantive policy end, is a process where "fair play" prevails.

relationship between government executives and members of Congress is motivated in part by their mutually-felt responsibility and constitutional obligation to the general welfare versus some more narrowly conceived interest.

The government bureaucracy has both national and local components. Local officials and government institutions play an important role in the policy process along with the more obvious functions of the federal agencies and bureaus. Indeed, a leading member of the White House congressional liaison office in 1965 argues that a major reason education legislation did not pass before 1965 was the issue of federalism and the division of power between national and state government:

> The states' righters (both genuine conservatives and racists) recognized the school systems as the last bastion of states' rights. The education bill was going to breach that wall and they fought it tooth and nail.

Local officials usually deal with individual members from their districts or states, while federal bureaucrats typically have ongoing contact with the committees of Congress through both the chairman and staff. The federal agencies are more involved in the internal decision process in Congress than in local governmental structures and, therefore, are of greater importance and concern to Congress. However, the federal nature of our governmental structure affords mayors, governors, and other local officials greater access to Congress and on different terms than are available to private groups.

The Presidency and Congress

The President is the only elected national public official with major administrative *and* legislative responsibilities. His place in the legislative process is that of a fulcrum between the diverse participants and forces in the external and internal environments of Congress, and it was precisely this

role that the Presidency played in 1965 on the education
bill.

The President is the chief administrative and executive
officer in our government. His task is to provide the leader-
ship for the federal branch of government as it executes
policy and interprets legislative mandates. The President has
the difficult task of giving cohesion to a disparate set of
agencies and bureaus while simultaneously seeking a high
level of harmony among a complex set of private, public,
and semi-public institutions. There is no individual or group
that is not an explicit part of the President's constituency.
All elements in the Presidential environment have the
legitimate right to solicit his support and his endorsement
of their special interests and programs. As more of these
constituents have exercised this right, the Presidency has as-
sumed greater responsibility for initiating governmental
policy.

The network of "transactions" that characterize the Amer-
ican political process is profoundly influenced by the choice
of what is to be transacted.[9] In other words, to know "who
initiates" is to know the source of these transactions which
are so basic to the system. Eventually we want to know the
source of legislation, or more particularly, why one bill
rather than another becomes the legislative vehicle for re-
solving a social conflict or need. To answer this question
about federal aid to education it was necessary to identify
the person(s) and group(s) that provided the initiative and
forum within which to negotiate the stubborn differences
that divided people on the education issue. It was not a
surprise to learn that it was the White House and related
agencies (Office of Education and Department of Health,
Education, and Welfare) which set the agenda and estab-
lished the ground rules by which this particular education
formula was finally drafted.

The power to initiate has its limitations as well as ad-

[9] Raymond A. Bauer *et. al.*, *American Business and Public
Policy* (New York: Atherton Press, 1963), p. 405, describes
politics as a series of transactions.

vantages. The President's power is circumscribed. He can bring people together, but the hard bargaining and negotiating is the province of all the participants. Some minimal level of agreement must be achieved or the policy outcome is likely to be a postponement or an avoidance of the issue. The participants must agree that there is a conflict that needs resolution. This is not to say that all participants bring similar resources to the bargaining process. The differences in skills and other resources go to the heart of the bargaining itself rather than to the question of who starts the process.

In our view, the shift of power that has occurred from Congress to the White House is not the result of a protracted legislative-executive struggle, but is instead a simple response to the shifts of expectations that have slowly evolved both inside and outside of government. The variety of groups that are served by government have come to expect important policy initiatives from the President, not from Congress. Surely this was one major reason why Keppel and Douglass Cater were able to assume the roles they did vis-à-vis the major interest groups. This shift is reflected in the fact that control over the most critical phases of policy formation is increasingly centered in the White House and executive bureaucracies. It is members of the executive branch in consultation with select Congressmen who define the social needs and problems that occasion governmental response. These changes in expectations and behavior have resulted in the President assuming the task of initiating a coherent legislative program for each Congress.[10]

[10] Richard Neustadt, in an article written in 1956, has interpreted this changed pattern of expectations to be a Presidential "obligation to initiate . . . bound . . . by the nature of our institutional adjustment, up to now, to the complexities of governing this country at mid-century." Indeed it was Neustadt's view then, and has undoubtedly been reinforced since, that this obligation had become "routinized and even institutionalized." "The Presidency at Mid-Century," *Law and Contemporary Problems*, 1956, pp. 609–645, 613.

(Typically Congress waits upon the executive for a series of messages and programs which it will critically examine, and ultimately accept, amend, reject, or postpone.)

The Presidency is intimately involved in the workings of Congress. Their relationship is tightly interdependent. The pressure for increased integration of function (at least on domestic policy) between legislature and executive is great.

Regular and routine meetings between the President and legislators, as well as the establishment of an elaborate Congressional liaison office in the executive branch, testify to the pervasive interaction and spirit of interdependence that characterizes the relationship between the White House and Capitol Hill. President Johnson regards his congressional liaison personnel as second in importance only to the secretary or director of the department himself.[11] Each legislative issue may have its unique qualities, but it is fair to say that the expectation on any given issue is that Congress and the President will work together closely and cooperatively. However, the President still faces the dilemma of having to serve all the constituencies of the nation, which can affect his capacity for achieving his goals.[12]

[11] Hugh A. Bone, "The Politics of Federal Aid to Education," paper delivered at Western Political Science Association meeting, 1966, p. 4. The notion that the basic theme of executive-legislative relations is the jealous guarding of institutional and personal prerogatives strikes us as misinformed. To illustrate how this legislative-executive relationship has affected 1) the perception of what each side contributes to the policy process, and 2) how ingrained the concept that the President initiates policy is; note that as long ago as 1953: ". . . the very senior chairman of a major House committee reportedly admonished an administration witness, 'don't expect us to start from scratch on what you people want. That's not the way we do things here—you draft the bills and we work them over.'" (Neustadt, "Planning the President's Program," *American Political Science Review*, 1955, p. 1015.)

[12] Once again it is Neustadt who has articulated the effect of this dilemma: "It means he cannot, as he pleases, moderate, adjust or set aside the rival, overlapping, often contradictory

The real impact of this observation is simply that no President can afford to be the handmaiden of any particular interest. We have already discussed President Johnson's recognition of the limitations on the influence he could wield over Congress even with the huge majorities of the 1964 election. The following table shows that under more normal mid-twentieth-century congressional conditions, Congress grants less than half of the specific legislative requests Presidents make. The power to initiate congressional debate is not the power to direct the conclusions of that debate.

Legislative Scores, 1954–1966[13]

YEAR	NUMBER OF PROPOSALS	NUMBER APPROVED	APPROVAL SCORE (%)
1954	232	150	64.7
1955	207	96	46.3
1956	225	103	45.7
1957	206	76	36.9
1958	234	110	47.0
1959	228	93	40.8
1960	183	56	30.6
1961	355	172	48.4
1962	298	133	44.6
1963	401	109	27.2
1964	217	125	57.6
1965	469	323	68.9
1966	371	207	55.8

In short, the President must strive to accommodate a series of interests and forces in the political process that sometimes appear irreconcilable. Thus it is that the Presi-

claims of his constituencies. *He has no option but to act, at once, as agent of them all, for their conjunction in his person as the keystone of his potency;* none is dispensable, hence the demands of none are automatically disposable at his convenience. Events, not his free choices, regulate their pressures and condition his responses." ("The Presidency at Mid-Century," *op. cit.*, p. 614, emphasis author's).

[13] *Congressional Quarterly*, Weekly Report, 48, (2 December 1966), p. 2911.

dency becomes the fulcrum on which is balanced all the forces in the policy environment that affect Congress.

One of the clearest impressions that results from close study of the education issue during 1965–1967 is the diffusion of power and control in the American political system. There is no single official or institution of government that was responsible for the passage of federal aid legislation. This simple but important observation comes as something of a surprise at a time when people are growing accustomed to reading and talking about the Presidency as being an inordinately powerful institution. The problem with this assessment of the Presidency is not with the premise but with the conclusion. Precisely because the Presidency is at the center of most policy debates, it is under fierce and sometimes confining cross pressures. The Presidency may offer special opportunities for initiative in the policy process but it does not offer control.

In 1965 President Johnson had the image of being a political negotiator par excellence. The Johnson stereotype was that of a shrewd manipulator with an almost ruthless zeal for winning his point at any cost. It was assumed that President Johnson's success with Congress was due to his experience as a successful leader in the Senate. The President was often pictured as having two faces. The one was that of a polished leader sophisticated in the ways of Washington. The other was that of a roughhewn courthouse politician who strictly adhered to the political maxim of rewarding one's friends and punishing one's enemies. This latter face of Johnson gave rise to the commonly held assumption that the President won his way with Congress by applying high pressure tactics and arm twisting.

During the first session of the Eighty-ninth Congress, Johnson was often described by the Washington press corps as one of the most skilled and successful legislative leaders in the history of the Presidency. And when one reviews the volume and magnitude of Administration programs passed by Congress in 1965, it is impossible to deny that Johnson

had phenomenal success with Capitol Hill. But was this impressive record due to the legislative skills of the President and the so-called "Johnson approach" of persuasion?

In the case of the Elementary and Secondary Education Act, the keystone of the President's program, success did not depend upon the lobbying skills of Lyndon Johnson personally. The President closely followed the progress of the bill and periodically met with strategically placed congressional Democrats, but he did not blitz Capitol Hill and neither did his lieutenants. As soon as the 1964 election returns were in, the Office of Education and the federal aid advocates in Congress felt there were enough votes to pass a bill. But not just any bill. It would have to be a measure which would avoid the inflammable issue of church and state and still appeal to congressmen from urban centers as well as rural areas. It would have to provide for an objective allocation formula which would channel assistance with a minimum of control by the Office of Education.

The most significant contribution the President made to the passage of the 1965 act was his initial effort to work out a bill which would appeal to federal aid advocates and avoid the church-state controversy. It was Francis Keppel's role to negotiate the settlement between the contending forces— albeit with the aid of many others in and out of Congress. Mr. Johnson presented Congress with a bill calculated to draw solid support—and it did. But passage was not dependent upon the arms the President could twist or the amount of pressure that could be applied. No one appreciated the limits of Presidential power vis-à-vis the Congress in 1965 better than the President himself.[14]

However, the Presidency does afford an energetic and ag-

[14] President Johnson is reported to believe that the congressional fight over home rule for the District of Columbia, which he lost in the House on September 29, 1965, started his "troubles with Congress" which were reflected in fewer successes in 1966. Andrew Kopkind, "Washington: The Lost Colony," *New Republic* (23 April 1966). In fact, on the education bill itself, in 1965 the Administration lost only three freshmen Democrats on the recorded roll calls, while eighteen voted

gressive incumbent the resources of information, manpower, and loyalty to initiate and encourage the dialogue within a variety of arenas that can lead to enough agreement to stimulate congressional action.

It is clear that even with the congressional victories of 1964, the Democratic leadership in Congress was powerless to act effectively on the education issue in the absence of well-coordinated White House leadership. It is because leadership is a relational concept that the new Democratic majorities in Congress gave new meaning and effectiveness to the leadership that was being provided by the White House. The hard fact of political life for any President is that he can be an effective leader only when those he would lead are willing to follow. The nature of executive-legislative relations places a premium not on coercion and threats but on compromise and manipulation. The two institutions of government share their responsibilities, and both sides have to agree on the role each will assume on each issue or there is stalemate.[15]

One of the reasons the Presidency in recent years has been a more innovative and adventurous institution than Congress is because it has been forced to respond to certain societal demands *before* Congress has been required to take action. (One should not conclude from this, however, that these political institutions impassively sit back and wait for demands to arise from their external environments.) The decisions that flow from Congress and President are not so much the rewards given to those who exert the most pressure, but rather are a consequence of the way Congress and

against the Administration on the District of Columbia Home Rule Bill. The 1967 environment was substantially changed by the loss of forty-six freshmen Democrats from the Eighty-ninth Congress who lost seats to the Republican party that had controlled those seats before the 1964 elections.

[15] See Roy D. Morey, *Politics and Legislation: The Office of Governor in Arizona* (Tucson: University of Arizona Press, 1965), pp. 111–113, for a discussion of this principle of executive-legislative relations at the state level.

the President perceive the nature of the problems and the intensity of support behind them.

Experts

Congress, without an extensive bureaucratic arm, has a unique set of problems informing itself on highly complex and specialized matters. The congressional workload has been increasing, and the wide range of issues that members are called upon to decide puts great strains on the member's ability to familiarize himself with the basic issues at stake, let alone to fully understand the nuances involved. For this reason there is an increasing reliance for information on nongovernmental experts. The legislator, conscientiously seeking to understand a matter of some importance, will range quite far to find people who can help him. The practice of academics being asked to write position papers, to testify before committees, and generally to be available for reference purposes is increasing.

Further, it should be noted that the "experts" are not necessarily sought for their objective evaluations of policy questions. Particular men are sought because of their views on controversial questions. Such has been the role of Roger Freeman, a senior staff member of the Hoover Institution on War, Revolution, and Peace at Stanford University, who has also been an expert spokesman for the critics of federal aid to education legislation. His expertise in the education field dates from the 1950's, when he undertook several studies in the field of school finance for the Education Committee of the U.S. Commission on Intergovernmental Relations, served as a consultant to the White House Conference on Education, and repeatedly testified before committees of both houses of Congress on pending education legislation.[16]

[16] See Roger A. Freeman, *School Needs in the Decade Ahead* (Washington, D.C.: Institute for Social Science Research,

The education issue over the period we observed it did not elicit an increased flow of information between academic experts and Capitol Hill. The issue was hardly new to Congress and the issue had been a visible one over the years. Positions were taken in some cases a decade ago. There was no apparent reevaluation of the education issue within Congress. It was generally understood after 1964 that the issue would be fought out once again, but the mere prospect of a fight is hardly enough to cause professional public office-holders to rethink positions taken on what appears to be an old issue. Some new consideration has to be in the offing.[17]

Finally, there was little conflict within the routine channels of communication that were supplying Congress with information regarding the 1965 bill. From the perspective of Congress there was surprising agreement among the various factions, which minimized the need of soliciting the advice and counsel of outside experts beyond the minimal gathering of testimony.

Staffs

The professional staffs of Congress perform vitally important functions for the system. The staff network is the only organization with sole responsibility for directing and filtering the flow of information to Congress. Staffs investigate, research, schedule, edit, compile, and distribute much of the information on which legislative decisions are based. The *raison d'être* for staffing is the collection of information.

The organizational setting in which staffing operates makes

1958); and *Taxes for the Schools* (Washington, D.C.: Institute for Social Science Research, 1960).

[17] See Theodore Lowi, "Distribution, Regulation, Redistribution: The Functions of Government," *Public Policies and Their Politics*, Randall B. Ripley, ed. (New York: Norton, 1966), on the routinization of conflict.

for a complex communications network. There are Senate
and House counterparts for each committee, and on most
committees there is division between minority and majority
party staff personnel. Fifteen of the twenty standing com-
mittees in the House of Representatives have minority
staffing. Congress was extremely slow to develop a profes-
sional staff for its committees, while it has almost always
had some kind of personal office staffing.

The acknowledged role on the education issue of Senate
staff director Charles Lee and House subcommittee staffer
Jack Reed have been mentioned earlier. What needs to be
emphasized is the extent to which Congressional staff mem-
bers are a highly professional organization making consider-
able contribution to the resolution of difficult policy prob-
lems. The members themselves are torn by so many com-
peting demands on their time that they grow increasingly
dependent on specialists like Lee and Reed to stay abreast
of the torrent of information that flows into Congress every
day.

In a real sense Lee, Reed, and House education chief
staffer Deborah Wolfe acted as an intervening bureaucracy
between committee members and the network of advocates
seeking committee action. They filtered the competing de-
mands for congressional attention and helped decide who
would be granted access.

In addition to the Majority staff, the role of the Minority
staff was important. On the House side Charles Radcliffe,
Minority Counsel for Education, and Michael Bernstein
both helped shape the Minority's response to the Adminis-
tration bill in 1965. In the Senate, Minority staff members
Stephen Kurzman and Roy Millenson assisted the Repub-
licans in the Senate as they sought to amend the House bill.

The line the congressional committee staff walks is a thin
one between sufficient initiative and visibility to accomplish
their tasks and the necessary submersion of their roles to
those of their principals. One House committee majority
staffer reportedly was fired for delivering a speech in Okla-

homa taking personal credit for working out the formula that paved the way for education legislation in 1965.

The Members

The members of Congress themselves are the final and most important element of the internal legislative environment. Congress is really no more and no less than a part of the policy-making stream, filling certain constitutional functions at given points in time which only it can perform, but maintaining continuous participation in the process through its committee members and principal staff assistants. All the evidence we have been able to gather about the education issue supports this view.

This conception of the congressional process implies that the divisions and coalitions of forces that are active in society are probably going to be reflected at some time in Congress. In the long run Congress will articulate the interests of most of the policy elites, even if no favorable action is taken on their goals. If this is an accurate description, then Congress should reflect the swirling and overlapping contentions over policy preferences that we regularly observe in society at large. The multiple subgroups inside Congress do suggest something of the complexity of American society itself. Regional groupings, ideological associations, party divisions, and all the rest have their reference points in the broader constituencies for which they occasionally speak.

The most characteristic kind of subgroup in Congress has its origins in performing some function for its members. That is, the variety of forces trying to influence the outcome of the member's choice are so great and intense that he seeks to organize his legislative world in a more manageable way. For example, the freshman member (recall that there were sixty-nine freshman Democrats in the Eighty-ninth Congress) first occupying his seat is faced with a bewilder-

ingly new environment. He needs guidance from his senior colleagues to avoid making mistakes from ignorance that could hinder his legislative effectiveness. One of the many paradoxes of congressional life is that the skills necessary for nomination and election are not the skills necessary to become an accepted and effective member once seated. Members from marginal districts are forever having to determine what is in their partisan interests and what is in the interests of their effectiveness inside Congress (there were, for example, seventy-one members of the House in 1965 who had been elected by less than 53 per cent of the vote: thirty-nine Democrats and thirty-two Republicans; the marginal Democrats voted together on most of the major Administration programs better than eight times out of ten and most of them were defeated in the elections of 1966).

It has been said that these informal groups in Congress perform important functions for the member "by offering him viable conceptions of the national legislative process and his role in it."[18] It is instructive to note that in only two of the twenty-three states with more than one Democrat and with at least one freshman in the delegation in 1965 was there an absence of complete agreement on the crucial roll-call votes on the education bill; they were Georgia and Texas.[19]

The formal structure of Congress provides a number of smaller arenas in which a member can take cues about behavior and voting expectations. Some of the most permanent and visible of these are the standing committees which are jurisdictionally delineated in the Legislative Reorganization Act of 1946. Broad lines of subject matter specialization flow from the jurisdictions of the committees, and the members who may be seeking direction on an unfamiliar

[18] Alan Fiellin, "The Functions of Informal Groups: The State Delegation," *Journal of Politics* (February 1962), 72–91.
[19] Freshmen Democrats Support of State Delegation Majority Position: Education Bill 1965:

	Majority Position of Delegation			Freshmen Position		
STATE	N	RECOMMIT	FINAL PASSAGE	N	RECOMMIT	FINAL PASSAGE
California	23	N (23-0)	Y (23-0)	2	N (2-0)	Y (2-0)
Colorado	4	N (4-0)	Y (4-0)	2	N (2-0)	Y (2-0)
#Georgia	9	Y (7-2)	Y (5-4)	2	Split	Split
Illinois	13	N (13-0)	Y (13-0)	3	N (3-0)	Y (3-0)
Indiana	6	N (6-0)	Y (6-0)	2	N (2-0)	Y (2-0)
Iowa	6	N (6-0)	Y (6-0)	5	N (5-0)	Y (5-0)
Kentucky	6	N (6-0)	Y (6-0)	1	N	Y
Louisiana	8	Y (5-3)	N (5-3)	1	Y	N
Maryland	6	N (6-0)	Y (6-0)		N	Y
Michigan	12	N (12-0)	Y (12-0)	7	N (7-0)	Y (7-0)
Missouri	8	N (6-0)*	Y (6-0)*	1	N	Y
New Jersey	11	N (11-0)	Y (11-0)	4	N (4-0)	Y (4-0)
New York	27	N (27-0)	Y (27-0)	9	N (9-0)	Y (9-0)
Ohio	10	N (10-0)	Y (10-0)	4	N (4-0)	Y (4-0)
Oklahoma	5	N (4-1)	Y (5-0)	1	N	Y
Pa.	14	N (14-0)	Y (14-0)	2	N (2-0)	Y (2-0)
So. Car.	5	Y (5-0)	N (5-0)	1	Y	N
Tennessee	6	N (5-1)**	Y (5-1)**	2	N (2-0)	Y (2-0)
#Texas	23	N (14-8)***	Y (13-9)***	3	N (2-1)	Y (3-0)
Virginia	8	Y (7-1)	N (7-1)	1	Y	N
Washington	5	N (5-0)	Y (5-0)	4	N (4-0)	Y (4-0)
W. Virginia	4	N (4-0)	Y (4-0)	1	N	Y
Wisconsin	5	N (5-0)	Y (5-0)	2	N (2-0)	Y (2-0)

#—States in which all freshmen did not support Majority delegation position.

*—Two votes were not recorded.

**—Two votes were paired with Majority position counted as actual votes.

***—One vote not recorded.

Data based on material in *Congressional Quarterly Weekly Report*, No. 14, week ending 2 April 1965, pp. 600-601.

subject will look to the senior members of the relevant committee for guidance.

Most of the "informal groups" in Congress are noteworthy, however, for their organizational looseness and simplicity. They are founded on the innumerable patterns of personal interactions that characterize any human organization.

Committees

The congressional process is also the process of decentralizing the decision-making power through the sixteen standing committees in the Senate and the twenty standing committees in the House. The existence of these thirty-six distinct centers of power within Congress is one of the reasons that no single locus of influence (such as leadership) can control the entire process.

This kind of system places enormous strains on its members. The personal attributes that work in a collegial decision-making system where prestige and power are distributed over a series of independent committees within a complex normative structure are deference, patience, and endurance.

The elements of bargaining became essential ingredients because the committee structure divides power in Congress horizontally, not vertically. One committee chairman is not necessarily more powerful than another. The inequalities are those that make one man more persuasive than another or are the differences in subject jurisdiction among committees.

Once the salient elements in the environment are at work they seek access to one or more critical stages in the congressional process. The subcommittee, committee, pre-floor, and floor stages are distinct levels of congressional action. The events that occur at each stage profoundly affect the action to be taken (if there is to be future action) at succeeding stages.

There is no general rule that access to one stage rather than another increases or decreases the chances for success, but there is a general recognition that the substantive changes in most legislation come at the subcommittee and committee stages. Our observations of what occurred with the education bill in 1965 and 1966 will not threaten the accuracy of that view, although the events of 1967 seemed to shift the focus of decision from the committee to the floor of the House. The defeat of the Quie substitute in 1967 was not assured until all the votes had been tabulated.

The pre-floor and floor action stages are the tactical points in the process. The substantive decisions of the committees have to be communicated to the rest of the membership in such a way that the party position is supported by the rank and file. It is at this point that the elected leadership comes most visibly into play in its effort to solicit votes.

At any of these stages of the process one of two things can happen. Either a positive legislative decision is reached (the passing or defeating of the bill—a decision is forced) or Congress defers the time of decision. Since most legislative proposals never see the light of day there is some validity to the argument that Congress has as one of its primary functions the responsibility of postponing decisions.

The Congressional Party

Ultimately the principal organizing element of Congress is the political party. The majority and minority parties each have their own organizational apparatus and much congressional conflict follows party lines. The congressional party is an important cue-giving mechanism for its members especially when they are faced with conflicting wishes from other elements of their environment.

The party is primarily responsible for providing most members with a rationale for making policy decisions which are consistent with the leadership's wishes. Both the Democrats

and the Republicans in the first session of the Eighty-ninth Congress supported their respective elected leadership's public position on legislation eight times out of ten.

On most issues a member is free to look to the party for his voting cue in the absence of some overriding reason for not voting with his party's official position.

The margin of the Democratic success in 1965 on the education bill is reflected in the Democratic leadership's ability to capture 60 per cent of the available Democratic vote, while the Republicans were only able to keep a minority (48 per cent) of their members voting in opposition. There were only two other major bills that came before the House in 1965 on which there was greater Democratic unity: the constitutional amendment providing for Presidential continuity and the medicare program which captured 84 per cent and 71 per cent of the available Democratic vote respectively. On the other hand, out of an identical list of bills the Republican leadership was able to keep its members voting together with more success on fifteen other bills.[20] As hard as the Republican leadership tried, they could not make the education bill a party issue in the face of the concerted support of the major elites for the Administration bill.

There is much debate and tension within the party as it comes to its official legislative posture on a controversial bill precisely because its decision has so much effect on the rank and file members. Because party leadership recognizes that its positions will sometimes be untenable for some members in terms of their districts, it will tolerate seemingly endless violations of party discipline. The paradox of party politics

[20] House Democrats voted together on eighteen selected roll calls in 1965 slightly better than one-half of the time compared to the Republicans, who voted together on the same eighteen roll calls at a somewhat higher rate. The selected roll calls are the eighteen "key" administration legislative requests that were voted on during the first session of the Eighty-ninth Congress in 1965 as identified by *Congressional Quarterly*, Weekly Report, No. 44, week ending 29 October 1965.

in American Congress is posed by a system which tries to enforce discipline but which recognizes the need for flexibility to maintain or gain a nominal majority.

Conclusion

All of these elements are present in the congressional environment all of the time, but all are not equally important or even relevant for all issues. Only those individuals and groups that have fundamental interests or associated interests in particular issues will attempt to gain access to influence legislative decisions. One of the men closest to the White House education effort during the 1960's summarized the convergence of forces that led to favorable congressional action in the following words:

> Between 1961 and 1965 there were several major developments that paved the way for an education bill. When the 1964 Civil Rights bill was passed, the race issue in education policy was a moot point. The South had expected the filibuster to last forever; but the Senate had in 1964 cut it off—a move as significant in its own way for education legislation as the rules changes in the House in 1965.
>
> Everyone involved in the 1964 election knew the results would be read as a mandate of some kind about the education issue. Whether it was in fact such a mandate is neither debatable nor relevant. All we know was that Charlie Halleck (former House Republican Leader) had killed himself and the party on the issue with their rigid obstructionism.
>
> A protestant President could champion a bill that somehow got funds to students of nonpublic schools. The poverty problem had been drummed into peoples' minds through 1964. The Kennedy education bill gave that program the force of Presidential initiative and concern; and when the legislative vehicle for education

was couched in terms of fighting poverty, it became most difficult politically to oppose.

There were essential and basic changes in both the external and internal environments of Congress for an extended period of time that enabled legislation to be passed. As this same official told us:

One or two obstacles can always be removed in a legislative battle in the short run. Before 1965 there were too many circumstances operating against education legislation. By 1965 there had been enough changes.

A description of the passage of elementary and secondary education legislation is an important story if only because of the issue's significance. In addition it is hoped that coverage of this legislation has illuminated a complex world in which many important social choices are made.

We have not attempted to judge the process as good or bad, desirable or reprehensible. That judgment depends upon the values each want promoted by the policy system. Those who value stability and the ordered change of public policy will gain comfort from the events of the past three years on education policy. The American system appears to be an almost perfectly balanced mechanism of equal forces working in a variety of directions keeping the probabilities of radical change to a minimum.

If, on the other hand, immediate responsiveness to demands wherever they arise in the society is to be maximized, then the American system falls short. The American policy system moves slowly because it weighs the legitimacy and the degree of support for each demand before acting. The inherent conservativeness of the system is tied to the ageless problem of attempting to reconcile majority rule and minority rights.

Finally, the extent to which the policy system is open to new participants, and hence truly representative, becomes another criterion to use in evaluating the system. It is difficult to say how typical the education issue is. We have de-

scribed a system that places a premium on expertise, and acceptance into the community of individuals and groups that have organized interests in specific policy outcomes. How adaptable and responsive is such a system to the demands and needs of large numbers of Americans who are not organized or who do not have institutionalized interest in policy outcomes? Is the present state of affairs to be preferred to some basic change that would make the system somehow more representative? We are not confident of the answer.

We have attempted to offer a sensible and coherent explanation of recent national decisions on federal aid to education. In addition we have attempted to contribute to a broader knowledge of the role of Congress in the policy process.

Appendix

RÉSUMÉ OF THE 1965 ELEMENTARY AND SECONDARY EDUCATION ACT
Public Law 89-10

Public Law 89-10 provided an initial authorization of $1.3 billion distributed through five major titles. Most of the authorization ($1.06 billion) was contained in Title I, designed to assist areas with a high concentration of low income families, that is, those families with less than $2,000 yearly income. This affected approximately 94 per cent of the nation's school districts in 1965. Funds may be used for equipment, classroom construction, and hiring additional staff. Nonpublic students may benefit through such services as educational radio and television, dual enrollment programs, and mobile educational services and equipment.

Title II made an initial one-year authorization of $100 million. It directed the Commissioner of Education to launch a five-year program (fiscal 1966–1970) of grants to purchase library resources, instructional material, and textbooks. These materials are acquired by public educational

agencies within the states and are loaned to local public and private school students. Funds are distributed among the states and territories based upon public and private elementary and secondary school enrollments.

Under Title III a five-year program (fiscal 1966–1970) of matching grants to local educational agencies was established to finance supplemental education centers and services. An initial authorization of $100 million was made for fiscal year 1966.

Title IV extended the authority of the Commissioner of Education to enter into contracts with colleges, universities, and state educational agencies for the purpose of conducting educational research, surveys, and demonstrations. Grants may be made to either public or nonprofit private agencies and institutions. An authorization of $100 million was made for fiscal years 1966 through 1970.

A five-year program (fiscal 1966–1970) of assistance was established under Title V to help strengthen state departments of education. An initial appropriation of $25 million was authorized for this purpose.

Index